MAKING YOUR FILM

for LESS OUTSIDE *the* U.S.

Mark DeWayne

ALLWORTH PRESS
NEW YORK

05 04 03 02 01 00 5 4 3 2 1

Published by Allworth Press
An imprint of Allworth Communications
10 East 23rd Street, New York, NY 10010

Cover and interior design by Joan O'Connor

Page composition/typography by Sharp Des!gns, Lansing, MI

ISBN: 1-58115-215-9

Library of Congress Cataloging-in-Publication Data
DeWayne, Mark.
Making your film for less outside the US / by Mark DeWayne.
p. cm.
Includes bibliographical references and index.
ISBN 1-58115-215-9
1. Motion pictures—Production and direction. 2. Low budget motion pictures.
3. Motion picture industry—Foreign countries. I. Title.
PN1995.9.P7 D46 2002
791.43'0232—dc21
2001006955

Printed in Canada

For Dorothy
My Great Ally

Contents

Part Three PRODUCTION

Part Four DEVELOPING THE PROJECT

Part Five MARKETING AND DISTRIBUTION

Part Six ADVANCES IN TECHNOLOGY

Charts and Tables

Acknowledgments

I wish to thank everyone who made this work possible. First of all, let me acknowledge the fine filmmaking professionals who granted time out of their busy schedules to give the interviews found in this book. They are the few who stand out amongst the many. Likewise, thanks to those who answered my numerous questions outside of an interview context. May they be rewarded in ways unexpected.

A word of gratitude for all those who have written books on the subjects of producing and distributing film and video projects. Though none wrote specifically on the subject of making films overseas, they all contributed their knowledge as the foundation upon which this book was constructed.

A special thanks to those who helped check my material for errors and guide me through the process of writing this book: Derrick Warfel for his encouragement and insights; Dale Dreher and Chris Lowenstein for their budgeting expertise; Gilbert Yablon at Filmout Xpress for his expertise concerning video production and transfers; my publisher, Tad Crawford, for finding value in what I had to share; and to Nicole Potter and the entire editorial staff at Allworth Press for making my work presentable.

Preface

By now we have all heard about "Runaway Production." The entertainment industry unions have found common ground and a uniform voice in their protests against the practice of film companies taking their productions to Canada, Mexico, and other foreign countries rather than shooting them in the United States. Actors, drivers, and studio craftsmen marched as one in 1999 against the state capitol in Sacramento, California, demanding that something be done to keep production at home where it belongs. Over fifteen thousand film workers and vendors crowded Hollywood Boulevard on August 18 of that year in a rally of historic proportions. Complaints resonated like an oft-repeated litany: "It's not fair. They're stealing work from us. I have a family to feed, house payments to make. Why are they taking work away from us?"

Of course, the answer may be that the script requires exotic locations that cannot be duplicated accurately in the United States. Artistic integrity is always a consideration, but there is another primary reason why film production has been leaving the United States—money. It costs less to produce a film in Canada than it does in California. It costs less to shoot a film in many countries than it does in the United States. Arguments abound as to why this is so. Certainly the higher wages demanded by union performers and craftspeople here has much to do with it, but there are other contributing factors. For instance, how can a producer resist a two-for-one exchange rate that increases his or her budget from a $2-million film to a $4-million film, simply by crossing a border? And how many producers can resist the temptation to have their budgets further enhanced by foreign governments offering below-the-line incentives and tax rebates? We who

have made our living from filmmaking in the States must contend with these realities, and that means, first of all, accepting them as such and seeking viable solutions. Our competition is willing to make sacrifices in order to get our business. Are we willing to make sacrifices in order to keep it? Let's accept this indisputable fact: Producers will continue to shoot their films on foreign soil as long as it is financially feasible to do so.

There were several options on how to compile this book. I could have arranged the chapters by pre-production and production; by professions of the interviewees; by regions of the world; or by topic. I have chosen to combine all four of these options:

Interviews are arranged by chronology. The producer's first task is to set up the film and research the locations, and then comes production and postproduction.

In the pre-production period, the producer will consult location scouts, film bonding executives, and film commissioners or film services organizations in the foreign countries. The production section is comprised of interviews with production managers and producers who have actually experienced filming in foreign countries; thus, the interviews are arranged by profession.

The interviews with film commissioners and local production entities are arranged according to regions of the world.

The questions asked in interviews are arranged topically so that readers will be able to compare the answers given by the various interviewees. This is helpful because readers will note the differing perspectives and be able to draw their own conclusions. You will note that the interviewees were asked many of the same questions. This was necessary in order to recognize the general truths.

Finally, I have combined all the information from the various sources into a step-by-step guide to producing a film in a foreign land, with special sections on digital video and marketing/distribution of finished product. Lists of resources are included to aid the producer from start to finish, making this book not only informative but also immensely practical.

Please understand, this book has not been written as a manifesto encouraging runaway production, but neither has it been written to discourage it. It is intended as a truthful guide for independent producers, to present the realities of filmmaking abroad—both the advantages and the disadvantages. Yes, a film may cost much less if you decide to produce it elsewhere, but there are also pitfalls and dangers that should be recognized before making that decision. Being forewarned is being forearmed. By reading this book and wisely considering the advice of the experts who were interviewed, you will gain a clearer understanding of how to produce a film for less money outside the United States. And, after gaining this knowledge, you may decide to shoot the film in your own backyard.

Part One

PRE-PRODUCTION

The independent producer with a terrific idea or a dazzling script (at least in his opinion) must resist the temptation to dive in headfirst before researching the depth of the pond and how hot or cold the water might be. Preparation is the key to filmmaking. The wise producer will try to anticipate every possible problem, know the answer to every possible question, the solution to every possible crisis. Of course, you will undoubtedly be confronted with a situation that is a complete surprise, but at least, if you have done the homework, you will be able to improvise with a higher degree of success.

It is always preferable to visit the potential foreign locations yourself, especially if you are a low-budget film producer. Travel and accommodations cost money, but not nearly so much money as can be lost through lack of knowledge. It's better to spend some money now and at least have a nice vacation than make a critical mistake that will cost much money later, or may even shut down your project. Another option, if your budget will permit, is to hire a consultant or location scout to do the work for you; or you could hire a local producer with an established track record and reputation for filming in that country.

The following three interviews will shed much light on the subject of pre-production when it comes to filming in a foreign country. Pay special attention. Our experts will raise ideas and questions that you perhaps have never considered, but definitely should.

Chapter 1

Location Scout/Manager Paul Pav: Watch Out for Hidden Costs

Mr. Pav has had a long career as a location scout and location manager for every kind of film, from low-budget independents to big studio films. His credits include *Congo*, scouted Zaire, Uganda, Zanzibar, Costa Rica; *Contact*, shot in Puerto Rico, Fiji, scouted Tahiti and Cook Island; *Mission to Mars*, shot in Canary Islands; *Uncommon Valor*, scouted Mexico but shot in Hawaii; *Sandblast*, scouted Morocco; *Snow Falling on Cedars*, shot in Canada; and numerous other projects.

Initial Decisions

MD: In which countries have you filmed?

PP: There are two kinds of countries. There are countries where you are scouting and sometimes not filming, and there are countries where you are filming and scouting.

MD: Then let's discuss the scouting first because that's where it all begins. What are the main things that you are seeking on behalf of the producer and the production company?

PP: Well, mainly, you are looking for the site. When you read the script, you decide where you would like to do it, or where you would like to find it, and so on. And then you try to look for the site. That's number one. We go from country to country some-

times. Then you decide on the site, and you start preparing where you can put the crew, which means looking for the hotels. Trying to find out where you can get the equipment, trying to find out the cooperation: if they have a film commission or if they have the government only. You are meeting with these people, trying to find out what you can do in that country, if they require a script, and so on. This is the pre-production. Then you try to figure out how much it will cost, and then you decide if you will go or not.

MD: Sometimes you have to speak with the prime minister or other high officials. Do you ever find difficulty in getting access to those people?

PP: I don't think so. I've never found anyone who said, "No way." Sometimes you have to wait.

MD: A lot of low-budget films are action genre. That often means explosions and gunplay. That becomes an issue in a lot of countries, doesn't it? How do you deal with the situation?

PP: Some countries will not even allow guns in. But you can bring fakes. And then there's the explosions. It depends on the country. For example, Costa Rica will not allow you to do any explosions or fires in their national parks. Many people go there for the beautiful rain forests, but they won't allow explosions. So you go to Brazil. Brazil will let you do whatever you want.

MD: When you are looking for equipment, if the equipment is not readily available, then obviously that's going to be a factor in deciding if you go to that location.

PP: Also, you are looking for the closest location from which you can bring equipment in. For example, if you are shooting in Puerto Rico, you know there is no equipment on Puerto Rico Island. You have to bring everything from Miami. So you figure out what it is. But you have the same problem in Hawaii. It's still part of our country, but on any island you have to figure out how to bring in the equipment and people.

When we were planning to shoot in Uganda, we knew that you can't find anything in Uganda, so you have to decide: bring something from Kenya, which has a little bit; or is it cheaper to bring everything from South Africa, which is more equipped and ready for filming.

MD: If you know that you have to import all the equipment from another country, you must take into consideration whether the location's government will be cooperative, don't you?

PP: You have to go to customs and find out whether they will allow you to bring it, how much you will pay for it. This is what you must consider in the budget. The thing is this: The director wants to see the best; the producer wants to spend as little as possible. So you are stuck somewhere in the middle, trying to please both of them. So you find the best, the second best, and the third best location. This will cost this, this, and this, and they must decide.

MD: Not every country has unions, so it's not as though you can check a chart that lists union rates.

PP: It's actually much easier than it is here. Even in Europe, they have unions, but the unions are not as strict as they are here. In England that's a different story, but . . .

MD: Do you find that to be beneficial or a hindrance?

PP: I don't know if it is *beneficial.* Sometimes it is, yes, but you get what you pay for. If you pay good money, you will probably get a good person. If you pay a little, you don't get much, especially among professionals. You know, the labor and so on you can save money on, but the professionals you don't want to be cheap.

The producer must be very careful in making the decisions. Find out if the crew member was really working on movies. It depends on what the producer is shooting. If it's a commercial, that's one thing. If it's a feature, that's another story.

MD: Is your job as location manager also to scope out the availability of professionals in that country?

PP: No, it is the production manager's job. But recently I was cooperating with some of the production managers and producers to at least prepare some of this information for the production manager before he came.

MD: Do you work more closely with the production manager or with the producer?

PP: You know, in the beginning, I was mostly hired by the production managers. When I came to America that was the only way to get a

job, but after you establish your relationships, you are either hired by the director because he liked working with you or by the production designer who likes to work with you, because the visual is decided by him and the location manager. And also by the producer. The producer likes to work with you if he trusts that you don't waste money. So lately, I'm hired more often by these people than by the production managers. Also, sometimes I even start earlier than the production manager, before he is hired.

MD: You really have a crucial job because their initial decisions as to where to shoot are based on the information you give them.

PP: Yes, sometimes. On the big productions, it's sometimes the producer, the director, the production designer, and the location manager. The first, of course, are the producer and director, but these four people are starting with the initial decisions.

MD: You also have to know the availability of electricity?

PP: Yes.

MD: You have to know where to put the production vehicles, where you can build the sets.

PP: Yes.

MD: You're doing this schematically?

PP: It depends upon where you are. When we were shooting in Africa, there was no experience or anything, especially in Uganda, Zaire, and Zanzibar, where we were scouting. So you go and establish a relationship with the government. We were talking with the prime ministers over there to get permission. And you know, there is no infrastructure at all. There are no roads, no hotels . . . So if you want to bring a crew of 200 people, regardless of whether they are from the United States or South Africa or England, you know you have to put them somewhere. So in Africa, we decided to build a tent city, like the tourists who go on safari over there. They have the tents, the bathrooms, and everything. So we put together our own city. Those are the kinds of decisions you have to make.

Unveiling the Hidden Costs

MD: Let's go to the subject of the money. Let's say that a producer wishes to go to an exotic location. Even if the locations already have pre-built sets, there's no guarantee that it's actually going to cost less than if they filmed at a studio.

PP: Think about it. You have to bring everybody, pay them per diem, pay them, put them in hotels, airfare, and travel. Sometimes you find that it's much more expensive than you originally thought, even if the dollar is strong and you have maybe two to one over there. Figure out everything before you go somewhere so that you don't get surprised. And it depends where you go. Sometimes there are hidden costs in these things. You also have to take into consideration the weather. How the weather is in that area during the time you wish to go there. If you have two weeks of rainy season with floods when you're trying to shoot, you're going to lose a lot of money.

You must find the location first, then you go looking for the problems, the pluses and minuses. This is the responsibility of the production manager and the location manager, and the producer has to make the decision.

MD: One of the grand realities of location scouting is that you might have absolutely everything that you need, but there might only be two weeks of good weather the entire year.

PP: Yes. The point is that moviemaking depends not only on where you shoot, but also on availability of the actors, the availability of the money, perhaps the availability of the director. So the producer finds that he's only able to shoot the film during a specific period of time. You must take the weather into consideration.

If you go to Alaska in winter, you know you can't get anywhere. All the roads are closed and you don't have accessibility. All of a sudden, you have to use helicopters only, and the cost is ten times higher. All of these elements must be taken into consideration.

MD: What are the big mistakes that first-time producers make?

PP: Very often the first-time producer makes the mistake of trying to save money by not hiring people. It's funny. I'm not saying this because I'm a location manager, or even that it's a necessity to have a location manager, but it's necessary to have someone with prior experience. The producer should have people around him

who will make knowledgeable recommendations, then he must make the decisions. I think that that is the biggest mistake—when the producer wants to do everything on his own.

MD: Which is better, sending a location manager who lives in the United States or hiring a location manager who lives in the region where the film will be shot?

PP: Again, pluses and minuses. If the guy is living there, you save money by not having to send the guy and feeding him, etc., but the local one will always try to do something most beneficial to the local place he is from, while the location manager from the United States knows the needs of the production company, and he looks at everything from a different point of view; he takes into consideration every potential problem, while the local hire may not. The local man will always tell you, "We have no problems. We have perfect people. We have perfect locations." Then the problems come.

MD: Even though they may have a better idea of what is available, they also have a built-in conflict of interest.

PP: Absolutely. He is trying to get the company there. He is working for himself, or the government or whatever, so he wants to bring the business. My experience with all these film commissions is that if you call any of them and ask, "Do you have this?" they always say they have it. They will just say, "Yes. Come in and we will show you that we have everything." But it's not always true.

MD: You had mentioned hidden costs. You might be interested to know that in my interviews with film commissioners I always bring up the question of hidden costs, and I have only found one or two who have actually mentioned the possibility that there might be such things as bribes that need to be paid in order to continue production. What can you tell me about that? If you go to a third-world country, what might you expect in the area of hidden costs?

PP: You will sometimes encounter the need for bribes, or whatever. They will promise to do something for a previously agreed-upon price, and then, all of a sudden, when you need it, or they feel that you need it. . . . For example, customs will promise you that they can clear something in one day, and then the next will say, "I'm sorry, we have a small problem." And you know that you have to put some money in if you want to have it the next day.

Sometimes they will say, "If you pay, we will . . . ," and sometimes they won't. But you know that if you don't do it, you won't get it. The same goes for labor. All of a sudden, in the middle of shooting, they will say, "Oh, we are not paid enough," and they will not work. What do you do? There is no union; there is nothing to push them.

MD: Do you actually have any examples of situations where you needed to pay a bribe as a hidden cost?

PP: Mostly I paid at the borders. The worst part is always dealing with customs. That can cost you a lot of money. The other thing in some countries is the police. They may come to you, and you may have to pay money.

You called it a "bribe." It's not that people come to you and say, "You must pay me"—though that has happened to me as well. Mainly, you just know that unless you pay, you won't get what you want. This is not bribes, but this is what you have to do. It's not only customs, but in many other things. If you want something in the countries that are more inclined, you have to have a lot of cash in your pockets all the time.

MD: And sometimes it may be something as simple as a bottle of cognac, right?

PP: Oh, I do that normally without asking. If someone does something for me, I show gratitude. If the producer has anything left from the budget when he leaves, it's always good policy to acknowledge help and show thanks.

MD: If you must accomplish something, I imagine it's always best to go bearing gifts in hand.

PP: Absolutely.

MD: Should you anticipate having more than 30 percent added to your budget for unanticipated costs? For example, is 30 percent enough in the Philippines?

PP: I would go higher. Forty percent.

MD: Mexico?

PP: Forty.

MD: You mentioned Brazil.

PP: Over there I think it can be 30 percent.

MD: Europe? England?

PP: Thirty.

MD: Canada?

PP: If you go to Toronto, British Columbia, even less. But if you go to Quebec or Montreal, I would say you can expect even more problems. The area over there with the French-speaking people sometimes is not the best to work with. They are very pleasant; they want the business, and the film commissions are beautiful. I love them all and I love their locations, but when you deal with the individuals and you don't speak French, you have problems. That can sometimes cost a little more money than you expected.

Contrasting Work Ethics

MD: You had mentioned earlier that there are disadvantages to not having unions.

PP: These are probably the worst situations to look out for. I feel that in these countries, like Mexico and even in Africa, the rhythm, the work ethic, and everything is very relaxed. We, in our business, are accustomed to go and go because every minute costs money, so our crews here (in the United States) are used to being efficient. But over there, they don't care that much.

MD: You can be in a country where they may actually produce many films, but their pace of work is much slower.

PP: *Different.*

MD: So that's another thing to take into consideration. Is that more because of the union situation or more because of the culture?

PP: That's because of the culture.

MD: Let's talk about the various regions where you have worked. You've worked in Africa.

PP: Yes. I've worked in the Canary Islands, Puerto Rico, Fiji, Cook Islands, Tahiti, Zaire, Uganda, Zanzibar, Costa Rica, Nicaragua. In Europe—Switzerland, Austria. Also Mexico, Morocco, and Canada.

MD: You've been a world traveler. Are there differences that you should anticipate if you go to various regions of the world as far a film production goes?

PP: You have places where they have film commissions or they are used to filming. And there are countries where they don't know what to expect or what to do for you. There are countries that want you to be there, and there are countries where they don't care or the government isn't even enthusiastic about filming. I've never shot in China, but I was there. I was talking to people in China, and the government is not really too thrilled about having western film companies there. So it's a different attitude in different places. Shooting in Fiji for example. If you are looking for the most beautiful island, and gorgeous color of the ocean and palms and so on, you can go to these islands. But you know that everything is against you. You have to bring everything from Australia. There is nothing. There are no hotels, so you have to bring a ship to put the crew on. There are a lot of problems involved. You have to decide if it is worth it or not, and if you have the money for it. If you have a company that says, "Money is no object," then you can shoot anywhere. But they will never say that.

 If the director is a director who has been successful for a long time, brings in a lot of money for the studio, the studio is more likely to allow extravagances, because they know somehow it will be repaid. So, if the director is pushing for a particular location, he will probably get it. If you are a first- or second-time director, or not as successful, the studio will be more tight with the money—for which you can't blame them. It's definitely easier for Spielberg to achieve something than for some lesser director.

Filming Low Budget for Top Quality

MD: If you were a low-budget producer of a film, what would be the most friendly, cooperative countries to work in, where you are going to get quality for your money and good local hire. Do you have a short list?

PP: I will say that obviously it is Canada. You have English-speaking

crews. They are equipped. They have stages, most of the necessary elements, and the dollar is strong. That's why everybody is going there.

Second, I would say Australia. Again, English-speaking crews and equipment, if you are shooting closer to the major towns. Australia is too big. We were trying to shoot *Thorn Birds* and couldn't do it because the closest hotel to the location that was decent was three hundred or four hundred miles away. On my list, Australia is probably the second-best location for overseas shooting.

MD: Would you include New Zealand with Australia?

PP: Yes, I would also say New Zealand, but it is not as easy unless you are around the main towns. They are efficient. The crews are pretty good, and you will save money. Their rates are much lower than they are here. But again, you have to think: How many people are you bringing from the States. You can't bring too many people.

Now Europe is expensive. It's not cheap. But if you go to Prague, and if you go to Budapest, it is much cheaper. They have the equipment and people, but you have language costs: hidden costs for the interpreters.

The Language Barrier

MD: You just brought up an interesting point. In speaking with film commissioners, I have found that they discount language as being a problem. How does language really affect shooting time and getting specifically what you want?

PP: It's very difficult. Believe me. In some countries, they say, "We will give you English-speaking interpreters." Now I speak miserable English, but the interpreters over there may not speak half as well as I do. They may not understand half of what the director or cameraman tells them, because they haven't worked around films. And you don't understand what they are saying. It can slow you miserably and cause mistakes.

MD: Can you give me an example of how language problems ended up hurting a film shoot?

PP: When we were shooting *The Bridge at Remagen,* for example, I was

working with the local Czech company. Wolper brought his whole crew from the States, and we gave each of his main guys an interpreter. Now the director of the second unit had a run of tanks and a train and explosions and action to shoot, and we lost about three days because there was such bad communication. If you have large locations and you are dealing with three or four interpreters for the main people (the gaffer, special-effects man, the director, cameraman, and sound), it takes hours for them to communicate back and forth. It was a horrible time. I can't tell you that anything devastating happened—nobody was killed or anything like that—but we lost time.

MD: Time really is money.

PP: It is definitely.

MD: How does the infrastructure of a country affect shooting?

PP: If you are shooting in Europe, anywhere other than in England, it will probably be a major production to find a decent lab that will guarantee good developing, and you will probably end up sending the film to London. Everything will cost money because you have to arrange for shipping, etc.

Shooting in Costa Rica, you have to send everything to Los Angeles. A screening room for dailies is no problem; you can use a room at the hotel, but sending the film back and forth is an additional headache.

MD: So would you suggest to a low-budget producer that he spend extra money for video assist rather than deal with the headaches involved with shipping and processing?

PP: Yes.

Paul Pav's Picks: The Best and Worst Locations

MD: What are the best countries in South America for film shooting?

PP: I would say probably Brazil and Argentina.

MD: Central America?

PP: Probably Mexico, and next best would be Costa Rica.

MD: What about Africa?

PP: South Africa. They have everything there. I'm not saying it is a better-looking country. Uganda is, to me, a nicer-looking country. But shooting in Uganda is difficult. The infrastructure is not there.

MD: The Middle East?

PP: Israel probably. It is dangerous, but it is still the best. They have an industry there.

MD: Europe. You would say England?

PP: England, yes. England is the best.

MD: And what other countries?

PP: Money-wise, I would say Eastern Europe. And I will recommend Czechoslovakia [the Czech Republic] highly. They are very good. Eastern Europe has a problem, though, that the equipment is not state-of-the-art, but it is usable. If you want to save money, you can use their equipment and make a decent picture, but it depends. Germany is very well equipped, but it is much more expensive.

MD: Australia is a continent in itself, as we have already discussed. What about Asia?

PP: I would say Japan, but it's very, very expensive. And I would say Thailand. And I would say Indonesia. It depends, of course, on the kind of film you are trying to shoot.

MD: Let me ask you about two countries in particular. Many films are made in the Philippine Islands. How do you feel about filming in that country?

PP: You know, when we were talking about the weather problems, the labor problems, all the hidden costs. You will encounter that.

MD: What about Hong Kong?

PP: I can't say *now*, but Hong Kong was very good. But I don't know how it works there now. I don't think there are major restrictions

from the mainland, but I don't know. It's one of those places that you don't know what you might encounter until you are there.

MD: That's a good list of the better countries to shoot in. What are the countries you would never want to film in?

PP: There are countries where you should first call the State Departments, and they will tell you not to film there, because it is dangerous. There are many countries like that. Today, you can't shoot in Uganda or Zaire and a number of other countries because the State Department will not allow you to go there. Or, there are countries that they will not recommend, which means the insurance company will not insure the star or the director.

MD: That's actually an important point. Even though you might want to shoot in a particular country, you have to take into consideration the aspect of insurance.

PP: Yes.

MD: Let's talk about the most overrated places for filming.

PP: The Philippines is one of them, I think. People don't expect all the problems over there.

MD: Would you also encounter that in Indonesia?

PP: You will encounter similar problems. In mainland China, for example, I feel it would not be worth it to fight all the difficulties you will be hit with, all the censorship and so forth. I don't think it's necessary to go through that, unless I really must shoot the Imperial Palace. I would look for different countries that give the same visual sense.

From my point of view, nothing is too difficult; everything can be achieved. The only question is whether you are willing to sacrifice to pay for it.

Mistakes Producers Make

MD: What are the biggest mistakes that producers make other than not hiring experienced professionals?

PP: My feeling is that wherever you go, you must remember that you are a guest. Very often filmmakers go to a foreign country with the attitude, "We are from Hollywood; what are you dummies thinking? I'm bringing you money so do what I want." If you come with this attitude, they will do everything they can to bust you. That's everywhere. Not only in foreign countries, but in local communities in America.

The other thing is not being prepared and not telling the truth about what they intend to do. They sometimes go and say, "We will only shoot outside that house." And when the time comes, they try to run inside and tear it apart, and they become very surprised when the owner says "No!" I always feel that both the location man and the producer must lay everything on the table and say, "Look, this is what we want to do"—and even say more than you want to do—and judge their reaction.

Don't surprise people. Every surprise you spring will cost you money. Don't pretend. Don't speak half-truths.

MD: If you are fully prepared and if you get the people together who have experience in that foreign location, it is possible that you can save a lot of money shooting in an exotic location.

PP: Yes.

MD: And if you do things in the wrong way, you will probably spend . . .

PP: Much more.

Chapter 2

Bill Bowling: Covering the Multitude of Details

Mr. Bowling has been to sixty countries in his capacity as location scout and location manager. With more than twenty years of experience, he is immensely qualified to speak on the subject. Mr. Bowling is on the advisory board of the Association of Film Commissioners International.

MD: Would you please give a brief description of what you do as a location manager?

BB: I work mostly on feature films, and there are three phases to my job. The first phase is finding the locations. The second phase is arranging or negotiating the deals and logistics of the location. And the third phase is the most arduous: that's managing the location during shooting. And there's a fourth part actually, which is wrapping up the location.

MD: About how many films have you done in your career?

BB: About twenty-five feature films.

MD: Where have you worked outside the United States?

BB: I've been in sixty countries, and about twenty to twenty-five of those countries were for scouting.

MD: South America?

BB: Central America, and I've been to Peru. Not a lot of countries in South America.

MD: Asia.

BB: Southeast Asia pretty extensively.

MD: Europe?

BB: Every country except one or two there.

MD: Africa?

BB: Only North Africa. I've been through Russia, Australia, the Caribbean. I've been all through the Caribbean a couple of times. Probably the most intense scout I had actually was in seventeen countries in the Caribbean.

Evaluating Needs, Recognizing Limitations

MD: What are the things that you want to find out from the producer before you begin a scouting trip—obviously, the look that the picture entails—but what else?

BB: I'm not sure how to answer that. The process is more that I read the script. We talk about what parts of the script are likely to be shot in certain countries overseas. And then what our particular needs are. How much of the crew needs to be local hires. Whether the crew might be an Australian crew or a U.K. crew overseas, rather than American. It might be a lot of Americans we bring. Another concern, on big pictures especially, is if there are a lot of special effects that might run into environmental and ecological problems in certain countries.

MD: I imagine there are a number of countries where you can't bring pyrotechnics.

BB: Yes, but it's more a matter of use. Pyrotechnics I've never had a problem getting in if you have permission from the film commission and the government. Weapons are sometimes a problem in themselves. Guns are illegal in some countries, but it's more a question if you're going into a jungle and doing a war picture. The most interesting jungles are, in fact, national parks and

reparative sites or protected areas in one way or another. You can't just go in and do an action movie in the middle of these protected areas.

MD: What is the process if the country doesn't have a film commission?

BB: First step is to try and find people who have shot there before. Find out what their experience has been and get contacts from them. The next stage would be to get contacts one way or another, whether you're going through the embassy or private parties. There's always some kind of filmmaking infrastructure. Virtually every country has it. Even Burma [Myanmar], which is really behind a curtain, has its own motion picture division. That one's run by a general, in fact.

MD: But you can't always expect every country to have the equipment you need, and you might have to bring it in. How does that work with the government and customs?

BB: Well, there are a lot of issues. That's a very complex arrangement. You can sometimes get equipment in a country, if they have it. Sometimes you can get it shipped easily from neighboring countries, say Singapore or Hong Kong, if you're in parts of Asia. There are a lot of customs concerns and clearances and shipping bills and taxes; all these kinds of things going both ways, in and out. In some countries it's difficult to ship exposed film out without a censor's approval. It's very tricky. You've got to be sure that you've got all that wired before you go there for production. You should not assume that you can get equipment easily, especially if a piece of equipment breaks down. You've got to have plans in place to get quick replacement.

MD: Is that part of your responsibilities—where to get replacement equipment?

BB: Probably, but in the end it would be done by the production department.

Whom to Hire

MD: Let's go to local hire, since you brought up that issue. As an independent producer, how do you decide whether to hire local or ship in an outside crew?

BB: The whole business runs on reputation. So you just find out what reputation people have and their credits. Then you check their references. Talk with people; find out if they are any good. First of all, "independent filmmaker" doesn't mean very much unless you are defining it as low budget. If you're talking about a low-budget film, that's a different world.

Last month, I was in the Philippines and Australia talking about construction crews. A local construction person with experience in film in the Philippines costs about $20 a day. A local construction person in Australia may cost you $300 a day. These people could be of comparable skill, but there is an enormous difference in labor costs. I suppose the reasons you go are for the look, or the labor costs, or you go for some other reason, like a tax reason.

MD: Can producers assume that they are going to save money on a film overseas just because they can save money on crew and cast?

BB: You mean versus shooting in the United States?

MD: Yes.

BB: In general, many other countries have lower labor rates than the United States. However, there is less assurance that your project will come out exactly the way you want. There can be all kinds of problems overseas: governmental problems, civic and political unrest, financial-conversion difficulties. I would say that probably the best crews come out of the United States, and the U.K.—experienced, big-time crews.

MD: So, if you are adamant about achieving your artistic intent, you have to figure the cost of that big-time U.S. crew into your budget.

BB: If that's the crew you're going to use, then you wouldn't necessarily save money by going offshore. You're going to be housing people, flying them, paying per diem. A lot of producers bring in keys, maybe one or two people per department, and then they'd hire locals at significant savings to fill out the crew.

MD: And if the country has a film commission, you're probably getting referrals for that purpose.

BB: Yeah, or you may get local producers who probably know the crews even better. You don't always get referrals from film commissions because there's a legal question about it. If the film com-

missions are government agencies paid for by taxes or government funds, some of them consider it inappropriate to recommend one person over another.

MD: They're not a hiring agency.

BB: And there have been cases of them being sued for speaking negatively about a certain person.

Censorship

MD: You mentioned that there are some countries where you can't ship the exposed film without a censor's approval. Does that mean that you're going to have to develop the film in the country and give a screening?

BB: You may, in certain countries. I don't know what they all are—in Egypt and Thailand you need script approval before you are allowed to shoot. Then they have a censor on set at all times, standing next to camera, to see everything that's recorded. Then that censor's government agency needs to sign-off on that film before it is sent out of the country. I don't know that it's always required to be processed in that country; some countries just don't have professional processing facilities.

Southeast Asia

MD: You have a sense of the film-friendly countries versus the countries where you will have this difficulty?

BB: Yes.

MD: Is this based upon personal knowledge, what you've heard, or what the government officials tell you?

BB: All three.

MD: What are the best countries in Southeast Asia for independent production?

BB: It depends upon why you're going. Are you talking about money or ease of shooting or equipment availability?

MD: Let's start with cost.

BB: The Philippines is a very good place to go if you want to save money. They have very good local crews, and they work for a reasonable amount . . . a very reasonable amount.

MD: Are there any other countries that can compare to the Philippines in that regard?

BB: No other countries come to mind that have a lot of film experience and still have the reasonable rates like that. Malaysia doesn't have all that much shooting really, and it's kind of a difficult political situation there. Thailand has quite a bit of experience with filming, but it's not always cheap in Thailand. And their policy seems to be that you can shoot a lot of movies in Thailand as long as they're not about Thailand. If the subject matter is about Thailand, they have a lot of concern about their image, and you must go through their censorship board for approval. They're shooting a lot in Australia now, and there are some savings there, but it's not the kind of savings like you find in the third world. Australia's definitely not a third-world country. Hong Kong has a great, established, huge, major film industry there. All the equipment you need, but very limited terrain really.

MD: What should a producer expect in regard to speed of production in Asia?

BB: They just do things in a different way. You may have more employees but they cost less. They usually know what they're doing. It depends, of course, whether they are gaffed by an outside-crew department head. I would say that you can generally stay on the same schedule.

Anticipated Difficulties and Unanticipated Expenses

MD: If you're shooting in a foreign country, should you anticipate increasing your cushion for unanticipated expenses?

BB: I wouldn't say you should increase that amount. I would say that you need a lot of latitude because you can run into film-delivery problems, or enormous traffic problems, or equipment breakdowns. These places are not first world, especially in terms of

equipment, trucks, highways, infrastructure. If you go to some-place like North Africa or Ukraine, you can run into problems.

MD: You had also mentioned the possibility of civil unrest. Have you ever had problems in matters of security by going to other countries?

BB: I was scouting a few months ago in Mindanao, and they wanted me to have three armed bodyguards. But that was for location research, and we wouldn't shoot there under those conditions. I think it would be very questionable to take a crew into an environment like that. Filmmaking is an expensive process, and you want everything to go as smoothly as it can.

MD: Are there places you would not want to shoot?

BB: Well, sure. The pleasure of my job is scouting, and I love to scout, but there are a lot of places I scout where I would prefer not to be involved in the production, because of all the headaches and hassles and potential for problems, as well as physical difficulties like weather.

MD: So even if the producer chooses to film there, you may choose not to go.

BB: Absolutely. Even countries in Western Europe. I could just imagine having to shoot a car chase through the streets of Paris. That would be one gigantic headache.

MD: It's not that it hasn't been done or can't be done; you just don't want to be the one to do it.

BB: Right.

MD: Is it worthwhile for a producer with a $3-million budget or less to try to film in Europe?

BB: If someone has $3 million or less, they are making a nonunion movie. You're not going to be taking people from here and housing them and flying them, other than maybe a couple of people. You're going to be working with the low-cost people whether you're working with them in Hollywood or Prague or Timbuktu. I guess one of my considerations would be that mostly throughout

Europe you can find equipment. In Timbuktu or some other remote part of the world, you wouldn't be able to find equipment, and it would be more expensive that way. But at that kind of budget level, the costs may in a way be the same in a lot of places. You're going to take as few people as you can. You'll hire local labor at as low a price as you can, and you're going to make your picture.

MD: The Australian commissioner essentially told me that if your budget is less than U.S.$2.5 million, you might as well not even come to Australia; you won't save money.

BB: Yeah.

Flexibility, Not Intractability

MD: What are the biggest mistakes that American producers make when they go to film in other countries?

BB: The biggest mistake is assuming that things will work as well there as they do around here. You've got to leave a lot of room for impromptu adjustments. There can be a lot of things that go wrong: a government permit not coming through at the last minute; political issues; equipment not showing up or working.

MD: When I spoke to the Mexican commission, they said that the biggest problem they have is American producers thinking they can get away with the same things in Mexico as they do in the U.S., such as stealing locations.

BB: Well, I think that's ridiculous. I've done this for more than twenty years, and I've never run across people trying to get away with things here. I don't know what they're talking about really, and I would never go anywhere and try to get away with things like that. It's asking for trouble. But that's kind of the difference between a low-budget show and higher-budget shows. There's really a lot of liability with these studio shows, and the last thing the studios are interested in doing is taking on an enormous liability exposure by doing something illegal.

Managing a Foreign Location

MD: Does difference in language slow down production?

BB: No, that's a very minor problem. In fact, usually you don't hire interpreters at all. More and more, the business side of the world is run in English no matter where you go. And almost always the keys speak English, or you will have someone there like the AD who is bilingual, and they can clearly translate to people. And then, often, the local crew will get their marching orders from their department head in their own language.

MD: How are your duties as location manager different in a foreign country than if you were here in the States?

BB: It's very different. You would also have a local location manager. They would know the details of how to get the permits, who to talk with, and know the details of their own government's infra-structure (which I would not), and they also have relationships built up with these people; whereas, if we were in the United States, I would do it all myself. So there's quite a bit of difference. It would be more of a management job outside the U.S. than it would be here.

MD: Does that ever put you into conflict with the local location man-ager? It would seem that the local person is going to do the best he can for the people he has relationships with, and that may not be in the best interest of the production.

BB: That's one reason that I'm hired and kept there. My allegiance is more to my employer, whereas the local person's allegiance may not be as strong to the producer or studio.

MD: The producer or studio may never come back to the country.

BB: Whereas, the local person lives there and has ongoing relation-ships, so he may wish to make them the best deal, rather than making the sharpest deal for the producer.

MD: What are the other things you look for in a location?

BB: There's so much. Transportation. Is there air service to the place? Freight service. Whether equipment can get in and out. What the customs regulations are. What the censorship regulations are.

What the crews are. Another big factor is hotels and the level of hotels, whether they are of a quality for the crew to stay in. Whether there are telecommunications available. How far the locations are. What the roads are like and how long it takes to go to locations. What the traffic is like. What the weather conditions are likely to be. Issues of security and political instability. Whether there are experienced crews that can be hired locally, and what their rates are going to be. What the tax system is. What the permits are; whether there are special permit situations. If there are extras available for the movie and actors for the small parts.

MD: Are you involved in making the final decision, or do you merely provide the information to the producer?

BB: Well, the decision is almost always made with information that I provide. We all consult about it. I don't make the decision as to where we should shoot the picture. It's whoever handles the financial aspects of the project, usually in alliance with the creative director.

MD: You had mentioned environmental issues. Is it your responsibility to also make sure that the location is restored to its original condition after filming?

BB: Yes.

MD: So that could keep you in the country even longer.

BB: It could, or you hire local people to do it. For example, with *The Beach,* the location was a government beach. I think a 5-million-baht deposit was required, and all the restoration was done to the satisfaction of the government. A hundred percent of the deposit was refunded to the film company. However, there was a local group that had a concession on the beach, and they are trying to get a very large amount of money from the production company by claiming that the beach was damaged; whereas, the government, which is responsible for the property, is fully satisfied.

MD: So you might have to look out for people who want to profit undeservedly from the company through threats or whatever circumstances they can manufacture.

BB: *The Beach* is probably a good example, but there are times when the production company, for various reasons, has such a high

profile that everyone has their hands out. It's definitely something to watch out for, especially if there's a big star, a big studio, or a big director.

MD: Do you find that to be less of a problem if you're a smaller production with no big stars?

BB: Sometimes these people are unaware. They think that if it's associated with Hollywood it's a big deal. They put their hand out automatically.

MD: Whose responsibility is it when a payout does have to be made?

BB: It depends entirely on the deal. It can be from the lowest level to the highest levels. It can go from a few dollars to a million dollars.

MD: Have you heard any horror stories where this occurred?

BB: It's usually the opposite case. The stories are stories of how successful they were at getting something by paying for it. Whether it's a payment under the table to someone in the military to get military equipment to show up on the set, or other kinds of things.

MD: Basically, you can anticipate that in a foreign country money will grease the wheels.

BB: No, not necessarily. I'm just saying that certain countries operate by paying off people, and that's the way their economies work. In fact, there are United States laws against U.S. companies doing that. It's a complex issue.

Some Friendly Advice

MD: What word of advice would you give independent producers who wish to produce their film overseas?

BB: Going overseas is such a big rope. If you go to France or someplace, you may have a crew that only wants to work eight hours a day and take a two-hour lunch break with wine, and it may be very expensive to shoot. If you go to Madagascar, you may end up with a local crew that will work for very little.

One of the issues is taxes, where your payroll comes from,

whether it's offshore money, whether it's U.S. money, whether there are foreigners hired, and so on. A lot of issues like that can save money. The way it's usually done is that you find a savvy, experienced local producer, and that's who you hire to put the picture together. If you're shooting in Italy, you find someone who does it in Italy. If you're shooting in Morocco, you find someone who does it in Morocco. If you're shooting in Thailand, you find someone to do it in Thailand. And that's who you rely upon, usually by referrals and contacts. You wouldn't go there as an American and expect to know the nuances and intricacies of the culture. It may be an issue as small as a camera part that gets hung up in customs. You've got to have someone who can get this stuff through quickly, who knows the system.

MD: Would you say that the visiting producer needs to trust the local people to get your production done properly?

BB: Yeah, you find the most talented person, and you hire him. It doesn't mean blind trust, but you're going to have to hire local people who know the ropes.

Chapter 3

Lionel A. Ephraim: The Completion Bonder As a Valued Resource

Mr. Ephraim started his film career as a film editor for Walt Disney and at 20th Century Fox, but quickly progressed into work as a director, cameraman, production manager, and line producer. He then became head of production at MTM Enterprises during the first ten years of its existence, produced the miniseries *Kent State* for NBC, and has worked the past twenty years as a completion bonder. He is currently Senior Vice President of Cinema Completions International, Inc.

MD: You know the ins and outs of the business. You've seen the changes in the industry for more than four decades, and you know the business of completion bonds both in the United States and abroad.

LE: Well, I don't know that I know everything, but I've had some experience.

MD: Many of the lower-budget films are being made abroad, not because the script necessarily calls for it, but because it is less expensive to film in another location. Perhaps they were only able to raise half the money they needed to film in the U.S. Do many producers come to your company under these circumstances?

LE: It's not a preponderance of our business because we do a lot of the bigger films as well, but producers are always looking to get

the most on screen for their money—whatever that means. In some cases they can't raise any more money than a certain amount, in which case they may go to Canada because there's an economic advantage, or they'll find places around the world where there are government incentives via subsidies or tax incentives of some sort. The world picture changes from time to time. One country will be hot and then that will dry up, so they go to another one. Producers are a pretty resourceful bunch, and they usually find the money somehow.

The Philippines has for many years been a place where low-budget films can be made. We don't get involved with a lot of them. Many of these films don't have bonds because they're cutting corners every way possible, and usually they're finding the money from some sort of equity financing, which doesn't require a bond, though that isn't always true.

The Involvement of the Bonding Company

MD: Where does the bonding company fit into the time schedule? When do producers come to you with the project?

LE: It varies. When they come to us, and when they should come to us, are not necessarily the same thing. Quite a number of producers will call a bond company way before they are ready, thinking that perhaps having a bonding company on board will help them to get the money. Some producers are confused, by thinking that we somehow help in financing films, which is not what we do.

But in many cases the producers try to put together a package to attract investors. Sometimes they think banks are investors rather than lenders, and that requires an educating process. And there are a couple of banks around who mislead the producers—not necessarily intentionally—by saying, "Yes, we will help finance your movie." The producer hears, "I'm going to invest in your movie," when the bank is really saying, "We will lend against collateral to help you make your movie because that's the business we're in." They tell the producer that he will need a completion bond, so the producer then calls a bond company and says, "Gee, I've got this bank ready to finance my movie and all I need is a completion bond." We kind of help him understand what the reality is. What it really boils down to is looking for some sort of conditional letter of intent to show that they've talked to a bond company, and the bond company is perhaps interested, provided

the project comes together. It's a relatively insignificant letter, but it seems to carry some importance in that it helps give the producers a little bit of legitimacy, and some people read it that way. There are no promises made in that letter. It simply says that if you have a project that meets the conditions we require, we will be happy to provide a bond.

MD: When is the right time to contact you?

LE: The right time is really when they are at the point, or close to the point, where they really have the money committed, whether it be a commitment from a bank to make a loan based on specific conditions which exist, or whether it's investors that are putting in money but they won't release the money until there's a bond. Something real.

The best descriptive scenario is the common *negative pickup* process, whereby a producer is able to package a project to the extent that he gets a major distributor interested in distributing the project, not to the extent of funding the production but to the extent of buying it when it's finished. They will enter into an agreement, or at least have a notice of agreement subject to the final document being done, that they will pay a certain amount of money upon delivery of the completed film. In the simplest version, they are doing 100 percent. More often than not, these days, it's multiple parties. There's one party that has domestic, one for foreign, or maybe there are five or six different entities. But let's say it's a major studio that says it will give you 100 percent of the agreed-upon budget provided the film has certain agreed-upon elements and provided it meets certain specifications.

The producer has now gone a long way toward getting his picture made. He, at that point, has to find a way to get the money to make the picture, because all he has is a contract that pays him when he delivers. So that's a contract the producer will take to a bank, and a bank will lend against that kind of a contract, assuming the distributor is creditworthy. Most of the bigger ones are. But the bank will require a completion guarantee so that the bank is assured that the picture is actually made and delivered, because if it isn't made the bank has no means of collecting because the contract calls for payment only upon delivery. What we are doing really is enhancing the creditworthiness of the producer, because the bank knows that we will pay if something goes wrong. The process of putting the bond in place is concurrent with the finishing up of the lending, distribution, and other documents. It's sort of like an escrow closing when everything comes into place, then

documents change hands, money changes hands, and the picture starts to get made.

Bondable Elements

MD: What are the elements that make a bondable film—for example, the actors?

LE: That's always a good question. Some actors are bondable; some are not. Some are only bondable given certain protective mechanisms. The bond company analyzes every film in great detail. One of the elements is the people—both in front of the camera and behind the camera. We like to satisfy ourselves that the people being proposed for the project are actually capable of doing the project and that they can be reasonably relied upon to complete it. If we have doubts, then we are going to ask for certain changes or certain backup conditions in order to make us comfortable. If you have an actor, producer, or director who has a bad track record, we're going to shy away. We could ask for someone to replace them—that's possible—or we are liable to reject the bond. Perhaps, it's somebody that has problems that can be dealt with provided certain conditions are met. Maybe you want to have a part of their salary in reserve pending performance. That sometimes works; it sometimes doesn't. It depends on what the problems might be. Sometimes it's conditions you want to impose as to the kind of place they stay in or the kind of support people they have around them. Most of the time, this works fine. There are a few people in all categories who have problems, and we have to recognize that and deal with them.

MD: What about a producer who doesn't have a track record? Are you going to make requirements to have a line producer with a strong track record attached?

LE: Absolutely. We have to be sure, to the best we can be, that the picture can get made. If a producer doesn't have an extensive track record—I'm not saying a bad track record, just that there's not much to go on—we are going to make sure that he's surrounded by people that do, that we rely upon to get the film made and support him or her in whatever might be their weaknesses. An inexperienced director may have very little way of judging how long it's going to take to shoot a scene. It has to be budgeted out and planned on a schedule to fit the budget early on, and we want

to make sure there are people there who can do it, should the director fail. It's not unheard of, although it's rare, that we might have to replace someone in the middle of a show if they are unable to complete their duties.

Foreign Production Incentives

MD: Relating this to shooting in another country, let's say the film is shooting in Canada. If you are placing restrictions on a producer or director, are you looking for a production manager or line producer from Canada or the United States who has a track record?

LE: It depends. In a country like Canada it could be either. In its broadest form, it doesn't matter whether it's somebody from that country or somebody from this country with long experience shooting in that country. But when you go to Canada or some of these other places, there are other things involved besides just experience. Often, particularly in Canada, there are certain governmental incentives in addition to the advantage of the exchange rate. So let's say we had somebody from the United States who is very experienced, but he's an American citizen. He wouldn't qualify, or he wouldn't allow the production company to qualify, for some of those tax subsidies. The producer from here would have to make an arrangement with a production company in Canada, and have certain key personnel who fit the Canadian definition, in order to qualify for those monetary advantages.

That happens in countries around the world. It depends on how they set up their various incentives. Some of them are stricter than others, or have been over the years, as to who can qualify. But, usually, when a government is setting up an incentive, they are trying to benefit their country and their country's people, so there are restrictions that make it certainly advisable, if not mandatory, that you have locals hired. So we have to have a track record on those people, something to go on to make sure they can deliver. And, if you get to a more exotic country, a country with whom you have had less experience, then you also have to satisfy yourself, as best you can, that the government is such that things aren't going to change in the middle. It's not unknown for countries in the past to have made a change to their tax rules retroactive so that a company can get very badly hurt once they've already started and committed. They find the rug pulled out from under them.

MD: Does the bonding company check out the proposed tax incentives?

LE: We would have to. There are several factors involved. One, to the extent that those things apply to the film, we check them out carefully. We do not, as bonders, invest in the film, but we do take certain financial risks. If the guaranteed performance doesn't take place, it may cost us a lot of money, but one of the conditions of a bond is that 100 percent of the agreed upon financing to make the picture is, in fact, delivered and put in the picture before anybody can call on the bond. If they're going to a country, like Canada—in a certain way—or Austria, where if you shoot the picture in that country and spend a certain amount of money there, you will get an amount of money back as a subsidy. Well, that's terrific, but we can't go in there and bank that promise. So if we're going into Canada, for instance, the Royal Bank, amongst others, will bank their own government's promise to pay. We will undertake to make sure the conditions are met, whatever those conditions are, as long as they're definable. But we will not guarantee that the government isn't going to change its mind and not pay. There must be a bank that will lend against that contract so that the money is there.

Sometimes other countries are not as sophisticated or not as used to it, so it's harder to find a bank to do that. We did a picture in Belgium, for instance, where we had an overseas insurance company that insured against the government not paying what they were supposed to pay at the end of the day. The bond company will check it out, but if the budget is 2 million and you only have 1.5 million, and you're counting on that other half million to come from the government, that isn't good enough for us. We're not taking that half-a-million-dollar risk that the government won't pay. You have to find another way to bank that promise or to cover that promise and get reimbursed from the government later. But we have to have that 2 million going in.

Defining a Completion Bond

MD: Essentially then, a bond is insurance?

LE: It's technically not insurance, but it's close enough that everybody thinks about it as insurance, and probably for discussion purposes you can think of it as such. It's really a performance guarantee.

MD: Is the percentage you charge for bonding determined by the amount of risk?

LE: If this were pure insurance, it probably would be. But this is a very specialized business. Yes, the charge may vary somewhat depending on the type of production or the production company, a lot of factors, but it's a very narrow range. More likely to change significantly in a situation like that is the amount of contingency. Or, to put it in insurance terms, the amount of the deductible. With insurance, if you were in a car accident, you would have to come up with, say, $500 and the insurance company would come up with the rest. In this circumstance, it's the same thing, except that the deductible amount must exist and be in a bank where we can get our hands on it, because we are ultimately responsible for delivering a completed picture. The normal contingency on a picture is 10 percent. That 10 percent has to exist. We have control of it to use (if, as, and when needed) for unexpected things outside the control of the producer. In some cases, if the picture is particularly dicey, we may require 15- or 20-percent contingency.

Concerns Related to Overseas Production

MD: Are there certain countries or regions of the world where the contingency must be higher?

LE: I'm sure there would be. I can't give you any specifics right now because I don't know, and I don't want to demean any particular countries without specifics. If you're shooting in a place like France or England or Germany, you're in a pretty sophisticated country. If you're shooting in Russia, in certain areas of that region, you might wonder a bit more because there are governmental things, criminal things, there are different ways of doing business that you have to be concerned about.

You mentioned to me earlier that you're going to Thailand. I've done films in Thailand. Thailand's fine to work with, but it's a different culture. This is not a negative, but you have to understand the culture when you're going there. We didn't require an additional contingency, as such, on that picture, but we did require that there be budgeted amounts for certain things, because there are different ways of doing business there that require different kinds of payments that you can't exactly quantify up front. There are things that happen. You have to know what you're doing when you go in there. The last picture I did in

Thailand was some years ago, but they have a censorship policy where they wanted the film developed so they could see it, and, if there was anything they didn't like, they could comment or do whatever they wanted. The negative was not developed there. It was shipped out. It was developed outside the country and video-tapes were sent back so they could look at it. But the negative was out, so there was no chance of it being held up, thereby impeding delivery of the picture. In order to make that happen, we hired an employee of that department of the government to work for us and help expedite the film.

A lot of countries have that similar situation. If you're not aware of it, you can find your negative tied up for weeks at a time, and it can affect your delivery date. You can get it straightened out eventually, but you're damaged in the meantime. When you're in another country, you have to understand that they make the rules, and you have to work within their rules.

MD: Obviously, the third-world countries are the ones you would have the most concerns about. When you're going to a country that is of a totally foreign culture and language, are you looking for the producer to get hooked up with a production company in that country?

LE: Usually. Again, it depends on the circumstances. I did a lot of pictures some years ago in South Africa, which is sort of midway between a first- and third-world country. I had a very good experience down there; did twenty-some-odd pictures and it worked out fine. Sometimes, an American company goes on location to a foreign country and they just need help to move things around. It's simply another location and no more than that. At other times, a producer is going there to take advantage of special conditions, in which case they definitely need somebody local to make sure it all happens properly. It's one thing if you're coming in as an American and just spending your dollars and doing your stuff. It's another thing if you're trying to get an economic advantage. The less you know about it, the more important it is to have somebody local and to check out who that local is. There are people who can be very, very helpful, and there are people who are con artists.

MD: If a producer were planning to work with a company that you know is less than beneficial, are you going to inform him?

LE: Oh yes. We have to. For instance, we have a picture right now that

is being prepped to shoot in Austria. Austria is a good country, and they have certain incentives. And this producer got together with a local established company with a lot of credits, but it turns out that, while they know production, they also know some pretty good ways around handling money. The Austrian government refused to give the contribution to that company if the company got the money, which tells you something. So we had to make other arrangements there. Sometimes it's hard to find those things out because the company has long credits, but you have to be careful who you get hooked up with.

The Bonding Company Is an Ally, Not the Enemy

MD: The thing you really don't want to have happen is for the bond company to take over production.

LE: That's right.

MD: That's something you do as a last resort.

LE: Absolute dire necessity.

MD: A lot of producers look at the bond company as being the enemy, but it's not as if you're outside the door just waiting for the opportunity to pounce on the production.

LE: That's the last thing we want to do. The best for the bond company is if the producer does what he's supposed to do and there's no muss or fuss. It happens and that's terrific. Sometimes they need some help, and we're happy to give them help. We're a resource for the producer. We do hundreds of pictures each year, and over the years that's a lot of pictures. No producer in the world is going to come anywhere close to that kind of volume or being connected with it. Out of all that, we know a lot of people. We've had a lot of experience in a lot of different places, solved a lot of problems. Producers appreciate that and use it. It's not forced down their throats; it's just there, and we don't charge extra for it. We just make life easier for them. But there are producers who are either new to the whole thing or they've heard apocryphal stories and say "Oh my god, the bonder's an enemy! I'm being forced to have this guy on my picture because my 'money' wants him. I'm afraid he's going to hurt my film." That's nonsense. We don't devise the production plan; the producer

does that through his organization. All we do is then ask, "Given what you want to do, is it doable within the framework of the time and money that you have?" If we're agreed that he can, then all we want him to do is what he told us he would do.

Snares and Pitfalls

MD: What are the bad circumstances that producers get themselves into in other countries?

LE: There are cultural differences. A hotshot American producer that treats the locals like they are idiots is not going to get a whole lot of cooperation. He's going to find that he has problems with the crew. He's antagonizing everybody, and they're going to sit back and let him sweat. A smart producer, as any tourist, goes into a foreign country and works within the framework of what they have. There are countries that don't like to work overtime or work more than a certain number of hours a day. Or they have different meal situations, different holidays. They want to be respected. No matter where you go, people take pride in their work, and you have to work with them. It's pretty much common sense, one would think, but there are people who just don't seem to have it.

You can also get into trouble by not knowing the rules and regulations. There are countries where what would be a minor misdemeanor here would be a major felony there. If you don't know that, somebody can find themselves locked up for a great length of time, and that's not good for a production. You have to understand where you're going, and you're smart if you get somebody to work with you who knows the territory.

The picture I mentioned in Thailand. We hired a production services company that works throughout the Far East that's well known. They supplied equipment, personnel, took care of expediting the permits to get equipment into the country and back out of the country and so forth. It's worth it to hire somebody who is in that business to do it for you. It makes life a whole lot easier.

MD: Do you have any examples where producers have made mistakes?

LE: Producers, particularly in the lower-budget area where money's tight and they're trying to cut corners, want to believe things that maybe they shouldn't believe. They'll go to a country and come back saying, "This is no problem. I have a great picture, and enormous amount of special effects that would cost me a fortune here.

I can do it for a fraction over there because that's what they'll do."
But how do you know that? "Well, they told me they'd give me the
army, and they told me the army would let me use their tanks all
at no cost. And boy, they really want me there!"

Maybe it's true, but what happens if they don't? Are you going
to have a hard-and-fast contract with the army that's going to sup-
ply you people and the planes and the trucks and the helicopters
and the fuel to operate them and the pilots and the drivers? You
need to have all those details worked out. In some cases that hap-
pens, by the way, but a lot of times it doesn't. If anything goes
wrong, there's not enough money to make the picture.

It happens with building sets. They make an arrangement with
one of the Eastern European countries that promise all kinds of
things and they can't deliver. Years ago, Yugoslavia was a hot spot
to shoot. They had two places: Zagreb and Belgrade. And there
were studios there, and they promised all kinds of things, and a
lot of pictures are made there. But what people didn't realize,
unless they'd been there, was that, yes, they agreed to do this stuff
and meant to do it, but they couldn't. Simple things. They didn't
have the Kleenex. They didn't have the nails; they ran out. They
didn't have hard dollars to buy them elsewhere because their own
currency had no value. So the companies agreed to buy this stuff,
but just to get Kleenex you had to go out and buy it in Germany
and bring it in. They wanted to give it to you, but it wasn't there.
So it's a siren's song when they tell you they're going to give you
all this stuff for free or to be included in a flat price.

One thing I might mention to you, since we're talking about
foreign countries and things producers should worry about. We
did a picture some years ago in Spain (though this is not unique
to Spain). Money was coming from the United States to Gibraltar,
which was where the production company was set up, and from
there to Spain. We learned this the hard way. The money was wire-
transferred, but the receiving bank said they didn't have it. They
can't find it. It isn't there. Whatever. Wire transfer after wire trans-
fer took seven, eight, ten days before it got credited to the bank.
There was a float situation. Interest was being earned by some-
body during all this time. That's the game that goes on, and
there's not much you can do about it when you're sending money
from America to Spain and trying to get it from a Spanish bank
that says, "It hasn't come in yet." You have to know about that sort
of thing; otherwise, you find yourself needing to pay the crew, but
you don't have the money.

We've worked all over. We've worked in Iceland, Africa,
Australia, Thailand, China. All those countries are workable, but

you have to anticipate that there are going to be differences.

MD: I take it you would recommend that a producer take a trip to these countries first or have a location scout do it for them.

LE: Absolutely. In fact, if we're not familiar with the country, we'll probably want them to take a representative of ours along with them to double-check it. You can be told a lot of things, and sometimes it's just wishful thinking. A producer believes what he wants to believe, because he has to believe it. And if it doesn't happen, "Oh, my God!" It's the bond company's problem now. So the bond company has got to check it out in advance to avoid having that happen.

MD: So it may not be that anyone is trying to hold you up for money. It might be good intentions and the inability to say no, the desire to please.

LE: That happens a lot. In most cases, this isn't malicious intent. I'm sure that the studio believes they can supply these things, but they can't guarantee it. It's not in their control. It's in their control as long as all parties agree. If anybody gets aggravated, things can happen.

You mentioned that you were going to Chiang Mai. In Chiang Mai we had a sequence to be shot that was supposed to be a major kickboxing event in a huge arena holding a thousand or more people. And the arrangement was made with the army there to supply the extras. Army personnel would sit in the arena and fill these thousands of seats with cheering spectators. That was set well in advance, and, two days before the sequence, we were notified that the deal was off; the army wouldn't cooperate. What had happened was that a local casting director had gotten involved with this, and the colonel who was in charge of the regiment or battalion had lost face . . . quote, unquote. Because what he was supposed to be controlling, somebody else was controlling, and the deal was off. Well, with a little bit of negotiation and time and $20,000 later, he got his face back and we got the sequence. Those things are hard to predict, other than by making allowances in the budget. It wasn't malicious, I don't think. But it probably wouldn't have happened in the United States.

The Contingency

MD: Do you recommend to producers going to certain countries that they should raise their contingency?

LE: Here's the thing. The contingency is not a discretionary fund for the producer. Producers and directors have a hard time understanding this. That's money raised for the picture; they want to spend it on the picture. "God, it's a tight budget, and I couldn't get the amount of extras that I wanted. I couldn't use the helicopter. But I've got money in the contingency." Well, that's not what it's for. The definition is "unexpected events outside their control." It's not for creative judgments and enhancements.

First of all, they should know what they expect to do. We're not coming into a picture, normally, where the producer says, "I've got this money. I don't know what I'm going to do until I get there, then I'll think of something." We want to know what he's going to do in advance. We want him to know what he's going to do. That's the way you plan a picture.

So he should know that he's going to need a thousand or fifteen hundred extras or that he's going to want a helicopter and budget for it. If he doesn't have the money, then he has to design his budget and script accordingly. If he has the luxury of having extra money, terrific! We don't mind him spending extra money as long as it doesn't interfere with the delivery date or anything on our part. He has to go through us to do it. But the contingency I'm speaking of is not his for that purpose. If he should come off the floor at the end of production not having spent any of it and he wants to do something, and we have more than we need for post, as far as we are concerned it's okay. But it may not be okay with his investor or the bank. The bank may want him to reduce the loan, so they have to approve it as well.

MD: The bonding company needs to have those daily reports coming in. Do you ever have circumstances where those things are slowed down because of the location?

LE: If they are slowed down, we have a concern. In this day and age in particular, there's no reason to not be forthcoming. Rather, there can be a lot of reasons, but they're not good enough. Between e-mail, faxes, and phone calls they can be done. It's not like the old days when Les Selander used to do these B-westerns out of Fox. He loved to go on location to this little valley outside Idyllwild, but

the real reason he liked to go there was that radio transmission couldn't get in, and the studio couldn't bother him.

But we want to know what's going on. Any responsible studio wants to know what's going on. They want to know if they got the scenes they were supposed to shoot. They have to know that the director did what he was supposed to do that day so that they don't run over schedule. There are lots of reasons not to let it slide.

In Summary

MD: What specific advice in summary would you give to an independent producer preparing to film in a foreign country?

LE: Talk to more than one person who has actually had the experience of working in that country in a capacity to know: a line producer, production manager, accountant; someone in a position to know what the problems are, and/or good points, so that they can plan accordingly. You can't plan in every country to get the same amount of work in a given amount of hours as you can in this country. There are differences in pacing and differences in culture, which you can only discover by being on the spot.

Part Two

LOCATIONS AROUND THE WORLD

*I*n this section you will find interviews with film commissions, production entities, and governmental representatives of countries throughout the world. It will serve us well to remember that the primary goal of film commissions and the like is to persuade you to make your film in their country. This is a source of revenue to them, so they are more likely to exaggerate the benefits of shooting in their location than they are to express the potential risks and problems. Ultimately, it will be your responsibility to discern and read between the lines.

This having been said, you will find common answers to certain common questions, and you should hold on to these as general truths. It is helpful to hear the same information from a variety of sources. You will also gain information that is specific to filming in the particular countries. If you are reading this book as an aid to help you select a location for your film project, you will find this section most enlightening.

Chapter 4

Canada: $1.47 for Every U.S. Dollar

Alice To, Operations Manager/Director of Marketing for the British Columbia Film Commission, graciously granted this interview at Locations Expo 2000.

MD: What are the advantages to filming in Canada as opposed to the United States?

AT: Financial advantage, as the exchange rate is lower. Efficiency of locations from beach to mountains to city-look to small-town-look all within the studio zone, if you're filming in Vancouver. Cost of suppliers and crew is relatively less at their rates than it is in Los Angeles.

MD: It's still unionized, but there is a difference in the rates?

AT: Yes. It's a very small amount (of difference), but because you're paying in Canadian dollars that's where your advantage is.

MD: What is the rate currently?

AT: You're getting forty-seven cents on the dollar. So for every U.S. dollar you spend, you're going to get $1.47 in Canada.

MD: How long has Canada had a thriving film industry?

AT: Well, the film commission was formed twenty years ago, and that's when the need was recognized. I would say in the last fifteen years there has been steady growth. In 1999 we had 198 productions, not all American, but feature films to television, documentaries, and broadcast singles, which left over $1.7 billion in our economy.

MD: Does Canada provide any other incentives besides the exchange rate?

AT: There's a government tax incentive that gives you 11 percent on your labor. We will give you a tax refund on the labor portion of your production. Most provinces—I can speak for British Columbia—match that 11 percent and also give an additional 11 percent for all labor on production filmed in B.C. When you stack it, it's not exactly 22 because they have a certain rule, but it comes to about 18 percent.

MD: How difficult is it to work with the unions? Is there flexibility?

AT: They have an agreement that they have to sign. It's a master standing agreement that they sign with the American producers association. They sign one with them for the next three years, which is for most productions coming out of the studios. That's kind of like a baseline. For an independent producer the unions are more than willing to negotiate. They take a look at what they negotiated with the studios, then they take a look at your independent production and the merits of either following exactly what the union rates are or going below to what is needed to help you make that production.

MD: What is the situation in regard to bringing cast and crew members from the United States?

AT: Your *above-the-line* personnel you have no problem with. You just have to inform immigration before you come in. Regarding crew members below the line, if there is a person in Canada who can do the same job, immigration would prefer that you use a Canadian over bringing in an American. Most producers do find, because we have a really deep skill base and have done so many productions, that it's much more economical to use a local crew in Canada than bringing somebody up and paying their per diem and flight.

MD: Does a producer have to pass a script through any kind of censorship board for approval?

AT: There might be certain private locations that require that they take a look at the script before they allow you to use the locations. But as a federal provincial, there's no agency that needs to look at the script.

MD: What is the biggest problem that producers from America face when they come to Canada to shoot?

AT: I think it's usually in regard to the tax. We have a provincial sales tax, which they sometimes mistakenly think is "rebatable." Or we also have a GST, which is a goods and services tax, which is "rebatable," but it's not an upfront rebate. It's after the fact. So I think it's a run-in with the tax and revenue part of the whole budget that gets the producer into financing problems.

MD: Is it that they think they don't have to pay the taxes?

AT: Yes. They have to pay those taxes and they have to file a claim to get it back. It's not something they are exempt from paying.

MD: And about how much of a budget does that involve?

AT: Well, our sales tax is 7 percent and our GST is another 7 percent.

MD: Now is that on the entire budget?

AT: Only certain goods and services.

MD: What kind of cooperation can the producer expect from the government?

AT: Our provincial government has been very film-friendly. We do see the benefit of it to our economy, and we help the producer to film the film that they wish to film in regard to stunts and special effects. If they must bring in a certain DP or they have an actor get arrested for whatever reason, we do try to help the producer and director get their film made. You know, they did us the courtesy of coming to Vancouver or British Columbia; we're going to make it as easy as possible to come again. I would say that in British Columbia about 70 percent of our foreign production is return clients.

MD: Are there governmental co-financing or co-production deals available?

AT: There are federal Canadian co-productions with different countries. Unfortunately, there are no co-production deals available for the United States. But certain parties might be able to access this public funding by getting a British producer and a Canadian producer, and then the American partner is the distributor. But there are very strict regulations on how you would qualify for this co-production. It gets quite complicated.

Chapter 5

Mexico: A Welcome South of the Border, But Don't Break the Rules

An interview with Mr. Sergio Molina, Location Coordinator, National Film Commission of Mexico.

MD: Why should a filmmaker seek the assistance of Mexico's film commission?

SM: The reason the National Film Commission is working out is because Jorge Santoyo, our National Film Commissioner, has been an actor and is a producer. I myself have been a producer and I am a screenwriter, so we know all the needs of producers, whether foreigners or locals. We know the problems of production. We know the problems of cinematography in its three sectors—production, exhibition, and distribution. We know how to help producers. For instance, when we are doing a brochure, we don't add tourists into the pictures or add tourist information. We add information from the producer's point of view.

The National Film Commission is an organism of the federal government. We are part of the National Film Institute, which is run by Alejandro Palayo. And both of these organizations are part of the Council for the Fine Arts, which is under the Ministry of Education. So we belong to the culture and education sector.

Our office is a link between foreign film producers and the services Mexico has to offer, such as rental equipment companies, unions, costume brokers, locations, permits, legal and financial matters, federal and state government contacts, hotel and travel,

creative and technical personnel, and so forth, as well as Mexican legislation, insurance, copyrights, co-production agreements, custom procedures, and employment requirements.

We have existed since September 1995. To give you some idea, in the four months of 1995, we received 72 requests for information. In the whole of 1996, we received 294. In the whole of '97, we received 663. We doubled that in '98 to 1,296, and in '99 we got 1,603 requests for information. This is the way we are growing. Of all those requests, we have helped bring into Mexico 1,074 foreign productions and 35 co-productions. Among these productions were such notable films as *Titanic*, which gave us a very good name in the industry; *The Mask of Zorro; Tomorrow Never Dies; Romeo and Juliet*; and *Deep Blue Sea*.

MD: What are the financial benefits of shooting in Mexico as opposed to the United States?

SM: Regardless of the project, if you have a very good local production coordinator or a local production company, you can lower your budget between 30 and 40 percent. Sometimes producers come and tell me that Mexico is not as cheap as they expected. Well, Mexico is not "cheap" at all. Mexico is less expensive. That's quite a difference.

MD: You have a long history of film production in Mexico, unlike many of the other countries with film commissions. Describe the infrastructure.

SM: We have the best. The crews in Mexico are comparable to the best crews anywhere—America, Europe or wherever. We have high tech, THX sound. We have studios in Mexico City, in Baja, in Puerto Vallarta. We have labs that can process anything you need. We have raw stock, cameras, and very good equipment. If you want to bring your own equipment, that's okay with us. We tell you how to bring it down, and our services are free of charge.

MD: Usually when people think of Mexico, they think of the jungles of the Yucatán or the desert. What variety of locations do you have?

SM: You would be surprised. For instance, I think it was a Delta Airlines commercial that came from London. This commercial was supposed to be done in several parts of the world: Morocco, Tibet, Africa, Brussels, and I believe Spain. All parts of that commercial were done in Mexico, because we have beautiful hacien-

das that you would swear are in Marrakech or Fez, Morocco. The interiors are astonishing. We have beautiful buildings where you would swear you were in northern Europe. We have convents and monasteries of all styles. And we have unique locations. We have a guy here who built strange architecture in the middle of the jungle, such as huge hands growing from the soil, stairs that go nowhere, doors that open to nowhere, huge concrete flowers, and it's a unique place because it's surrounded by jungles. And we have a place near Chihuahua that has three craters, and you would swear you are on the moon. We have a white desert from salt, which is amazing because you can look all the way around to the horizon and it's white and it sparkles in the sun. We have oases in Baja, California. We have mountains with snow. That's how the Delta commercial could be made to look like Tibet. We have some parts that look very much like Africa, with jungles and huts on pylons on the water.

MD: Does Mexico have labor unions?

SM: Yes, but they are flexible.

MD: But what about a low-budget producer that comes to you?

SM: The unions are flexible.

MD: Is the language a difficulty?

SM: Listen, with artistic people in any field, when two hearts meet the language becomes international. I have had people from Mexico work with people who only speak English. Don't ask me how, but they understand each other perfectly. But that's beside the point. In Mexico, most of the people involved in the film industry speak English.

MD: What are the biggest mistakes that independent producers make when they come to Mexico?

SM: When they don't listen. When you tell them, "Listen, when you come through the Film Commission you have to follow rules and regulations." When they want to do things their way, they usually get ripped off or get into trouble. Their equipment gets confiscated or whatever. Then they blame the Mexican people. It takes you ten days to get a permit. Perhaps, through us, you will get it in seven working days, but that's the most we can do. There are rules

and regulations, and we are here to help you follow them. If you do not follow them, the Film Commission will not back you up.

MD: You understand where that comes from. In Hollywood, low-budget producers do guerrilla filmmaking. They steal a shot at a location without a permit. The worst that happens is that they get a slap on the wrist, but it's a lot more serious in Mexico, isn't it?

SM: We have a case right now. I believe there are some people from Canada, but the company is from Germany. They came to us, and we said, "This is an official film. You have to go through the union. We have two unions; you can choose either one." And then, they didn't go to the union. They didn't listen to us, and now, instead of getting it arranged in advanced to get the union to be flexible, they have to do whatever the union wants.

MD: What other facts should American filmmakers be aware of, should they wish to film in Mexico?

SM: Depending on the project, if you are going to bring down explosives or firearms or anything having to do with the army, you have to do it in advance, at least two months in advance. Otherwise, you are going to get into trouble. You are going to hit a limit and maybe have to postpone your movie, and we don't want to be the ones blamed, so you have to do everything in advance. If not, we can maybe give you a hand. For example, if you want to shoot an archaeological site, you have to arrange it more than a month in advance. Let's say you don't do the paperwork right, and they deny you the permit and they don't tell you why. Then I can call them up and ask why. Maybe they say, "Because we don't want the product on top of the pyramid, and this guy wants to put the product on top of the pyramid."

Now I say to them, "Okay, if I tell this guy not to put the product on top of the pyramid, will you grant the permit?" They may say, "Of course." But now the producer has to resubmit the storyline without the product on top of the pyramid. That's going to take another week. We are a balance. We are between the rules that have to be followed and the producers, and we can mediate.

MD: Are there issues of censorship?

SM: The only thing that's forbidden are those films where you commit a crime, like snuff films; any kind of physical violence that's being shot for a film.

MD: You mean real violence, not stunt.

SM: Real violence.

MD: What about the security of the cast and crew and the equipment? How much of a problem is that in Mexico, and how is it dealt with?

SM: Unfortunately, in Mexico there is violence, in the streets, all over the country. I would say that downtown L.A. is dangerous. We advise producers and the crew not to wear jewelry. Don't keep jewelry in the hotels; get a safe-deposit box. If you are traveling, be aware of the people surrounding you. To meet your concerns, we usually get you a patrol car for your peace of mind or security twenty-four hours a day or on rounds every two hours or so. If you are going a long way by highway, state to state, we can provide you with security. Most of these are free, but if you want twenty-four hours, you can get it at a cut rate.

MD: Are there hidden costs in Mexico that you should be anticipating in advance? What kind of contingency do you recommend?

SM: We always ask for a crew to be insured. Weather has no word of honor, and when you're expecting a sunny day, all of a sudden it rains for three and you're losing money. That you can deduct from your insurance policy.

If you don't hire a local production company or a local production coordinator, I can assure you that you're going to get ripped off. It's the same thing as if I want to produce a film here in the States. If I want to do it by myself, I'm going to get ripped.

We say, "Beware of the unions in Mexico." You have to watch out for the small print. It's all there in the open. It says there are day calls, night calls, and mixed shifts. When you have a union call for seven o'clock in the morning, you have to do it at seven o'clock in the morning. If the director wakes up with the idea that he wants to shoot earlier and calls them up at six o'clock in the morning, you have to pay the extra hour, breakfast, a car (taxi). The Mexican producer will always tell the American producer to watch out for this. "If you want it, I can call them up. But this is like a chain. And if you multiply this by a hundred people, don't tell me later that I didn't warn you."

MD: So you're saying that American producers should go to the film commission because you can refer them to a local producer who will not rip them off?

SM: Our policy is that we never recommend a single company or a single person. We always give you a list of contacts that we think are better for your type of project. Usually, they are never the same: a commercial, a low-budget film, a large-budget film: and we have all sorts of people who have proven that they are reliable and know what they are doing. And we send you at least three or more referrals, because if I tell you, "This guy is the best," and you don't have any chemistry with this guy . . . So, if you don't like this list, you call me up and I'll give you another.

NOTE: Regarding Mr. Molina's comments about following rules and regulations, adherence is advisable no matter what country you choose as your location. The Associated Press is the source of a related story in Peru. A beer commercial was being shot at the ancient ruins of Machu Picchu. The shoot was approved by Peru's National Institute of Culture under the stipulation that the production company bring only light equipment. Nevertheless, the company, under the supervision of a U.S. publicity firm, secreted a huge crane to the set. The crane toppled over and damaged a portion of the Intihuatana, an ancient Incan sundial carved into the granite side of a peak. Criminal charges, carrying a sentence of two to four years in prison, were filed against the production company for destruction of national patrimony.

Chapter 6

England: Experience, Integrity, and Professional Standards

Sir Sydney Samuelson CBE, (Senior Consultant for the British Film Commission) is recognized as one of the patriarchs of filmmaking for his lifetime of contributions to the industry. Born in London in 1925, his career began as a rewind boy at the old Luxor Cinema in 1939. He progressed from that position into becoming a projectionist, an editor, a cameraman, director, and founder of Samuelson Group, which eventually developed into the largest film, television, and audio-visual equipment hire organization in the world. Sir Sydney was appointed Commander of the Order of the British Empire (CBE) in 1978, the first British Film Commissioner in 1991. He retired in 1997, becoming Senior Consultant in 1998. Space prohibits a full list of the honors he has amassed in his more than sixty years in the film and television industry. I am honored that he granted the following e-mail interview.

MD: What are the advantages of filming in the UK?

SS: There are many advantages to filming in the United Kingdom (as opposed to anywhere else, not just the United States): The tax advantages introduced by our current government (known as New Labor) are worth 8 to 10 percent of the budget. The experience, efficiency, and enthusiasm of our technicians deliver unmatchable value for money. As everybody knows, *time* is the most expensive item on any budget; therefore, efficient filmmakers—those who can get the job done quicker—deliver a budget advantage compared to others.

For productions originated/financed/produced by Americans, the fact that we have a common language is a huge boost to production viability. A simple instruction, say the adjustment of a lamp on the spot rail in a studio, which has to be translated from English to a local language, takes relatively forever. The fact that the interpreter may not understand the technicalities of what is being asked for causes the requirement to take even longer to achieve.

Britain is a film-friendly place. Every production is difficult. The fact that everybody is on the producer's side—from the government downwards—is helpful and economical. Also, filmmakers from abroad like coming here (and their wives enjoy shopping at Harrods). The social infrastructure makes for a degree of comfort not found elsewhere: housing, transportation, schooling, communications, shopping, etc., are all important, and, in Britain, available. As one superstar was heard to say, "I love the script. I have confidence in the director, but how would I educate my children during a fourteen-week location in Eastern Europe?"

Our production infrastructure is unequalled. The high caliber of our people—those who work in front of and behind the camera—is legendary. We only have twenty Oscar nominations this year, whereas it was twenty-six last year. It is important for everybody to be highly skilled if a film is to come in on budget. A poorly trained technician, an inept actor, a disinterested production driver, all can hold up a shoot and prevent coming in on budget. The breadth of our infrastructure allows filmmakers from abroad to arrive only with their script. Everything else can be provided here. The experience, integrity, and professional standards of our accounts and production management departments are vital to the budgetary control of a production and are available in depth.

The quality and quantity of ancillary services available in the U.K. is unequalled elsewhere. Technical equipment, props, costumes, transportation, vintage vehicles, model making, special-effects expertise of every possible kind, everything needed is available in Britain.

Most technicians work on prearranged, "all-in" deals that can be for five- or six-day working week with specified overtime included. This enables accurate estimates of the cost of labor.

We have buildings of every conceivable kind available as backgrounds and for shooting interiors of every period in history. One can say that the U.K. has a catalogue of architecture that took a thousand years to assemble.

MD: What are the disadvantages to filming in the U.K.?

SS: I am not aware of disadvantages. I suppose it would be difficult to reproduce the Sahara Desert anywhere in Great Britain; however, the Brits made *Lawrence of Arabia,* so even mighty "sandscapes" can be coped with.

MD: What makes working with a U.K. crew different?

SS: I think the main difference between working with a U.K. crew compared to the United States is the up-to-date working practices that we enjoy. As I have said above, the *all-in deal* is a very practical way of working and, providing the overtime facility is not abused, a very comfortable working arrangement exists between employers and employees.

MD: What are the biggest mistakes American producers make when they come to Great Britain?

SS: I have had personal experience of servicing American producers going back more than forty years. Mistakes I have witnessed during all that time are few and far between, and mainly concern experienced production chiefs arriving without understanding the level of knowledge that comes with British craftspeople. I have always felt that the absolute first essential is to hire an experienced British line producer. Everything follows from having such a person onboard from the very beginning.

MD: How do costs compare between the U.S. and the U.K.?

SS: Comparative costs are hard to calculate because there are so many variables. Fortunately, the exchange rate between sterling and the U.S. dollar is pretty stable, but it can fluctuate either way, a small percentage up or down. Certainly, when planning a production in the U.K., deals are negotiated to suit the level of budget. This applies to salaries, services, equipment rental, in fact all the necessaries of a production—high or low budget.

MD: Are there hidden costs, like payoffs, that should be considered in the equation?

SS: Your question about "hidden costs" is interesting, and I have heard horror stories of payments being necessary, in some countries, if you wish to avoid the stealing of your equipment during

the night or the appearance of heavies on the set demanding "security" payments. I can put my hand on my heart and say this kind of behavior is not found in the United Kingdom.

MD: But I imagine the producer should take weather into consideration before coming to England.

SS: Yes, we have another advantage here. We have more weather available than can be found pretty well anywhere else on earth.

Chapter 7

France: Efficient Crews, Diverse Locations

An interview with Benoit Caron, Executive in Charge, French Film Commission, and Dana Theveneau, Director of South of France Film Commission.

MD: What are the advantages for an independent producer to film in France?

BC: The efficiency of the French crews, very quick to understand what the director is looking for.

DT: I would say that is very true about the technical industries, and the crews are very motivated. We clearly don't have specific incentives yet, nationally.

MD: Like tax incentives?

DT: Yes. But we can work it out cost-effectively for productions if they contact us. We know how to get them the most for their money because we work with tourism and lodging. We can really get them good deals on lodging, car rentals, and the logistics of filmmaking. But more important is that once they carefully plan their shoot, they get most of the value on screen by shooting in France because the locations are authentic. We guide them through that process.

BC: We have such a large diversity of locations in France, from mountains to cities to seaside.

MD: What would you say is the general breakdown of costs compared to the U.S.?

DT: It's hard to say, but the dollar is going up, and that's an advantage to the producer.

MD: How much do French actors get paid as compared to American actors?

BC: Basic actors and actresses are paid, I would say, half as much as American actors are paid. The top actors of France, I don't know . . .

DT: They don't come anywhere near what the American top actors are paid.

BC: By far. And regarding the crews, our labor costs in France are perhaps 60 to 80 percent, including what we call "charge social." Social benefits. You must keep in mind that even though the social benefits are quite high, the total labor cost is okay.

MD: If you were just looking at what the producer was paying in social benefits and comparing that to what they pay in the United States, it would look high, but when you add them to salary and compare, it is reasonable.

DT: Yes.

MD: How is language a barrier?

BC: Many of the French technicians in various areas are fluent in English, and it's no longer a problem.

DT: We have entire crews that are specialized in the way Americans shoot films.

MD: Let's talk about speed of production.

BC: You mean the efficiency of filming? It's much more efficient to film in France than to film in the U.S. The crew in France is much

more compact. We don't have as many positions, and that's a factor in the efficiency of filming.

MD: Are your crews all unionized?

BC: The unions in France are not really a factor. Only maybe one out of ten French technicians is union.

DT: Because the social benefits are nationwide and mandatory, it's not the same as in America where unions are fighting to get their health benefits. All that is taken care of by the French state, so some people belong to unions just to defend their interests, but it's nothing like in America.

MD: But let's say that the production is falling behind schedule and they need to work extended hours. Is their flexibility on the crew's part?

DT: Well, a representative of the crew would negotiate for more, but that would be per group. In the south, they negotiate flat fees for so many hours. I don't know how in Paris they do it, but we don't have as much work down south—and people are hungry for work—so you can always negotiate with the director of production or the line producer.

BC: One point that is important to mention is that it is important to respect the twelve-hour turnaround.

MD: Are there hidden costs that an American producer should prepare for, such as payoffs to local politicians and the like?

DT: You shouldn't have to do that. People have encountered that sort of thing in the south of France.

BC: We had problems in the south of France a few years ago, but no longer.

DT: We would advise people to speak with the film commission if that was going on. The foreign crews have no withholding taxes. Would there be anything else?

BC: There is the VAT issue. The French government will refund the VAT money spent in France, but you must keep in mind that this

refund will come between one and three months after filming. This amount is between 5.5 percent and up to 20.6 percent.

DT: You should explain how to apply for the 20.6 refund.

BC: You have to work with a French representative who takes care of everything.

MD: What would you say are the biggest mistakes that American producers make when they come to shoot in France?

DT: They make a lot of mistakes if they try to do it on their own without contacting a local person. They have to have some sort of French counterpart, someone who knows the law of the land. It could be a line producer or a production coordinator, whatever they need. That is the key thing. An American coming into France can get rerouted, you know. All kinds of trouble, not necessarily because people are evil, but because there are misunderstandings. Culture is different. Language is different. Most of the time producers are better off with a French crew that can help them with everything.

The second thing I would say is the same for any place you want to film. The more preplanning you can do, the better off you will be. If you try to come in and have everything planned yesterday, you're going to run into trouble. The administration is very slow, very bureaucratic. There's no secret about that. The word is French—*bureaucratie*. You need to take the time to plan in advance.

And since we are lucky to have the liaison offices in France now, they should go to the local contact (the local film commission) as soon as they can. Those people will give the accurate information on what kind of permits are required, and they have the relationships that can't be made on the national or regional level.

MD: Tell me about the infrastructure for filmmaking in France.

BC: We have major film labs. From every part of France you can send your rushes and check your dailies quickly. It's not a problem. Regarding equipment, basically you can find all the same equipment you can find in America.

Bulgaria: Fully Equipped at Bargain Rates

An interview with Zlatin Radev, Animation Division Manager, Boyana Film, and Evgeny Michailov, Executive Director.

MD: Could you explain the divisions of Boyana Film?

ZR: We have three main divisions in the studios: Filmlab, which processes the material; Feature Film, which involves itself in all processes of filmmaking from script to the print; and Animation Division, which produces shorts, full-length, television.

MD: What is the advantage of shooting in Bulgaria?

EM: First, there is beautiful countryside; everything is in place. There are good qualified people, technical facilities, and better prices. All of this permits the independent producer to produce his low-budget film with the look of a high-budget film.

MD: A $1-million film would cost how much there?

EM: Two or three times less.

MD: In other words, it would cost $500,000 to $300,000.

ZR: $300,000 there.

MD: Are there unions to deal with?

ZR: There are unions, but they're . . . vague. [laughter] We work to the customers' satisfaction. You direct the schedule, work time, etc. There are no limitations when you're working with us. If you want to shoot eight days a week, okay eight days [laughter]. But you pay.

EM: Of course, you have to pay supplemental.

MD: How does the skill of labor compare to the U.S.? For instance, do you have directors of photography on a par with those in the U.S.?

EM: We have very good DPs with international awards. Good actors, good second team, good stuntmen, technicians, special effects.

MD: As a studio you have everything that is necessary?

ZR: Weapons, sound stages, construction . . .

EM: . . . plastic materials, wardrobe, makeup, horses.

ZR: Our film lab is controlled by Kodak. We have new telecine suites. We have very good quality.

EM: The lab has a Kodak certificate of international quality. We are the distributor for Kodak materials in the territory.

MD: So you can buy the film stock there?

EM: Yes, at a very low price, and we are the distributors for Arri lighting for the area.

MD: Are there any restrictions of censorship? Any approvals of scripts necessary?

EM: No.

MD: What about security in the country? Are there dangers regarding personal safety?

ZR: No. There were before, five or ten years ago, but not now.

EM: You know Bulgaria has started negotiations with the European Union to be adopted.

ZR: The situation is very good now.

EM: It's safe. You can ask the American embassy in Bulgaria.

MD: What about language problems?

EM: Almost all divisions speak English.

ZR: In the last ten years we have had much experience working with American producers.

EM: [The 1999] Academy Awards nominee for the best foreign film *East-West* was almost entirely shot in Bulgaria in our studio. Three months in Bulgaria, eighteen days shot in Kiev, Ukraine, and no problems.

MD: The momentum for filmmaking in Bulgaria is picking up?

ZR: Yes, very much.

MD: Does your country offer tax incentives?

EM: There are no special incentives. If the producer shoots in Bulgaria and rents some services from Boyana, our company, he should pay value added tax of 20 percent, but if he rents our laboratory and uses the processes with us for negatives and prints, then he avoids the 20 percent VAT because it is considered that the product is for export. So all facilities included come without value added tax.

MD: What would you say are the biggest mistakes that producers have made in Bulgaria that they should have done differently?

EM: One of the biggest mistakes is that the foreign producer comes to Bulgaria with doubts about the quality, and he tries to find the lowest possible price for hiring equipment and crew. But it's not always the best people with the lowest price. It's best not to go looking for the lowest price but for the norm of the country, then he will have a good team.

BULGARIA
Freelance Production Crew Rates
(prices reflect approximate weekly rates in U.S.$ unless otherwise specified)

Executive producer	600
Assistant producer	300
Location manager	300
Manager	240
Secretary	180
Accountant	300
Cashier	200
1st Assistant director	300
Assistant director	240
1st Assistant cameraman/focus puller	300
Assistant cameraman	240
Sound recordist	500
Assistant sound recordist	400
Assistant editor	200
Still photographer	250
Script supervisor	250
Production designer	600
Props master	220
Costume designer	350
Wardrobe	280
Makeup 1st	270
Makeup 2nd	180
Hairdresser	230
Gaffer	260
Electrician	240
Key grip	260
Grip	240
Set decorator 1st	240
Set decorator	180
Painter	180
Upholsterer	150
Security, Police	100
Translator	220
Pyrotechnician	250
Arms specialist	220
Casting director	300
Supporting player	160 per day
Stunt	160 per day
Extra	15 per day

Chapter 9

South Africa: Foreign Production Made Easy

An interview with Albert J. van Rensburg, Consul-General of the Republic of South Africa. Mr. van Rensburg is based in Los Angeles. He is the primary contact for American filmmakers with regard to filming in South Africa.

MD: What is the history of filmmaking in South Africa?

AR: Well, the history goes from the turn of the last century. The first film was shot in the town called Kimberly, which is very famous for its diamond industry. Very early on, the American film industry became involved in South Africa, and it has become a very lucrative industry in the country.

MD: What notable films have been shot in South Africa?

AR: You may recall the film that achieved international stardom called *The Gods Must Be Crazy*. It was an extremely charming film. Unfortunately, it came at a time when South Africa experienced isolation, and the country did not really benefit from it. There was a pretty long drought in what the industry produced since then. It was followed by the first major international film, *The Ghost and the Darkness*, starring Michael Douglas and Val Kilmer, which was shot in 1996, and it was one of the major grossers in Hollywood that year. After that, many films were made. None achieved the same kind of stardom, and recently Kim Basinger has done *I Dreamed of Africa*.

MD: Are you more involved with the major studios when it comes to filmmaking, or are you also interested in low-budget films?

AR: The big studios are involved in South Africa, in one way or another. That does not mean that we ignore them from our side. We still try to get them involved because we feel that infrastructurally we can benefit from the kind of investment that Australia has recently gotten from Fox. But yes, we try to concentrate predominantly on the smaller-budget films. Roughly forty foreign films are made in South Africa every year, and this ranges between the budgets of U.S.$2–8 million, which is what the industry is most ideally suited for. This does not mean that bigger-budget films cannot be made there, but this is what filmmakers have said the country is ideally suited for making.

MD: How far would one American dollar go in South Africa?

AR: The exchange rate is one to seven [at the time of this interview], whereas six months ago it was one to six. And this is one of the greatest drawing cards to the country. It is extremely inexpensive to go there. If you have a dollar in your pocket, it's very cheap.

MD: Is there a minimum budget level at which it is not financially beneficial to make a film there? The representative for Australia set their limit at around U.S.$3 million.

AR: Absolutely. Probably a bit lower than that. From, say, 1.8 million onward. So it's a bit lower than Australia.

MD: Let's talk infrastructure. Many of the people I've spoken to have lauded South Africa as the place on the continent where you can get anything you need. Is there any area where you are lacking in this regard?

AR: You will find that South Africa uses the latest equipment in terms of Panavision cameras, grips, the whole lot, and we have Kodak studios. Pretty much everything. In fact, we promote the country as a place where you can step off the plane and go right to work shooting your film, because film directors, actors, models, equipment, extras—the whole lot—are available in South Africa.

MD: Are there tax rebates or tax incentives available?

AR: There are no tax incentives, but you can claim the VAT (that's

value added tax), which is a sales tax, it's at 14 percent and can be claimed back within three weeks.

MD: Three weeks from completion of the film?

AR: From submitting the claim. From the point of purchase, you can claim.

MD: Do you have to follow certain regulations in order to receive this benefit, such as limitations on the number of crew members you can bring with you?

AR: No. We had regulations like that, but there are no such regulations anymore. In fact, South Africa had, until recently, a work-permit requirement for shooting and a visa requirement, and now that has all been abolished. So if you're in Hollywood, you get on a plane. You don't need a visa unless you're going to be filming there for longer than a month.

MD: What about the matter of censorship in South Africa? Do scripts or filmed material need to be approved?

AR: Most definitely not. The script does not have to be approved. In terms of censorship, there are general norms that have to be followed, such as no bestiality, sex with minors; that type of thing is not allowed. But in general the freedom of the press is one of the most important points in our constitution, which is only five years old and very conducive to democratic values.

MD: There has been a lot of concern in the past about safety in the country. Because of the political and sociological turmoil, people didn't want to risk going to South Africa. How has that changed with the changeover in government?

AR: Society has become significantly more stable due to the fact that we now have a democratic government. Politically, the turmoil has stopped. The challenges at this point are the economy, unemployment, and, as a result, crime, which became very well publicized internationally. However, if one reads the newspapers, one tends to first and foremost regard Africa (the continent) as a country, so if there is a civil war in Rwanda, which is six or seven hours by air from South Africa, South Africa tends to get tainted by that, too. In looking at the country, one should look specifically to where something like that is happening. The crime in South

Africa is confined to very specific areas, such as a downtown-Johannesburg area. Tourism to South Africa is largely unaffected by this. It's a big country, and there is ample opportunity to work all over the country in a completely safe situation.

MD: Are there specific customs regulations that the filmmaker should be aware of concerning special equipment?

AR: There are regulations that have been significantly simplified. You fill out a form at the airport or at customs. Bring documentation stating what the equipment is that you are bringing in. They make a record of that and likewise when you leave. You don't have to apply for it in advance; it's done at the point of access.

MD: How about transferring equipment from South Africa to a neighboring country?

AR: It's difficult for me to comment on that. Africa has fifty-four countries. The countries where shooting would take place typically would be Kenya or any of the countries of southern Africa. They now belong to SADC, or the Southern African Development Community. If you wanted to go shoot Victoria Falls or shoot a desert scene in Namibia, these are all neighboring countries with South Africa, and due to this agreement it has become greatly simplified to get equipment through. I should say that South African production companies and other companies in the industry work in these neighboring countries frequently. They know all the ropes, so if a company from here entered into a joint venture, everything would be arranged for them.

MD: What would you want independent producers to know about South Africa?

AR: I would direct them to our Web site (*www.link2southafrica.com*) and quote two paragraphs from there:

> When presented with eight months of long, hot, dry fourteen-hour sunny days, pristine beaches, indigenous forests, wheat fields, European look-alike scenery, and abundant wildlife, moviemakers pay attention. Add to that first-world infrastructure and financial services, no language barriers (and I think that's very important that South Africans speak English), advanced technical skills, some of the best directors, an exchange rate of seven to the dollar and no union activity; these advantages are unbeatable, especially in

light of the fact that they are available during the American and European winters.

And of course one can always quote other members of the entertainment industry. The Canadians are extremely active in South Africa. It's interesting that Hollywood worries about business from here going to Canada. There's a lot of Canadian business going to South Africa, and this is what the Canadians are saying:

> "I have never seen anywhere in the world any major productions community, including Los Angeles, Vancouver, or Toronto, where you can get so many interesting locations within a short drive," the *Globe* quoted William Cranor, executive producer of Spy Films Inc., in Toronto.

And there are several quotes that we've included in the same vein, which I think pretty much puts it together in a nutshell.

Chapter 10

The Philippines: Big Savings on Labor

An interview with Oli Laparal Jr. The Philippine Film Group supports filmmaking in the Philippines. Though not a film commission, they provide film preparation services for free. They attend the location expos, maintain a Web site, and consist of a variety of companies that provide various production services, including equipment rentals, catering, crews, personnel, etc.

Mr. Laparal was educated in the United States, has a management background, and currently has his own company in the Philippines, with his own production facilities, where he performs as a local line producer for visiting productions. He has personally been involved in the production of some thirty to forty films over the past five years.

MD: What are the advantages of filming in the Philippines as opposed to the United States?

OL: The big advantage is the money that you save in production. We obviously don't have the same infrastructure; we don't have the same convenience in a sense, but the reason people go there is to save money. I would say that nineteen out of twenty films being done in the Philippines are specifically for the purpose of saving money.

MD: Are there specific areas that are more cost effective for production in the Philippines, such as cost of crew?

OL: I'll give you an example. If you hired an electrician in L.A. for twelve hours a day, six days a week, you might be at about $2,000 by the time you've paid all the union wages, bonuses, and extras. Whereas, the same person in the Philippines, with all the overtime, fringes, and benefits, would cost something like $150 a week. The comparison is staggering.

MD: That's per week, not just a day?

OL: That's twelve hours a day, six days a week, and this is for a person with credits on other lower-budget Hollywood films. The big savings is really on the labor, and the more labor intensive the film is, the more sets you build, the more labor you need, the more input you need, the more money you save.

MD: Are the high-end crew members, like specialty cameramen, cinematographers and the like, also available? Or are they better brought from the U.S.?

OL: The Philippines does about a hundred and fifty theatrical-release 35mm films locally. So when you do a hundred and fifty films a year, you'll have crew, you'll have cast, you'll have production managers, extras, location people, art people, postproduction; you'll have them there. Now as far as key personnel, I think most of the films that go there will bring in their keys. A typical $2-million film might bring a director, a DP, maybe a first AD, and a couple of actors, but they will get all the rest locally.

MD: Are costs also lower on film developing, preparing dailies, and those kinds of operations?

OL: Oh yes. There are six laboratories in the Philippines, three of which we use quite regularly. People like Oliver Stone, Trimark, and Tapestry Films have all developed their films locally. Kodak and Fuji have offices in Manila, so you buy your stock locally. You don't bring it in and schlep it around and pay excess weight and worry about X-ray radiation, etc. I tell most of my clients to make their deal with Kodak or Fuji Hollywood, and tell them that you want to pick up your two hundred thousand feet in Manila. That way you have the same batch numbers and you're not stuck with having too much daylight or not having the right speed. It's not a first-world country, but, on the other hand, many people are surprised at the infrastructure and the film-friendliness that they find.

MD: Do you find that many of the independent producers actually do their postproduction there, or do they try to do that work back in the States?

OL: Most of the postproduction is done in Los Angeles. L.A. is the center of the world for that sort of thing. I also feel, as patriotic as I am, that the touch and feel of an L.A.-based editor is different. There are houses here that will do package deals with sound and postproduction. So except for a few that are locally funded, they will do the postproduction in Los Angeles. Today, for less than $22,000, you can buy your own offline nonlinear editing system and get the system paid off in less than one film, so it doesn't make sense to do your postproduction the old way.

You don't really need to do dailies anymore. In most cases, you watch dailies on video, except for some very sensitive things like tests. You can save on positive stock if you go video.

MD: How many problems does language cause?

OL: One thing that you can get plenty of in Manila is interpreters. This might worry you, but it shouldn't. We are either the third or fourth largest English-speaking country in the world. The government and business is conducted in English. A producer can communicate with a taxi driver or a grip or a PA and be understood in English. Of course, you shouldn't expect them to understand every idiosyncrasy, but, by and large, you can drive through town and 98 percent of the signs are in English.

Actually, one of our strengths is that you don't really need interpreters, which means you can deal with suppliers directly, with lab personnel, anyone. One of the dangers of going to a country where English is not the first or second language is that you are relying on the honesty and good nature of the interpreters. Even with the best of intentions, you can be easily misunderstood.

MD: Let's talk about speed of production. In general, is production at a slower pace in the Philippines?

OL: To be perfectly honest, I don't think you can expect a best boy and six grips to work as fast as a best boy and six grips from L.A. I would say they are perhaps 80 to 85 percent of the speed. But being a line producer myself, I think it goes back to explaining to your crew exactly what it is you want. When producers and UPMs do their homework, explain, draw things, are graphic, they do

very well. When you're in a meeting, time is inexpensive, but, when you are on a set with two hundred people, time is expensive. So go back to the beginning and explain carefully exactly what you want to do. Go back to the basics of good production management.

MD: Do you find that there is sometimes a clash between the cultures of the Philippines and the United States?

OL: Our culture is not the same as Hollywood, but we are not detached from the Western world. We are semi-Western in that sense. But again, I go back to proper production management. I go back to being clear, having proper meetings, doing proper breakdowns, communicating early. Because of the budget constraints, most of the projects going to the Philippines are low-seven-digit figures. If they had all the money in the world, they would be shooting in L.A. or going to Hawaii. If they only have half or a third or less of the budget they need, they come to the Philippines.

Sometimes low-budget producers skimp on areas that they shouldn't skimp on, like production managers and local producers. A producer, for example, who has never gone outside L.A., will have problems whether he goes to Italy, or Bulgaria, the U.K, or the Philippines. But if the producer has been to other countries outside the U.S., like Asia, he will be sensitive to explaining what he wants and in being sensitive to the local needs. Saving face, for example. There are certain differences. Filipinos like to eat regularly, which means breakfast is between six and seven o'clock; lunch is between twelve and one; dinner is between seven and eight. None of this six hours work and then you have lunch at midnight. As long as the producer is sensible and not trying to impose or take advantage of the locale, he will be okay.

There's no handbook available that can tell you how things are done, so you have to align with local producers who are reliable. Occasionally, producers work with someone who is not reliable, and there will be trouble. The best thing to do is ask around; ask people who have shot in the Philippines to find out who they dealt with. Referral is the best form of advertising. In the long run, it is the people whom we have worked with who will refer business to us. And it's best to only deal with people who are doing this on a full-time basis.

MD: What would you say are the biggest miscalculations that visiting filmmakers make?

OL: I would say, in general, not just in the Philippines but for any production abroad, it is the lack of preparation for their film. I'm a strong advocate of persons doing their homework, having a complete breakdown. It there are special effects or something very sensitive, I like to see it in storyboard, even in black and white, very rough. That way people have a clear idea of what they are supposed to do. If, for example, you want to shoot a POW village and you have to build the structure, and the DP is only going to frame a certain angle, then it's no use building the entire complex.

In the end, it's still a business. I have to build lines to stretch a dollar so that they'll be back six months or a year later. If I don't help my clients save money, in the long run, I'm not going to have clients.

Filipinos don't like to say no. The same holds true in Japan. If you ask, "Can you build this and that?" In America, they might say, "No, it can't be done." But in Asia they might say, "Well, let me study that." The producers need to be sensitive to a person who is not readily saying "yes" because they are really saying "no." And in Asia to say "no" is impolite. Of course there are people with us who have worked with Western crews, and they understand that it's okay to say "no." But if I ask a location manager if we're ready for tomorrow's shoot, and he says "yes," I would tend to ask, "Where are we going to park the trucks? Who is the local contact person? What's his cell-phone number?" Once he's answered all my questions and in my mind I say "yes," then I know we are ready. I don't really give a lot of credence to the words "yes" and "no." I like to make certain for myself.

MD: So you're dealing with the saving-face aspect of Asian culture?

OL: That's part of it. But the producer should also be firm in some aspects. As we all know, filming anywhere in the world, dealing with new people, they have the notion that Hollywood makes $200-million films, so you must be making a $200-million film. You have to be firm and say, "Look, my budget for an electrician is $150, and that's all I can pay." It's a matter of being firm, yet being open, while being realistic—a combination of these traits.

MD: What is a scale rate for local-hire actors in the Philippines?

OL: Spot extras are $6 to $8 per day. If they have speaking lines and they're not professionals, it might be $120 a day. I've gotten professional actors, like the top thirty in the Philippines, for $300 to

$400 per day, and even much, much less. I did a film as line pro-
ducer and said, "Look, you guys can continue to do schlep films,
or you can do a real movie." So we've gotten name actors for as
little as $200 a day.

MD: What should the independent producer anticipate in the area of
hidden costs?

OL: There should be no hidden costs.

MD: What about strong-arm tactics or bribes that need to be paid?

OL: Most films have a certain contingency. I'm a firm believer that
there should be no surprises in the shoot. If you work with some-
one reliable, you tell the person to give you a budget that includes
everything. I work with producers that tell me, "If it's not in the
budget and something has to be paid, then it's out of your pock-
et." And I think that's a fair way. If I were going to another coun-
try, the person I'm dealing with, I'm going to say, "This is all the
money I have. Even if you stick a gun to my head, this is all I've
got. I need this. I need that." You must try to work with people
who value your future business, not just the project at hand,
because if he cares about whether he works with you next year or
the year after, he'll be honest with you.

Now I try to allow a certain contingency. That might be in the
form of a gift, a bottle of whiskey; it might be in the form of a con-
tribution to the local people. When we were making a German
movie, and we wanted to film in a squalid area, we found that it
was better to donate to the community a basketball ring, which
was appreciated by everyone. I'm a firm believer that whatever
these expenses are, legit or not, by whatever standards, it should
be up front. They should not be hidden costs.

You should work with people who are reliable, who will
defend what is being done. There have been times when I've run
into problems. Locals will come to me and say that I didn't allow
for this or that. I say, "Look, these guys aren't Lucas and Spiel-
berg. They come to the Philippines because they don't have as
much money as they'd like to have, and it's a fixed budget. If you
charge me more, it's going to come out of my pocket, and I won't
go back to you because I'll be very upset. So help me out. I don't
have what you want. I can only give you this much, and we can be
friends, and I'll buy you lunch." That's my job.

There are charges if someone does incorrect paperwork and
doesn't follow the rules. If they "misdeclare" something, for exam-

ple, there are penalties, but if there is proper coordination, there should be no hang-ups.

There are countries where when you go in there you don't know how badly you're going to be pinched. But if you go into a lion's den unprotected and get bitten by the lion, whose fault is that? Is it the lion or the person who jumped in? So whether it's Europe or South America, or Asia, the rules are the same. Get reliable local production managers who know what they're doing.

PHILIPPINES
Freelance Production Rates
(prices reflect approximate weekly rates in U.S.$ unless otherwise specified)

Philippine associate producer	To be discussed
Actors	200–400 day
Bit/day players	60–200 day
Stunt player	40–150 day
Featured extras	20–60 day
Caucasian extras	40–60 day
General extras	10–20 day
Local casting director	2,500–4,000 Allow.
Extras casting coordinator	150–200
Stunt coordinator	300–500
1st Assistant director	400–700
Production manager/UPM	500–700
Script supervisor	300–500
Production coordinator	300–500
Assistant production coordinator	250–350
Production assistants and secretaries	150–250
Production accountant, Ultra	350–500
Field accountant/Field cashier	250–400
Location manager	350–500
Production designer	500–700
Art director	300–500
Set construction coordinator	300–450
Carpenters and painters	150–200
Day laborers	150
Key grip	350–500
Best boy	250–350
Grips	150–300
Grip rental package	3,000–4,000
Set decorator	300–400
Lead man	200–250

Property master	250–350
Assistant property 1	200–250
Assistant property 2	150–200
Picture car coordinator	250–350
Assistant picture car coordinator	150–200
Animals, weapons	To be discussed
Camera operators	500–800
1st Assistant cameraman	400–650
2nd Assistant cameraman	300–400
Loader	200–250
Clapper	200–250
Camera grip	150–200
Stills person	350–500
Camera Arri BL–4s package	4,000–6,000
Local gaffer	350–500
Best boy electric	300–400
Grip electric	200–350
Crystal genny operator	175–200
Lighting package	4,000–6,000
Special effects head	300–450
Weapons armorer	200–400
Costume designer	300–400
Costumes assistant	200–250
Seamstress	150–200
Key makeup	300–500
Hairdresser	250–350
Assistant hair and makeup	200–250
Soundman, DAT/Nagra, Smart Slate	To be discussed
Boom man	250–300
Cable man	150–200
Transportation captain	250–350
Drivers (no vehicle)	150–175
Non-air-conditioned vehicle, 8-passenger (with driver)	250
Air-conditioned vehicle, 8-passenger (with driver)	320
Air-conditioned minivan, 12-passenger (with driver)	400
Trucks with shelves, (with driver)	550–900
Star trailer, 40 foot (with driver)	800–900
Non-air-conditioned bus (with driver)	750
Wigwam, portable toilet tent	170
Locations—waterfalls/docks	500 day
Locations—int'l airport	1,500 day
Locations—open fields/jungles	200 day
Local Security, Policemen	50 day

Set doctor/set nurse	90/40 day
Catering, local crew	1.75 Meal/pax/3
Catering, foreign crew	2.95 Meal/pax
Craft services	2.00 pax
Steadicam rig and operator	900 day
Production room, staff, and computer	300
Film lab developing fee	.10–.13 foot
LAX/Manila/LAX (economy ticket)	600–900
LAX/Manila/LAX (business-class ticket)	1,350
LAX/Manila/LAX (first-class ticket)	1,800–2,200
Manila 4-star hotel (all-inclusive)	55 day
Manila local crew accommodations	N/A
Outside Manila crew accommodations (motel/dorm, per person)	7–10 day
Foreigners per diem	25–40 day

Chapter 11

Hong Kong: Renowned for Its Fast Pace

An interview at Locations 2000 with Esmond Lee, Asst. Film Commissioner (Entertainment).

MD: In preparing to film in Hong Kong, what are the first things the independent producer should anticipate?

EL: I think we have little restrictions over filming activities in Hong Kong. We do not get the scripts. They can go there depending on the duration of the filming and the purpose of the visit. They may need a visa, or they may need an employment visa. It varies from case to case, but let me assure you that the restrictions are minimal. You can go at any time and you are not obligated to contact us as the film commission. You can contact the local production houses or the filming companies.

Of course, you need to comply with local legislation. For example, licenses for the use of pyrotechnic materials, licenses for use of modified arms and blank ammunition, licenses for use of some police uniforms. Of course, they are not real uniforms, but they need to get that sort of permission. Apart from that, if you want to film in certain locations (for example, the railway station), you need to obtain the specific permission of the railway corporation. In this regard, we have, over the last two years, managed to obtain agreements from 150 government departments, as well as private organizations, to lend their premises for location shooting. In the past it was done on an ad hoc basis, but now

it is more systematic as a result of the establishment of our office.

Our office is called the Film Services Office. It is part of the Television and Entertainment Licensing Authority. This authority has different responsibilities. As far as films are concerned, the duties are to classify the films. The second is that of the film office: to support the development of the local film industry, and connected with that we want to project Hong Kong as a place for location shooting, and that explains why we joined the AFCI two years ago. This is the second time we have attended the Locations Expo. During these two years, we have teamed up with the Hong Kong Tourist Association, because we believe that if we promote Hong Kong as a filming location, it will have a spin-off effect in encouraging tourism.

MD: How much money could a producer save in Hong Kong as opposed to the United States?

EL: This year we have Salon. Salon is Hong Kong's film company. They do promotional materials for different companies. If you are an overseas production company coming to Hong Kong or Southeast Asia or even Korea to do filming, they can provide you with equipment and rates. If you are looking for a cameraman, the rates for the very best are comparable with the Hollywood rates, but there is a range. For the other cameramen it is obviously lower than in California. We don't have a union system in Hong Kong. In the United States you have all the unions. So, if we are talking about the very top cameramen in Hong Kong, the rates are comparable to the United States, but if you are talking about the less famous one, it is lower.

I cannot deny that the living standards have sort of risen over the years. It's still cheap, but not as cheap as you would find in the early sixties or seventies. The labor costs have risen for sure, but now because of the inflation, the economy, costs have been frozen, so that helps to upgrade our competitiveness.

MD: The change in government from British rule to mainland China's, how has that affected filmmaking?

EL: Not at all.

MD: So the new government is supportive of filmmaking?

EL: If we look at history, before 1997 there was no policy at all on film development. There was no clear commitment. In October 1997,

after the transition, the chief executive of the Hong Kong Special Ministry announced a policy to specifically support film development. That was against the background. The film industry then faced considerable difficulties. There was a drop in the number of films being made every year. The box-office receipts were not good, and there was an outcry from the people in the trade that they wanted help from the government. Therefore, the chief executive said in his policy address that he would set up an office for film development, and that's why we are here today.

Essentially, we are no different than film commissions anywhere—in the United States or the United Kingdom. We have our own resource library containing all the relative information. We put all the application forms together so that if someone wants to know how they can do filming, they can come to the resource center. We have prepared publications like *A Guide to Filmmaking in Hong Kong*. We have produced a production directory. We invited the local trade people to submit their details and categorized them, and you can get the paperback.

MD: These didn't exist before the change in government?

EL: No.

MD: What did producers do back then?

EL: Well, they relied on services like Salon. They lent equipment, and, on top of that, they had their own production staff. So if you wanted to come to Hong Kong, you teamed up with them. But now it's different. We are more proactive. We talk to the trade, ask for information, produce publications, send them out, attend the expos, and put Hong Kong on the world map.

Of course, this relates not only to the fact that we have locations to offer. We also have our own advantage because we maintain a low-tax regime. We only charge 15 percent profit tax. We have no complicated tax system, so we don't talk about tax incentives or tax breaks, because we charge the lowest profit tax. We have good telecommunications. We have good people, both in the trade and in general. We have good hotels. We have our own Chinese traditions, and it's always a cosmopolitan city where the East meets the West. We have our festivals, our very beautiful street scenes, our harbor, our peaks where you can have a panoramic view of Hong Kong. So we have something to offer. Obviously, we can't compare ourselves with, um . . .

MD: You don't have vast open spaces.

EL: Yes, exactly. We do have our countryside. If you are looking for something special, we are there to help out. Specifically, our office will do location-scouting services. A location scout comes to us, and we are more than happy to give our advice. And we've got more than a thousand pictures in our photo library, and we put all these photos on our Web site (*www.fso-tela.gov.hk*).

MD: Let's talk about censorship.

EL: Our censorship. We have a piece of legislation called the Film Censorship Ordinance. That mainly relates to sex and violence. These are the two specific concerns. Political censorship is no longer on the agenda.

MD: What are the sex and violence restrictions?

EL: The standards are comparable to those adopted in the United States or the United Kingdom. In some cases, the United Kingdom's are higher than those in the United States or Hong Kong. There is no approval of the script. You can shoot whatever you want. The Film Censorship Ordinance only relates to the public exhibition of the film.

MD: Security. How secure is Hong Kong in relation to the protection of cast, crew, and equipment?

EL: I think it's one of the safest cities in the world. We do have a very efficient police force. In the past years, a lot of major films have been made in Hong Kong. No problems have arisen.

MD: Is there a community in Hong Kong that will engage in joint ventures with American film producers?

EL: Film financing is very much a matter for the private sector, unlike the United Kingdom or France or some of the other countries. For example, in the United Kingdom they have a film fund, basically with resources coming from the lotteries. In Hong Kong, we do not have this sort of mechanism. Over the years, we have encouraged filming companies to pursue their own funds. There have been one or two instances where they have formed a film fund with finances from Japan, Singapore, that sort of thing, and they are committed to make ten films. Co-production is very

much dependent on whether the two companies can agree on the terms, but Columbia, I understand, has an office in Hong Kong and actually has a budget for making films in Hong Kong or China. Financing is very much private-led and not government initiated.

MD: Has the film commission been successful in bringing films to Hong Kong?

EL: We are on the support side. Whether there is much filming depends very much on the private sector. In the last two years, the position was not that positive because of the Asian financial turmoil; because of the pirated CDs; and because of changes in the entertainment cap in the cinema box offices. But recently we have heard from people in the trade that money for such productions is on the increase, mainly because of new developments in the Internet business. There are more channels, and it's quite clear that they need content, and an important aspect of this content will be films.

MD: What about the language difference?

EL: Given our past experience, English is not really a problem.

MD: What about speed of production?

EL: Very quick. Hong Kong is such a fast-paced society. Everything is done so quickly.

MD: That is an advantage to an independent producer.

EL: I think we are renowned for our fast pace. And that relates back to the overall advantage of Hong Kong being a financial center, telecommunications center, a good tourist location. The people are willing to work overtime. Twenty-four hours, forty-eight hours nonstop to make it work. It's sort of a can-do attitude . . .

We are among the fastest people. In most cases, the people are very enterprising. They work seven days a week. The shops are open seven days a week. The banks are open six and a half days. This makes a difference. We need to make extra efforts in order to be competitive with others.

MD: What are the biggest mistakes that American producers make when they come to Hong Kong?

EL: In the past, I think, they had a misconception of who the Chinese people are, but over the years, twenty or thirty years, Hong Kong has become a commonplace name. They do have a good understanding of what the Chinese traditions are: what you shouldn't do; what is polite; what is not polite in Chinese society. But what they do not know about is our presence, because our office was not established until 1998. We need to continue our publicity on our existence and our services. Our mission is to sell our good points, as I explained before: our good transport; the enterprising attitude of our people, rule of law; traditions. We want to spread the message that producers are welcome to come to Hong Kong.

MD: What about the concern on the part of people that it might be more difficult to film in Hong Kong now that it is ruled by China?

EL: My response to that is that we are a part of China, but we have our capitalist way of living. That is enshrined in the basic constitution for the Hong Kong special administrative region. In terms of the way business is transacted: before 1997 or after 1997, it is basically the same. We still use English as the way of doing business. We still maintain our competitive edge. I will say that we are now more organized to support filming activities in Hong Kong.

NOTE: There can be negative reasons why crews in a country work at a fast pace. Commerce takes precedence over everything else in Hong Kong. While filmmaking has been tolerated, it has historically received no encouragement or help from the government. Permits that in any way hinder the flow of immediate commerce (blocking streets or flow of traffic) may be very difficult to acquire, and the police may not assist at the set, so many local producers don't even bother to get a permit. They frequently bring a small crew, shoot as quickly as possible, and then run away before the police arrive. The best illustration I've heard is the story of a production company that needed to block a street for a shot, so they arranged for two PAs to crash their cars at the end of the block and cut off traffic. Now that's dedication!

Chapter 12

Australia: Vast Resources, Tax Incentives

This book would be incomplete without a word about the Land Down Under. It is, after all, unique on several levels: Not only is it a country, but it is also a continent with vast resources, not the least of which is locations (from mountains to deserts to seascapes to jungles to small period-towns in the Outback), animals, and people unlike anyplace else in the world. New Zealand, which I will include as part of the region, has seen major increases in production due in no small part to its natural beauty. This is one of the pluses. Others include the fact that Australians speak English (although some who have tried to understand the local dialect might argue with this point); the film industry has a long history; the crews are knowledgeable; and there is plenty of top-of-the-line equipment available.

But Australia also has its negatives. For one, you are dealing with a strong economy compared to other countries in that part of the world. Therefore, Australia is not the most ideal location for the ultra-low-budget producer. In fact, if you are not prepared to spend at least U.S.$3.5 million on a film, you are better off filming somewhere else. Many of the territories have economic incentive deals available if you follow the rules closely, but you had better be starting with a comfortable budget. Getting to those locations previously mentioned is another problem. The major cities are all located along the coast, with the film industry primarily centered in Sidney and Melbourne, but these cities may be far from the look you are seeking, and it is no small task to transport an entire company 800 miles across desert highways to reach your *unique* location. Transportation costs are just the beginning;

housing, feeding, and the like can also be troublesome outside the major cities.

This is not to say that a producer cannot save money by shooting in Australia. You can, but do not expect the same savings that you can find elsewhere. Depending upon the project, you can absolutely get the best value for the money you spend. The federal government offers tax concessions for films financed outside of Australia under Division 10B of the Income Tax Assessment Act, but the requirements can be quite complicated. Various states also offer incentives. Queensland and New South Wales offer payroll tax rebates, while South Australia and Tasmania offer payroll-tax exemptions when substantial parts of a film are shot within the state. Queensland also offers local cast and crew salary rebates of 8 to 10 percent, depending upon the size of the production budget, and special rebates for police and fire services. Victoria offers incentives through its Production Investment Attraction Fund, provided the budget exceeds $A3.5 million [Australian dollars] and meets other requirements. These moneys are issued in the form of grants. For further details, contact: Australian Film Commissioner, 2049 Century Park East, 9th Floor, Los Angeles, CA 90067; tel. (310) 229-4833; fax (310) 277-2258.

Part Three

PRODUCTION

*T*his is where the rubber meets the road. It's one thing to listen to the assurances of film commissioners, but it's quite another to experience production hands-on. The first interview in this section was conducted with an American filmmaker who now lives and works out of Thailand. Obviously, his insights are tested over time as opposed to brief visits to foreign countries for filming.

The second interview in this section was given by an ultra-low-budget producer who had tried to take a project to Mexico; the problems that had occurred and the efforts to get around those problems make interesting reading. You may wish to compare the comments of by the Mexican Film Commission with the experiences of this producer (who wished to remain anonymous).

Rubi Zack (UPM/Line Producer) will give you the straight story on production in Eastern Europe and Russia.

The final interview was a delight to conduct. Mr. Fred Weintraub (co-founder of Weintraub/Kuhn Productions) is an icon of independent film production. With more than thirty films to his name, many of them notable successes with recognizable titles, he has much to share. One is immediately struck by the confidence that comes from decades of experience and by his wry sense of humor.

Chapter 13

An American Producer in Thailand

Mr. Chris Lowenstein was interviewed on the set of *The Cave* while shooting in Mae Sot, Thailand. His production company, Living Films, through which he serves as local producer for companies filming in Thailand, is based in both Chiang Mai and Bangkok.

MD: How did you become an expatriate American filmmaker working in Thailand?

CL: I started in film in Portland, Oregon. After school I started with some films in Portland, including *My Own Private Idaho* with Gus van Sant. I was doing assistant directing then. I came to Asia in 1990, actually for a photo shoot in Vietnam. It was before Americans were allowed back in Vietnam, so it was through the Vietnamese government, and it was kind of a peace mission taking images back to the United States, and they had a Vietnamese person in the States taking pictures back to Vietnam. It was a very nice little gig, but I spent two weeks in Thailand on vacation at that time. I'd prepared for Vietnam and hadn't thought about Thailand at all, and it really resonated with me when I saw it for the first time.

Actually, through connections in Vietnam I met a woman named Le Ly Hayslip who was the author of a book called *When Heaven and Earth Changed Places*, which was what Oliver Stone based his movie *Heaven and Earth* on. And through those connections, I ended up on the *Heaven and Earth* set in Thailand, and

actually, before that started, did another film there. I started to go
back and forth between Thailand and the States doing films; did
a film called *Devil's Keep*—I was second AD at that point. To make
a long story short, by the end of '92 I was making every excuse I
had available to try to get on a film shooting in Thailand. So
great, I made a decision to move to Thailand. It's not such an easy
break, but I did that. It wasn't until after I did a film called *The
Quest* with Jean Claude van Damme as director and actor, which
was in the beginning of '95, if I remember right, and I was unit
production manager [UPM] on it. After that, I started my own
company with the intention of working on smaller film produc-
tions that in some way or another gave back to the community, to
be more on the creative side. I started mostly with documentary
with the idea of working my way back up to feature, creating my
own team and environment.

It was really a quality-of-life move. I was doing bigger films in
and around Bangkok and wherever they took me. We moved to
Chiang Mai and started a business with my partner P. Tim, a
woman in her early sixties who has been doing films in Thailand
for years. She started in 1977 with *The Deer Hunter*, and we'd
worked on three or four films together. She struck me as a very
hardworking person of integrity, and we complement each other
very well.

MD: How difficult was it to make that move from the States to living in
Thailand?

CL: You know, I live my life kind of like I would direct a film in some
ways. You have to have direction and have lots of organization to
it; but, on the other hand, when things come your way, you can't
just pass them up. You have to be flexible and see opportunity
when it's there. I felt so comfortable, I felt like being here was the
right thing, so I just followed that. It wasn't that difficult.

I think a lot of people find that they get stuck in a system,
especially in Hollywood. I was doing assistant directing. I could
have just kept doing that and been in that system. But I think at
the time I was more motivated by wanting to have more creative
influence, and since 1995 I've directed half of the productions
I'm on and produced the other half. The producing has been
mostly for productions that come from overseas, and I'll produce
or coordinate them when they're here. The directing has been
my own documentary work; I'm on my sixth documentary now. So
the combination has allowed me to fulfill both sides, which I
don't think I'd have been able to do otherwise.

Making Adjustments

MD: What did you find to be the most difficult things to adjust to when you made the move to filming in Thailand versus the United States?

CL: Thai culture. Asian culture in general, but certainly Thai culture is really different. I know that sounds like a generality, but often it's very subtle, and understanding those cultural differences is really important in how things are done and how people relate to each other. Filmmaking is a collaborative art by nature, and it's important to know how that collaboration can work . . . So language and culture is one of the biggest challenges in understanding what motivates people.

MD: You speak the Thai language fluently. Did that come out of the need to communicate, or had you already learned it before you made the move?

CL: No, that definitely came out of the need of having to learn it to get by, putting myself in situations where I needed to learn it, and that certainly helps. But language alone doesn't do it either. People also need to understand culture and people. One thing about Thai people is that on one hand they're wonderful and nice, but on the other hand they don't open themselves up to people so quickly. So it does take time to understand what people are motivated by and who they are. I've met foreigners who have been in Thailand for years and can say that they've never really had a close Thai friend, where they had a heart connection.

Developing a Core Team

MD: How did you go about assembling your crew?

CL: After '95, when we started Living Films, we started with some smaller production with a core team. Living Films has a core team and, beyond that, there's another level of team that are freelancers but will work on most productions with us when we need them. Now you can see that we're back to doing feature films pretty solidly. The core team works from the top down. We understand and trust each other very well. We have a very transparent style of working. Each production that we work on, our team becomes more refined. So I'd say it's only been about a year and a half now that I feel extremely comfortable.

 Sometimes it's tricky in a place like Thailand or elsewhere in

Asia where there's corruption or you see where money is being funneled off. It's really important to try and weed that out. My style of doing that is: clearly, if it's a bad case of it, we'll bring it up; but often, say it's a driver that turns in gas receipts for gas they didn't actually put in their van, I probably just wouldn't use them on the next production. We've done a number of commercials where each time the team became more refined and honest. I also invite a lot of our core team to be part of choices we make in terms of where we go as a business, which they appreciate. And so, they are willing to work on a lower-budget film, for example, to take less. And they're happy to do so.

Dealing with Thai Bureaucracy

MD: How difficult is it to work with the bureaucracy in Thailand?

CL: I don't think it's difficult at all. Actually, I think the bureaucracy can be daunting at times, but that's from an outside perspective. Often it's just a communication thing. Clearly, people need to have a connection inside, not in terms of inside the government, but they need a local who knows the ropes. For example, on this feature, the production manager in Holland . . .

MD: This feature being . . .

CL: . . . being *The Cave*, coming out of Holland and Belgium. They wanted to know what the procedure was with the work permits and stuff like that in detail, and you know it's kind of a long procedure, but we take care of it every time. It's pretty straightforward and easy for us to do, so I just reassured them that we'd take care of it. And we did. In terms of liaison with the government, there are two sides: the bureaucracy can be less than in the West, but often it's just not clear, so you need someone who understands it who's here. In terms of permits for stunts for example, special effects, if you want explosions, it's often much easier than it would be in the West.

MD: Now on this feature, *The Cave*, you had some difficulties because you were going to be shooting around a military base and Mae Sot is right here at the border of Burma and Thailand. With the problems they're having between the countries, it became more difficult for you. Can you tell me about getting the permissions?

CL: Well, P. Tim is very straight and very aboveboard and has connections in the government, so she went through the chain of command to ask permission from the military on a local level and on a central level in Bangkok. It was understandable that they were reluctant because there are actually skirmishes going on along the border right now with Burma, so she had to really explain clearly what we wanted to do. Despite their reluctance to do that, we went through all the process, and she ended up on the last stages sitting in the supreme commander's office for a day until they finally signed the last sheet of paper that we needed. And it turned out great. We had helicopters, military jeeps, GMCs, a Hum-V, and the cooperation was excellent. It was really a communication thing and also their respect of her (her age and what she's done). In the middle of it she was almost crying because she felt like she wasn't going to get it, but in the end we got it.

PRODUCTION WITHOUT A FILM COMMISSION

MD: How do you respond to the concerns of producers in the States who feel that it's too risky to bring a film here because there's no film commission?

CL: I think it's hard for producers overseas if they don't know people here, because it's hard to know over the Internet or phone who exactly you're dealing with. Certainly, I think it's true anywhere, that there are going to be companies to deal with who are less clear and less transparent. Things are changing a lot, too. There are companies with a preference to quote lump sums for services, a kind of Hong Kong mentality (it might not be fair to call it that), where you buy a camera in Hong Kong and you're about to leave with it when you ask, "Where's the case?" And they say, "Oh, you want the case too, huh?" This kind of mentality. There's much less of that than people actually believe. Again, it's not understanding the language and culture that often gets in the way. In my case, if there's a strong level of communication and people understand what services they're getting and what the process is and how filmmaking is done here and the costs involved, it can be budgeted out very carefully and be right in line.

MD: What about situations where locals have tried to take advantage?

CL: Definitely, in dealing with governments and bureaucracy— where people know you need service—you can have situations. If

the director picks an actor, and you haven't negotiated a price with her yet, and she knows the director loves her, the rate goes up. We faced a situation on *Operation Dumbo Drop*. One day we were working at the airport in Chiang Mai, and the Air Force there was in charge of the forklift that we needed to pick up the animatronics elephant that we were working with. This thing weighed like two tons and we clearly needed this forklift. They knew we needed it, and, as we were negotiating the price for the use of this forklift, every five minutes the price was going up. Finally, the price was getting a bit outrageous, and we started thinking quickly about what options we had. Of course, we could have paid if we had to, but you want to limit costs, especially a cost like that. Finally, I just said, "No, we're not going to use it." They looked at me like I was crazy. I went outside, kind of on a hunch, and called on a walkie-talkie for everyone that was working on the set that day. I think there were sixty-five of us, and between all sixty-five of us, we lifted this thing and put it into the airplane that we needed to get it into. You could see the officials swearing under their breath because they should have said "yes" to the last price we'd offered.

MD: Have there been any problems that were insurmountable?

CL: There are always solutions to every situation. In terms of bureaucracy, there's almost always a solution. There have been situations where we're not allowed to shoot something. For example, we were shooting a car commercial where the car had a statue of the Buddha in the background. The image of the Buddha on the monitor appeared to be below the car itself, so the Thai censor told us that we couldn't shoot it like that. So we explained to the director and it was fine to change the shot around, and he ended up with something he liked even better. It actually ended up in a creative solution with the car being below the Buddha, and it was fine. There have been a number of situations like that.

SCRIPT APPROVALS

MD: Have you ever had trouble getting a script through the process of approval by the government?

CL: After *Anna and the King* was rejected for shooting in Thailand, we had a lot of inquiries from people, and they would always ask why. That probably scared off a number of people, but clearly it was a very sensitive issue with the King of Thailand and very unusual in

terms of permissions. We've never had a script or an application for a film permit rejected, and P. Tim has been doing it since 1977 with *The Deer Hunter*. Often, if we feel there is going to be something that is going to be sensitive, then we will give an unofficial copy to one of our friends on the film board first. Sometimes, changes are requested, but generally speaking we've never had a problem. You know, mostly what they are worried about is something that reflects badly on the country or the religion or the culture. But that's not terribly strict, unless it's something insulting and offensive to the country.

Take the film that we're currently working on, *The Cave*. It's supposed to be a fictitious country in Asia, and there's reference to drugs and corruption and to smuggling, and it's not actually supposed to be Thailand. So we're careful not to have extras speaking Thai in the background and not to have Thai signs. We're a bit more careful about that. We had a scene with customs officers screaming commands in a different Asian language besides Thai, and it came off fine.

How to Save Money

MD: What kinds of advice can you give to visiting independent producers for saving money on budgets in Thailand?

CL: Well, one thing is that crews are much cheaper than in other countries, and they're very good. You know, it's a pretty small community, so there can be two major features shooting at any given time, and then you can get hard-pressed to get the really, really good crew: art directors and such. But the crews in Thailand have been working on Hollywood productions and the international standard films for a long time and are pretty much known as the best crews in Southeast Asia. They're used for productions all over (in Malaysia, Cambodia, Vietnam), and when other productions go to those countries they almost always take Thai crews. They're very good and comparatively quite cheap. Interestingly, I've had a client who has come four times to shoot commercials, and each time they've brought less crew from home. So this last time they only brought two people, the director and the producer. They saved a lot of money by using a Thai Director of Photography because their other DP was from Israel. So, in terms of crewing it, they can save a lot of money.

If you look at equipment, I'd say 50 percent of the productions we get bring their own camera equipment and 50 percent

hire the equipment here. It's pretty similar in prices, so you can't expect to save a lot on the camera equipment. Though there's a lot of equipment to be had here, often it's sourced overseas anyway. But if you take assistants, a focus puller here is $65 a day, something like that. A grip or an electrician is something like $30 a day or $35 a day. Obviously, there are huge saving to be had. On the production we're doing now, the gaffer came up to compliment me on the grip crew. We have fifteen grips and electricians on the shoot, which to a producer would seem like a lot, but actually there are some big "blanking" setups on this one. The advantage is that they're actually not that expensive and things get set up quick so that when we move, it happens fast. We're able to shoot more pages in a day just because the technicians are so fast and know their stuff.

Accommodation is often a huge savings in terms of foreign crews being put up. We have some excellent hotels in Thailand, and they're often very cheap. For example, the hotel we just stayed at in Bangkok, we get a rate of $35 a day and it's like a five-star hotel. For $35 a day, you just can't get that anywhere else. I just came back from Europe, and I'd forgotten how expensive hotels are. Hungary is now a center for lower-budget production in Europe and hotels are still much more expensive than that.

In terms of other parts of the budget, I think that across the line you end up saving. You have to keep in mind that the baht is very weak compared to the American dollar, compared to what it was before. So that's made making a film here 15 percent cheaper than what it was a year ago and close to 80 percent cheaper than it was four years ago. I hate to say that we profit off the bad economy in Thailand, but after the economy broke and the baht fell in value we've received twice as many inquiries as before.

MD: What is the minimum that an independent producer from the States should anticipate spending on a ninety-minute film here in Thailand?

CL: Well, that's a very difficult question to answer. It depends on what kind of film you're making. You can make a dogma film for $10. That really depends. On the other hand, we know how far money goes here. I've had a number of productions come to me. An independently produced film is coming to me from France, a film about Vietnam to shoot in Thailand. It hasn't happened yet, but I think it will shoot here eventually. And they were budgeted at about U.S.$350,000, and it's a character-driven film, kind of an artistic piece, a small core group for the crew. The crew was going

to be something like fifteen people from France and probably about fifteen or twenty Thais, so that would be a thirty- or thirty-five–person crew, which would be a nice medium-level to smaller-level crew for a feature. It was clear that it was going to be a nine-week shoot, and it was clear that we were going to be able to do that for $350,000, which is very low. Money certainly carries farther, but it depends on the production. We've had a number of medium-level European productions, $5-million productions, which is plenty. You can do a lot here, and also you get amazing production value out of the locations and the area.

MD: I understand that the high-level budget for the Thai film industry (making their own product) is maybe $3 million.

CL: That's right. Thailand is making a transition. There are a lot of independent low-budget features that are starting to come here. This is a transition, because Thailand has traditionally brought the really big-budget Hollywood films in. And I think this is something that scares producers of lower independent productions because there's no real track record for the last fifteen years for smaller-level projects, except for maybe Hong Kong, but that's a different level of production. But I think they're making that transition now, and I think that Thai crews understand that. With me, people have been willing to go with different rates depending on whether they like the film and whether they are interested in the position they have. For example, I know a Thai art director who is fantastic, and instead of working under a foreign art director on a big Hollywood production, he will work at a lower rate as the sole art director on a feature. Because of that propriety and that ability to really show their own style, they will take that drop in rate. So we are seeing more flexibility in terms of Thai crews' understanding what low budget means as opposed to high budget, instead of thinking that everything is high budget from Hollywood.

Virgin Territory

MD: This is your first time shooting in Mae Sot, right?

CL: That's right. We're the first feature to come to Mae Sot.

MD: So a person can still come to Thailand and shoot virgin territory that has never been filmed before.

CL: Absolutely.

MD: And they'd still get the same kind of response and support from the local community as a filmmaker in Indiana who is shooting in his hometown.

CL: Well, first, people don't know what Thailand is like. Clearly, it's easy to fall in love with Thailand because people are so nice, and communities are extremely accepting and safe. It's an amazingly safe country. That's what people don't understand, mostly because media is so negatively based I mean, what we hear about Thailand in the media in the West is often AIDS, drugs, selling your daughter into prostitution. The picture that's given is pretty bleak, and the fact is that shooting in a city like Mae Sot is an amazing experience. We've had an amazing welcome from the community and no problems. We closed down the central intersection of the city for like eight hours, and it was great. A lot of that depends on the production company making the film. I think a public relations campaign is really important. You can't just come in and force yourself on a community. There's a right and a wrong way to do it. But there are so many locations in Thailand that are untouched and that people haven't used. And they're such diverse locations. There are mountains in the north that people haven't shot. There are the beaches and tropical waters in the south. There's the busy city of Bangkok. There are the old temple complexes north of Bangkok. Amazing locations, and a lot of them have never been filmed.

Pre-production in Thailand

MD: In regard to scheduling, what considerations should an independent producer make?

CL: You know the most popular time to film is during the cold season. They call it cold, but it's still going to be eighty or ninety degrees out, but that's cold. During the cold season the weather is the most predictable of the year, but the hot season is pretty predictable too. It's just a bit more of a challenge for the crew, especially coming from the West in terms of the heat. But for filming it's usually fine. If people come to make films during the hot season, I often recommend that they have their crew come in three days before they are needed to start so they can get acclimated. It also helps in regard to jet lag.

The rainy season is much more of a consideration to the logistics of shooting. If your film doesn't call for rain, you probably don't want to shoot during the rainy season. Yet, even in the rainy season we've shot stuff. In the north it isn't going to rain all day. A thunderstorm will come in the afternoon and often makes it incredibly beautiful cause it will clean out the air and there will be steam rising out of the jungle. This can be very nice depending on what kind of film you're making.

A film permit takes at least two weeks to get, so often we try to get that process done a month before principal photography. And in terms of the work ethic, there are no unions here, but technical crews will get time off after a twelve-hour day, but even then . . .

MD: . . . they're not watching the clock.

CL: Exactly, and there are no meal penalties. For example, tonight we're on location working nights, and we'll finish about six in the morning. Tomorrow, we want to start at 4:00 P.M., so the turnaround will only be ten hours instead of twelve. I went around to the technical crew and asked if that was all right, and they all said that it was fine. So that's the kind of thing where we'll clear that with the crew, which out of respect we should do that. But they're very flexible, and if they work thirteen hours, they're not going to charge us overtime. If we have a long eighteen-hour night, of course they're going to—and they should. It's not like Malaysia where they have to go pray five times a day, and you have to break for that.

MD: The producer on this film said he'd come here three times. Is that something you would recommend? How much pre-production time would you recommend to a production coming in?

CL: It really depends on the art department often, but even there the construction and labor is cheaper, so you can put on more people and get it done quicker, so there's less pre-production needed than in a lot of places and that saves money. The reason the producers came three times on this one was: first, they wanted to meet with prospective production companies. I know they met with four other companies before they chose us. They probably would have come only one other time with a technical crew, with the DP, production designer, director, but they came twice because some of their funding fell through and the actual production crew changed. But I would say generally it's usually two times. One to meet people and figure out who they want to work

Production shot of The Cave, *filming at Mae Sot's airport. Photo provided courtesy of Living Films.*

on the production; and another time as a location scout, and then the crew comes in.

An Example of Cost Savings

MD: Tell me about the big market scene you shot for this film. That was a big undertaking.

CL: Yes.

MD: How much did that one day cost and what did you get for your money?

CL: We were going to shoot it in the day and in the night. At night it was supposed to be this abandoned kind of parking lot where the market is in the daytime, with an eerie, menacing atmosphere of stray dogs and trash. In the daytime it's this bustling market. Filling the thing was always a challenge, and our wide shot was from on top of the buildings, so you really needed to fill this whole square. We had military vehicles, taxis, three-wheel taxis, something like sixty-five different food carts. We had ninety extras just walking and buying stuff. We had extras in every cart, so I

The market sequence of The Cave. *Photo provided courtesy of Living Films.*

think that's about 120 extras in the carts. We had about sixty-five drivers for the different taxis in the scene, along with our normal extras in the picture car, which I think was eleven. The extras were $11 each. The extras that came with the art department were actually less because they came with their carts. The location rental for the whole square was $1,500, which included four days of prep and two days of shooting, and giving money to some twenty different establishments around the square. I don't have the art department breakdown here, but I think it was something like $1,800 for all of the props and carts. So for two days of shooting and four days of prep, literally 250 to 300 extras, and all the art department, it was something like $4,000.

MD: That's incredible.

CL: Yeah. I also have to credit our Thai art director on that one because she's amazing. She really takes what budget we have for that scene and makes it happen—creatively too. I'll tell you a story about her. We had a shoot where a team came from Greece, and they wanted to shoot Chinese people singing in the rice fields for a commercial, and they came without doing the proper research. I warned them, but they came anyway in October, which is when the rice has just been harvested. Of course, in their scene they

The market sequence of The Cave. *Photo provided courtesy of Living Films.*

wanted lush, bright green tropical rice blowing in the wind with
the singers on a terraced rice field. We found a great location
about seventy kilometers north of Chiang Mai up on Doi
Inthanon. Sixteen acres of rice fields, but there was no rice. The
foreign team arrived on Saturday. On Sunday we had a big pro-
duction meeting and tried to figure out what we were going to do.
Rice was the key to the whole commercial. Our Thai art director
was given the command to somehow make rice. She had rice
shipped in trucks and on top of trucks from the south, near the
Malaysian border. By shooting day, she had had planted sixteen
acres of rice, made three bungalows, planted six palm trees, had
elephants and buffalo fill in the whole scene. The director was
pretty confident because he had seen her other work, but the
agency and client came out and couldn't believe what we had
done in three days.

Chapter 14

Ultra-Low-Budget Production in Mexico

For reasons that will soon become clear, the following interview was conducted under the condition that the interviewee remained an Anonymous Producer. This individual has produced both independent feature films and television.

MD: You've had some experience producing a television project in Mexico. Some of that experience was not so good but very enlightening. Let's go back to the beginning. Who did you contact and how did you go about setting up the project?

AP: I contacted the head branch of the filming commission in Mexico City, which has jurisdiction over filming in all of Mexico. They initially did not take my budget seriously. They thought that I was joking or trying to pull one over on them. I told them "No, I am serious. This is my budget. I've shot many times in the States, in Los Angeles, with the same kind of budget, and so I'm sure it can be done in Mexico for a similar rate, if not better, because it's my understanding that Mexico is even more cost-effective than shooting in the States."

MD: Let me backtrack for just a moment. What kind of project was it?

AP: It was a thirteen-part video series which had not been pre-sold, and the target market was television. Anyway, it was frustrating

dealing with the Mexico City office. They were shrewd wheeler-dealers, in it for the money, knowledgeable about filmmaking.

I asked them, "Why don't I just run this by the local Baja filming office, since we would be filming in the Baja region of Mexico anyway? And if they could introduce me to a Mexican UPM who can tell me 'Yes, we can get this project done for this budget,' I'll go for it." They sort of laughed and said, "Yeah, yeah sure, you do that." Well that's exactly what I did. I contacted the Baja office direct, and they put me in contact with a UPM who could do it at my budget. But it also turned out that the Baja commissioner was not quite as knowledgeable about filmmaking. He was a nice guy; he didn't seem like a swindler at all, but he just wasn't as knowledgeable as he could have been.

Mexico's Acting Syndicates

AP: And by the way, in order to shoot in Mexico, it is a requirement that you be hooked up with a Mexican production company/UPM. Either the Mexican production company gives you a UPM, or the company is a UPM who has his own company, which was the case in this particular scenario.

Now I'm dealing with this UPM. The first hurdle we had to overcome was the Mexican syndicate situation. Normally, it is a requirement for all films to be going through the Mexican actor syndicate, ANDA, for films or videos. What this organization, ANDA, usually does is charge all kinds of fees to companies. They charge an overall fee, which could be a couple thousand dollars. Then they charge a percentage of what every actor is making, which is usually a high percentage. Plus, they also charge to have their union representative there sitting on the set. He just sits there on the set, does nothing, eats craft service, and gets paid a lot of money, which seemed ridiculous for our micro-budget video production. And there are a lot of regulations too, if you're bringing an American crew and cast. Per every American crew and cast member you hire, you have to hire a certain number of Mexican national citizens to work with you as well. And then they also start charging you fines for every American you hire, and this is all done through ANDA. So even if it's crew, the actor union is charging you fines for bringing down Americans.

I went down to have a meeting with the ANDA representative and explained our situation, the budget, the whole nine yards to see if they would go down in their fees. The Mexican UPM was at the meeting, of course. And they did go down slightly, but it still

wasn't anywhere near what I needed it to go down to, so I thought, "Hmm, maybe I can't shoot in Mexico at all." They were going to lose business because they wouldn't waive some of these fees or work something out.

Well, the UPM found a loophole in the Mexican laws. Mexican laws are not quite as black and white as they are here in the States. They are subject to change according to the official's mood or whatever, apparently. There seemed to be a loophole that the production company had to use *a* Mexican acting syndicate, but not necessarily ANDA. But ANDA disputed this, and more than half of the filming community down there in Baja insisted that we had to use ANDA. But the UPM found this other small syndicate, this little syndicate from a far region of Mexico. So he brought them into the Baja area and created a big stir. There were all these accusations flying. We were receiving phone calls threatening that our production would be illegal if we did this, and we shouldn't be listening to the UPM, and it got really political.

MD: So really the problem was the hurdle of ANDA, and you found a way around it.

AP: At first, everyone thought we had to use ANDA. Mexico City, Baja, everybody, but the UPM looked into the laws further. I don't know where he went, but, like I said, in Mexico you don't know who really the authority is. It's a weird situation, so it was kind of his word against everybody else's word that you can bring in another syndicate. Apparently the Baja guy eventually agreed that we could bring in the other syndicate. But ANDA disagreed, and we received threatening phone calls.

We paid the money to this other new syndicate. So that they could have their first client in Baja, the UPM got the new syndicate to agree that my production company should only have to pay what we could afford, which was a one-time $500 total fee. And they weren't going to send a rep to our set or anything like that.

MD: Approximately what kind of budget are we talking about for your overall project?

AP: Under $250,000.

MD: So you passed the first hurdle. What was the next one you encountered?

Bureaucratic Hurdles

AP: The first hurdle was actually getting them to take my budget seri-
ously. The second was this ANDA thing.

There was all kinds of paperwork,
approvals, and negotiations to complete; such as, you have to start
listing who your cast and crew are going to be and collecting their
passports. And you have to turn over all their passports to the
UPM, who then gets them to the Mexican federal agent to get the
official permission to obtain Mexican work permits. We were told
by the UPM that this would take approximately three days. Well,
it took much longer than three days; they were drawing it out.
And we were getting so close to our actual shooting date. Also,
our UPM was supposed to be getting locations for us. He was sup-
posed to be getting people to go out and take photos of locations,
which he wasn't doing. So we went down there a week before
shooting to make final selections. And he didn't have any loca-
tions secured, not one. (Keep in mind that a production is a huge
train that is very hard to stop.) No photos, and he didn't have any
finished paperwork for any of our cast or crew for work permits.
I was afraid that things weren't going to show up until the day
after we were to start shooting, and then he was going to start with
extortion and that I wasn't going to have a choice but to pay. But
at that moment, with one week before shooting, I still had a
choice. It was a hard decision to make, but I pulled the plug on
the whole Mexican operation.

MD: But you finished the project anyway.

AP: Yes, we actually ended up shooting in the States, but not immedi-
ately. The start-up date was completely changed. It took at least a
month to recover from pulling the plug and to set up new loca-
tions, new everything in the States.

MD: Did you ever get the impression that you were purposely being
stalled in Mexico?

AP: Yes. I felt like they were stalling in order for me to pay more
money.

MD: Was it said in words?

AP: No, that was never said, but promises were made from the begin-
ning, weeks before the actual shoot date. And I'd tell him, "Now

we have to have this by such and such a date. I can't start shooting without locations or without work permits." When those dates would roll around, nothing would be in place. Even a week later, nothing would be in place.

Guerrilla Filmmaking

MD: Now, you have had experience doing actual production in Mexico, but outside the normal parameters, on the sly. How did that work, and did you accomplish what you set out to accomplish?

AP: We did tape guerrilla-style and got what we wanted, but we were always looking over our shoulders. We'd grab a shot and go. Some of the stuff we shot in private locations, and we had no problems at all there. But when we were working on the street we kept a very low profile. We didn't use a tripod. We didn't create any disturbances. Our sound person didn't even step outside the van.

MD: So you did some of your shooting from inside a van shooting outside, and other times you just used a video camera with no lighting. Under Mexican laws that's okay to do, isn't it? You can shoot video in Mexico.

AP: Well, if it's like a home video or if it's for church and you have just a handful of people. Most people won't have a problem with that. But if they're money-hungry, they'll find something you're doing wrong and ask for money.

MD: You had mentioned to me a situation where someone had actually made a lot of noise.

AP: Well, that was in the States, unfortunately. No matter where you go there are going to be jerks around. But it happens more frequently in some countries than others.

MD: What was your situation regarding equipment while guerrilla filmmaking in Mexico? Were you able to get it insured?

AP: We could have, but we didn't because our budget was so low.

MD: If you were going to insure, would you have done it through Mexico or the U.S.?

AP: Through the United States.

MD: And as far as getting equipment in and out, going through customs: any problems there?

AP: No, because we had such minimal equipment. If we'd had several vans worth of stuff, definitely. That's a huge deal in Mexico. You have to hire a customs agent. You have to label every single box you have going in, every piece of equipment, every cable. It costs a lot of money and wastes a lot of time for a lot of employees to just sit there and label everything.

MD: Were there concerns about what would happen if you had been stopped by the authorities for whatever reason?

AP: Basically, my crew and cast were volunteering while in Mexico, and I only paid them for their work in the United States. That helps, if nobody is making money from what you're doing in Mexico. And we didn't have a prior established distribution deal. Nobody hired us to go down there.

MD: You had also asked advice of another producer who has worked in Baja.

AP: We won't use his name, but he's very seasoned at filming in the Baja region. He has indeed encountered some of these bribe situations. In fact, they jailed some of his actors on day one of shooting a pilot. His lead actresses were thrown into the Tijuana jail. Well, that wasn't a good situation. He was affiliated with a network and they even threw one of his network executives into jail. So, of course, they had to start paying bribes in a hurry, and they paid for several different bribes at several different times. This producer had complaints about numerous other problems with shooting in Mexico. He had complaints about this, warnings about that, but when it came to the end of the conversation I asked him, "Are you going to continue to shoot in Mexico?" He said, "Yeah." So I asked him, "Why, if you've had so many problems?" He said, "Well, in the long run it's still cheaper to shoot down there." One of the reasons I think it was cheaper for him is that even though he did have to deal with bribes and syndicates, he was able to avoid the high costs of American unions.

 The reason why it was cheaper and easier for me to shoot in the States was that I ended up not having to deal with the unions here. I wasn't sure I was going to be able to avoid all that. I knew

I was going to be able to avoid the electricians union and DGA, but I didn't know whether I'd be able to get around SAG. I did, and that made a huge difference.

My episodes are all set in Mexico, so it would have obviously been better to be able to shoot down there to get the authenticity of the area. But we ended up shooting quite a bit of interior stuff up here, and then some of our exteriors we shot guerrilla-style in Mexico.

Going back to this other producer. Another thing that caused difficulty for him was the pacing of the workers in Mexico. He said that you can find skilled workers who know what they're doing, but you have to be careful. I learned that too. My Baja UPM, because of our low budget, was trying to set us up with crew members who were pretty darned novice, and I wasn't that comfortable with their working style. He took me to a shoot staffed entirely with Mexican crew, and it was pretty much like a student operation.

Now, this other producer was able to find competent crews down there who know what they're doing, because a number of them have come off movies like *Titanic* and *Deep Blue Sea*. You can find them, but he said they would work more slowly, unless there was an American overseeing them. Basically, even though he had a number of Mexicans working for him in the various departments, like makeup, wardrobe, lighting, he would have to have someone overseeing each department from the United States. As long as there was an American keeping the department moving rapidly and efficiently, then the shoot would move. Just keep in mind that you will need to have extra people working as overseers. In general, if you think it's going to take x amount of time to do something, whatever it is: find a location, do casting, do paperwork, in reality you need to double the time. Even something as simple as going to the bank to get a deposit done will take longer in Mexico.

Recommendations

MD: What recommendations would you make to independent producers preparing to film in Mexico?

AP: High-budget projects are not going to have nearly as many problems because they have money to solve the situation, to help put out fires. But a low-budget project is going to have some problems. If you get too far into production and have already con-

tracted your hotels, built your sets, paid your actors, whatever, and then someone wants to twist your arm for anything, you're stuck. You can't just say, "Oh, we're going to pick up and go back to the States."

One of the most important things is that you must trust your local UPM completely, because he's responsible for everything. If it's not someone you trust, get out of there.

MD: Having gone through the experience of having to pull a project from filming in Mexico, would you return to Mexico on another project?

AP: At this point, I would not. I wish that there were some quick fix. You know, get the government people to get their stuff together and write out some kind of film-friendly manifesto for America and everything would be taken care of. But I don't think it's as easy as that. There's a different way of thinking down there, a different way that they do business in general. It won't change overnight. Whereas, it's easier to shoot in Canada because it's more like the way of thinking and doing business in the United States, there's just no quick fix to Mexico. I wish there was.

I would say, if you're on a limited budget, if you're going to shoot for maybe three days on the fly, you can get away with guerrilla filming in Mexico, if you're careful. But if you're going to shoot for three straight months, like we were planning, there's no way. If you're on a tight budget, I would recommend that you try to shoot in the States.

Chapter 15

Filming in Eastern Europe and Russia

Mr. Rubi Zack is an independent producer born in the Soviet Union. He studied filmmaking in Israel and New York and moved up the ranks from assistant director, to film editor, to UPM, to line producer on various films throughout Eastern Europe and Russia.

MD: Tell me about your film background in Russia.

RZ: Since 1994, I've worked in various capacities on five productions shot in Russia. It was very interesting for me because I've seen how the society has changed. Producing in that part of the world has its advantages and its dangers. They go hand in hand. However, I still think this is a very good place for independent producers, for low-budget productions.

The Film Community in the Former Soviet Union

MD: Even in Moscow?

RZ: When I'm talking about Russia, I'm not talking about Moscow. Moscow is a very expensive and complicated city in which to do productions. Nobody's going to save any money there. It's definitely not for low-budget production, unless maybe you want to shoot one or two scenes, and even that is going to be very expensive. Accommodations, logistics, the permits, everything

that's important is expensive. However, if you go to Ukraine, places like the Crimean by the Black Sea, places like western Ukraine, even Kiev, places in Russia but outside the main cities, you can find incredible locations very cheap. You can find local crews; however, you often have to bring key people from Moscow. In the former USSR, the best professional people worked there. We're talking about the gaffers, the camera crews, the costume designers. They were all part of MosFilm Studios, which still exists, but nobody today would want to go through there because you'll never get anywhere and it will be very expensive.

MD: If there is no central hub for outside production, what is the film community like?

RZ: Well, today you still find the big studios that were built during the Soviet era, and the biggest of them is MosFilm, the Gorky Studio, and some others. However, the studios as a production entity do not exist anymore. They still have not found a place as independent companies; they are still somehow connected to the government for funds. Basically, they rent their facilities to independent companies. From the Soviet era, they have this incredible real estate where you can find huge sets, but most of the people who were employed there are gone. If you go to Moscow, you will find immense sound stages, studios for special makeup and design, model-making and so on, but they are empty. There's not enough work. MosFilm used to produce eighty to a hundred pictures a year. Now they produce none as a studio.

The other part of the community is the independent producers, the new companies that came to life after the opening of the society. Producers from the West should look for partners or assistance in services from amongst those companies. Some are basically connected to the old power structure and are still connected to the studios or people who control the funding that goes into the movies. The Russian government still funds most of the films that are done now, so those contacts are very important to the local producers there.

Selecting a Local Production Company

MD: How do you find the right company to work with?

RZ: As anywhere in the world, it's extremely important who you deal with and how you find the right people. You cannot just go to

Russia or Ukraine and make a movie. You have to find a company to provide production services and so on. You call everybody who has made a film there in the past five years, ask who they worked with, get their numbers, try to speak with them. The right people you find by their credits, by talking to them, finding out what kind of a deal they will give you. Can they read the script? Most people there would not be able to read the script in English. They translate the script to Russian and give it to their people and, in most cases, you will get back a budget that has very general numbers.

MD: Can those numbers be trusted?

RZ: Sometimes those numbers are so low that you are tempted to do it, but you have to realize that those numbers may be impossibly low. That's where you get into trouble. You go to the shoot and, suddenly, the agreement is not an agreement. You get outdated equipment. You cannot shoot with the lights, which are flickering. Then if you want better stuff, you're going to have to pay for it. Everything is now two or three times more expensive than if you had done your pre-production work properly and hired the right people. Whatever you did not check in detail you will find screwed up. When you get a budget, you have to go line by line. This is my experience as a line producer and production manager. Get a detailed budget. Of course, sometimes you cannot give them the idea of what you need right down to the last detail. There's always surprises. Nobody knows exactly what they need, but you have to ask many detailed questions and make many detailed requests from the local company that you are going to work with. And you want a detailed response to every question and request. Money-wise, time-frame–wise, and so on. The producer has to read between the lines to determine where there might be trouble. It's better to solve them ahead of time.

MD: One concern of producers might be that there is no government agency to assist outside producers.

RZ: Russia does not have a film commission, but a film commission would be the last place you'd want to go if you were working in Russia or Ukraine or some other places for that matter. If an independent producer went to a Russian film commission, he would be referred to someone who would not save money or give the best value for the money. This is not due to malicious intent but because the film commission would work with the largest

company connected politically to the film commission. A commission would not know the really young, good producers who are active there. The structure is like this: there are companies in Russia who work only with foreigners, and these are good companies, reliable. They speak English and you can communicate, which is very important in that part of the world. Sometimes you get on a movie and nobody on the local crew speaks English. Every department would need a translator, and, of course, the energy and time you put into explaining what you want becomes a big mess. But there are Russian companies that have produced ten or twelve hours of British TV. There are companies who produced maybe a dozen low-budget American pictures. There are companies who have shot in the Ukraine for Showtime, and you would not get the name of those companies if you went through a film commission in Russia.

Saving Money

MD: What is one area of a budget that one can check to make sure the Russian company knows what they are doing?

RZ: Transportation is the one line where the producer can save the most if he does a small production. You can get a driver with a car for $20 a day. Sometimes, you have a major move and you need a lot of cars. The difference between the price in Russia for this and the price almost anywhere else is significant, maybe $100,000 difference, or more. This is $100,000 he can save or profit on this picture. I'm just talking about one line, but if you will not understand who is going to work, how many cars, what they are getting paid, whether the gas is going to come up . . . gas can be very expensive there. The price of gas can add $30,000 or $40,000 to the budget. If you want to make a picture for under a million dollars, you're talking about 4 percent of your budget right there.

MD: What is the rate per day for a cameraman or some of the other key positions?

RZ: It depends on the current state of production. If it's very slow and the economy is not so good, you can get a very good DP for somewhere between $1,500 and $2,500 per week. And we're talking about the level of craft that would cost significantly more in the U.S. Of course, you can find cheaper or more expensive. However, this is not the area where you actually save money. You

are going to go to Ukraine or Russia because you can get something that is significantly cheaper. You can make an action picture or a war picture or a period picture where you need an incredible amount of extras. This is where you save money. If you need soldiers, tanks, or a submarine. You can get a submarine for less than you would pay even in the Philippines. Of course, you, as an independent producer, would never get permission to use a submarine. That's why you need the local company. They know how to get it; they know their contacts. They will tell you the price and it's going to be very reasonable. Your picture is going to look very rich.

Now, if you want to use stunts, the crew of a very good stunt coordinator from MosFilm would cost you less than the crew almost anywhere else. They would not charge you per stunt or per fall. It's a global price. They come there and do what you want. Or, for instance, you look for some incredible locations. If you go to the Crimean, you can find the sea, three or four different kinds of forest, rocks, and mountains, all within a half-hour drive, and you can get it cheaply or for nothing. I was in a production there, shooting in the czar's palace where the Yalta Conference took place. We shot a love scene in the bedroom where the British prime minister slept. At the moment this is a state-controlled museum. You can get it for a very reasonable price, but you have to go through the people who have the contacts.

MD: What kind of film can a low-budget producer expect for a couple million?

RZ: The producer would probably want to bring a couple names from the U.S. He may bring a couple key people from the U.S. or Europe, and he can get everything else there. You can get four weeks of shooting, six days a week, twelve-hour days with no overtime. A low-budget action picture, excluding stock and lab, in below-the-line costs, is between $400,000 and $600,000. This would include decent equipment, but you have to make sure the locations are what you want, and you can't explode ten cars. You can maybe explode one or two. But you can get value.

Protecting Your Budget against Hidden Costs

MD: One concern that American producers are going to have is that they might be held up once they go into production. It used to be the KGB; now it's organized crime.

RZ: This matter is on everyone's mind. As an independent producer from the U.S., you don't want to deal with these people directly. Others call them organized crime; they call themselves businessmen. In the Ukraine, the local authorities are extremely friendly towards production, because they understand what business is. They understand that this is work for the local people, and they are extremely helpful. You are not going to come into a local town and ask, "Who is the big boss here?" This is the wrong approach. When you make a deal with the local producer, they know how to secure the production. You sign agreements. If you want to know exactly how things work, they know the power centers in every place. You personally don't want to talk to anyone on a local level, unless it is a mayor of the town or it's maybe a chief of police, but only if you go to dinner and are introduced by the local producer. You don't want to deal with any local businessman or organization.

MD: How much does an experienced production company include in the budget? Does it include bribes they may have to pay out?

RZ: It includes everything. This may not necessarily be a bribe, but maybe a commission of some sort. You can call it whatever you want. But this exists anywhere you want to shoot. This is part of making business, any business. If they have to get you a thousand soldiers for $5 per person per day, this is not going to cost you $5,000, but maybe $10,000. But it's still a soldier with his gear for $10 . . . very cheap. How they divide the $10,000 is not your concern. You know you get the value, and you don't mind as long as you get what you want.

MD: The production company will tell you this in advance so that there's no surprise, right?

RZ: There are no surprises. If it's a professional production company that has worked with foreigners before, they know how important word-of-mouth is. They want to continue working. They cannot screw you as a producer. When they give you the budget, everything is going to be included. And I am a witness. When they get bitten, they take a loss when unexpected problems arise.

Eastern Europe

MD: You also mentioned having worked in Eastern Europe.

RZ: I also worked in Budapest, and also I produced a picture in Israel, but we used postproduction studios in Hungary. And also I worked on a French production in Morocco.

MD: Tell me about Hungary.

RZ: Well, Hungary is much like working in a Western European country. They are very reliable, very good. They're not as cheap anymore. To go shoot in Budapest, for example, you go because you want your picture to look like Paris. Budapest is a beautiful city. The river passes right through the city, and you can call it the Seine. The architecture is very similar to Paris or Vienna or someplace like that. The crews are very professional and it's easy to work with them. They are easier to work with than crews from Russia or Ukraine, but the costs are significantly different.

You have to understand, there are some curious things that happen when you shoot in the Ukraine. The local producer spends more time and effort to have decent catering on the set than to have three helicopters land on the set, because there just are no catering services available. So in Hungary you would just call five catering companies and get decent meals the next day. In the Ukraine, they would have to set up the whole thing themselves. They would hire a few cooks, arrange a place to cook and to eat. You see? It's different, but they get it done.

Israel

MD: How was Israel for filming?

RZ: The problem with Israel is that the political instability cancelled more production than actually was completed, especially in the past few years. The big actors just don't want to go there, and you can understand them because you read in an American paper, A BOMB BLOWS UP IN TEL AVIV. Who in their right mind would want to go and shoot there?

Israel has very interesting locations, extremely professional crews on the same level as those in the U.S., the same kind of high-quality equipment. But the prices are not low anymore. They have their unions. The prices are pretty much like a nonunion production in the U.S. or in Europe. But if you want to shoot Iran or Lebanon, you don't go into Lebanon. You go to Jaffa or some villages that look like Lebanon.

Israel does have first-class accommodations, which is very

important. In the Ukraine, if you bring a big star, you really have to spend some time arranging accommodations: the hotel, the car, the meals. They just don't have the tourist infrastructure. If they have hotels, they are not five-star hotels like in America or Europe or Israel.

Morocco

MD: You also mentioned Morocco.

RZ: I personally love Morocco as a country. It's just the most beautiful country I think in the world. There is a production infrastructure, but the crews usually are brought in from France. They are very much tied into French production entities. Morocco is one of those places where if you want to shoot a good movie you need to know somebody who is a friend of the king; somebody who can introduce you to the people in the government or whoever, because that is how the government works. Everything is on a personal level.

MD: Whereas in Ukraine you don't want to go to those people. . . .

RZ: In Morocco you want to go and you have to go. If you can get an introduction to those people, everything is going to work as a clock because they only have to make one call and you get what you want. The local people are very pleasant, and this is why it is a wonderful place to work. The service is tremendous and the food is the best I've tasted anyplace in the world. Morocco is the one place where the synthesis of European and Oriental actually works. Of course, you have to speak French or work with French people because this is the common language. There are people who know English, but you really must know French in order to get around.

MD: What would be the center of the film industry there?

RZ: If you want to shoot an interesting port, or if you want to get an atmosphere of danger—someplace that is oriental yet a large city—then you go to Tangier. Casablanca is a business center. A lot of people who live in Casablanca actually work in film production. Of course, you can go to Fez. This is the most incredible city for views. And Marrakech. Everything in Marrakech, the whole city, the buildings, modern and old, everything is in the shade of ter-

racotta. The first time I saw Marrakech was from the direction of Casablanca at sunset, and suddenly the whole golden city looked like it was on fire because of the sun's reflection. Of course, you have the market, which comes to life in the afternoon with everything that you would expect from an oriental market: the snake charmers, sellers, etc.

I don't have to say too much about Morocco because so many movies have been shot there, like *Lawrence of Arabia*, *The Sheltering Skies*, and many other big movies. Of course, if you want to shoot a small movie it's different. You have to find the right people. It's not expensive, but you have to find your way around.

Speed of Production

MD: Lets talk about speed of production in those various countries.

RZ: In general, the American speed of independent production is probably the fastest in the world. A similar speed can be found in Israel because the people are very professional and know how to work quickly. It's going to be somewhat slower in Ukraine and Russia because you're working with local crews, and their experience is not for working fast, but slow. When you work with the local production companies, you will not be able to shoot thirty or forty setups a day, like on an American production. But if you work with people who are accustomed to working with foreign companies, they can work fast. The pre-production periods are significantly different. You can put together a small independent production in only three or four weeks here. Over there, they would take much longer. But that's okay because they know the time that they need. Still, the budget they give you will be six days a week, thirteen hours a day, all included, no overtime.

The other thing is that American directors often work with multiple cameras at the same time. It's very important to know how your director is going to shoot. Usually, a Russian production never works with more than one camera because they've never been in a hurry and they just never developed the techniques to work with multiple cameras. One of the problems I faced on one production was that the director liked to shoot low-angle, moving camera. In the States it's very simple. You go to any production house and get the equipment to mount low and shoot. But on this particular production the crew had never had the experience of having the camera so low all the time and moving it on a dolly, so at first they were spending hours every day just to mount the cam-

era. And, of course, it would fall or not be steady. This is the kind of detail the producer or line producer has to find out from the director and cinematographer, because if they need a high hat or some specific piece of gear, the Russians may not have it. They might come up with something similar that takes four hours every day to mount, and everybody else is sitting around and drinking tea. And that's why you need experienced people who work there, understand the production, and know the equipment. If you think there will be a problem, you go to the local producer and ask them what they have. In fact, you should go and see what they have. You go to the production houses. "What do you have? What is this piece of equipment? How is it mounted? How long does it take to get it mounted? Who is going to do it?" This is the distance to which you must go before production.

MD: Is it better, if you have a choice, to get a director from that country?

RZ: The choice of director cannot be made on the basis of whether he has shot in that country or not. A director from the U.S. is accustomed to independent production; he knows how to make a particular kind of picture. You as a producer want this, because you want a thriller or action picture. You want a visual style within your budget. You might get a great director from Russia for the same money or less who knows how to work with actors and direct Shakespeare, but he cannot shoot an action scene because he doesn't have that visual style. He doesn't have the dynamics needed for your picture. You choose the director for the picture and find out what he needs and wants.

A Horror Story

MD: Do you have any specific stories about producers who have gone to Russia and made big mistakes?

RZ: I forget the name of the picture, but there was an American production that went there a few years ago. They made a deal with a guy that I know. He's a good, decent guy, but he came to produce from being a stunt coordinator, so knew a great deal about how to set up stunts and action; however, he still didn't know what it means to be a producer. So there were some problems getting what he wanted: the payments, the money, the transfers, and all that kind of stuff. I won't go into too many details.

There were instances for Israel Pictures. I didn't work on that picture because I was on another production. And it was earlier, in '94 or '93, they went to shoot in Moscow. They got a local producer who gave them a budget, and when they came to Moscow everything changed. And it went so far that the Russian actress, who was signed for x amount of money; she would call the evening before she was supposed to show up on the set and say, "I want twice as much money." So this is a disaster story. They shot much less than they wanted there. They paid much more than they planned.

And this disaster happened for one reason only: the producer did not do his homework well enough. The producer hired the local producer through a cameraman who knew him before as a friend, so they found this local producer and he said, "Yeah, sure. I have experience. I made twenty pictures under MosFilm." But all these pictures were made when MosFilm was a Soviet studio, and when all this ended, he became like a hustler. He became a person who wanted to make a quick buck. So, it's very important to check a person's background, to know what they did before, to get a reference, and to work with people who have already been there. And also it's very important to get someone who understands production, who is on your side, and speaks your language.

Chapter 16

Independent Production Around the World: An Interview with Fred Weintraub

Fred Weintraub is an independent producer with more than thirty films to his credit. A graduate from Pennsylvania's Wharton School of Business, Mr. Weintraub began his career in entertainment as a personal manager, discovering and guiding the careers of new talent such as Woody Allen, Bill Cosby, Joan Rivers, Neil Diamond, The Four Seasons, and many others.

In the 1960s, Weintraub opened the legendary New York nightclub The Bitter End and hosted a weekly television series. Hired by Ted Ashley, Warner Bros. Chairman of the Board, Weintraub became the first Vice President in charge of Creative Services and served on the Board of Directors. His first project for the studio was the landmark film *Woodstock*. He went on to supervise a spate of successful movies including *Klute, Billy Jack,* and *The Summer of '42.* He was also instrumental in developing several popular television series, including *Kung Fu* and *The Dukes of Hazzard.*

In the early 1970s, Weintraub left the studio ranks for independent production. A few of the films he produced are: *Enter the Dragon,* starring Bruce Lee; *Tom Horn,* with Steve McQueen; *Rage,* starring George C. Scott and Martin Sheen; *Outlaw Blues,* with Peter Fonda and Susan St. James; and *High Road to China,* starring Tom Selleck.

In 1988, Weintraub produced two action films for Golden Harvest and the CBS telefilm *My Father My Son,* starring Karl Malden and Keith Carradine. He recently completed *Chips, the War Dog* for The Disney Channel; *The Best of Martial Arts Films* for CBS/Fox; *Show of Force* for Paramount Pictures, starring Robert Duvall, Amy Irving, Lou Diamond

Phillips, and Andy Garcia; *Born to Ride* for Warner Bros., starring John Stamos; and a television series *The New Adventures of Robin Hood.* During this time, Weintraub also taught a course at UCLA titled "The Role of the Full Line Producer."

Mr. Weintraub's extensive knowledge of worldwide production sets him apart as one of a small number of producers able to meet the challenges of tomorrow's film business.

Full Line Producing

MD: What does it mean to be a "Full Line Producer?"

FW: It means I get the money. I get the acts. I do the budgets, sometimes with or without help. I do everything. I'm an executive producer, a producer, a line producer. Everything necessary, and I feel that that's what a producer does. That's not true today as much as it used to be, because today everything's broken down into four hundred nonfunctioning executive producers and three hundred producers and six hundred agents and friends and all the rest. But that's what I do, and that's how I work. I feel if I'm responsible, I should be responsible. Good or bad.

MD: That makes you far more qualified than most to speak on the subject of filming in other countries. You're not just sending people to do the grunt work; you're dealing with the headaches yourself.

FW: Absolutely. I don't send people out anywhere without my knowing all the headaches beforehand. And usually the people I send out are very qualified. Basically, I'm pretty good about using the people in the locales. One of the key things I try to do is not bring a lot of people. I try to use the locals, and that's made me different than most producers who go overseas.

MD: Are you still bringing your key people?

FW: It depends upon the size of the picture. Sometimes you're bringing your cinematographer. Sometimes you're bringing your soundman, if you need him. Usually, in Europe for instance, the artwork and the costumes are unique and must be handled separately. You just can't paint a brush on it. Each country is different; each one has different incentives. Some of them, with all the incentives they give, are still more expensive than shooting in your backyard.

The Question of Trust

MD: You also have to believe that the country's offers are legitimate.

FW: I trust them more than the Americans in most cases.

MD: Really?

FW: Oh, sure. Much more. I would trust them more than going to Pittsburgh and depending upon a Pittsburgh supplier or a Miami supplier. I mean, they want the business as much as anybody else, and they want to earn the reputation. And I would say that when I make a deal with a foreign country, it's been to my benefit and to any completion bonder that I've never gone over, ever. Because I make a flat deal, and they keep to it, and they give you little extras. If you're straight with them, they're straight with you. If you take advantage and ask for an extra thousand extras, you've got to pay for it. But if you've made a deal and you detail everything, they really hold to it, and they're really good. Some countries are better than others. Some people who run studios overseas are better than others. Some people you can trust a little better than others, but you learn.

How Filming Overseas Can Make Sense

MD: Suppose you're going to a country that you've never been to before. What are you looking for?

FW: A uniqueness about it. Let's say that it's the dead of winter and I need an inexpensive country, and I want a place where I've never been before, like Albania. Let's say that the current situation there allows Americans to travel there, and you don't have to worry. Well, there's always a couple studios, old Russian studios, and a lot of them speak English. I would first want to find out, through my contacts, who they know there. And since I know a lot of people in Europe, they would refer me to somebody. I would start with that and either have them come here or I would go there to see them. I would most probably go there to see the facilities for myself.

At that point, I would see if I could shoot the picture that I have in hand and try to get a price on what they have, and look at what films they've done. Do everything possible. In some cases, when you start a new country, like I've done, they've got squat toi-

lets, terrible facilities. You've got to build things to the American sensibilities before you even start; otherwise, your American actor won't come. Or you train, like we've done in some countries. We've trained the local people who are sensational now, who run the studios and speak English perfectly.

MD: Is it easier for you to make changes and build sets in another country to accommodate the script, or is it easier the other way around?

FW: You usually change the script to fit the abilities of the country. A rock is a rock is a rock. If it's a television show and you're in pretty close, you don't have to worry too much about whether you're shooting the corner of the building or the whole building. When you get into a big feature film, you're in a whole different ball game. And, of course, with CGI now you can do almost anything you want. That's something new that has raised its head in the last seven to ten years, and I've used it extensively. But most of the films shot over there are movies-of-the-week or projects of that type. You're not getting the big $100-million films, except maybe in Australia with *The Matrix* or something of that nature.

MD: I'm assuming that most readers of this book won't have a budget of $100 million to work with.

FW: Your readers are people who want to make a movie, I assume, and the best way to make a movie, if they've got a limited budget, is to go overseas. They really can do better. It has a lot of advantages. For one, if you set a European company, you have a European company that can hire everybody. Once you hire everybody, you're into a different situation union-wise. A German guy, a French guy. You're not in a SAG situation. Residuals can be almost a third of your project in America and can destroy you, any kind of profits. That's something you don't get when you're overseas.

MD: Do you alter the contingency amounts on your films depending upon the country?

FW: No, the contingency amount is whatever the completion bond company wants, if they want it. Some people use 5 percent; some people use 10 percent.

MD: So basically you're leaving it to the completion bond company.

FW: Whatever their rules are, you use. The completion bond companies love to deal with people who have been around. Most of the people they get are brand new and scared shitless.

MD: I imagine you have no problem getting a bond.

FW: No, I just make a phone call. I know how to make a film in the price range. I mean, I wouldn't make a film if I couldn't make it within the price and come in on budget.

Be Prepared

MD: What advice would you give a first-time producer? We've heard all kinds of horror stories about people being taken advantage of. Is that really true, or is it the fact that the producer is not prepared?

FW: The producer doesn't know what he's doing. The producer should firstly hire somebody who knows what the heck he's doing. Or get advice from people. Lots of people will give you advice. First-time producers come to me and I tell them what to do and where to go and who to see and what kind of production guy who's been working overseas he might want to use to help him. And which guy is trustworthy depending on which country he's going to.

 The problem is they just don't know. This business has the most unknowing group of people trying to do the most unknown project. The guy walks in; he's got a script. "I'd like a million dollars for these eighty pages." You can't do that even in the supermarkets. It's crazy. And then they're all going to do $400 million, and they're not going to. Nobody does. There's so much unreality involved. The best thing to do is work for a lot of companies. Go around and see what's going on. Get any kind of job for no money. Just get in, if you want to get into the business. Or have a rich relative or a father who's a celebrity.

Each Culture Has Different Benefits and Problems

MD: Let's take a world tour of some of the countries where you've shot films. Have you been to Africa at all?

FW: No.

MD: Would you like to go there?

FW: Well, I've been to Africa myself. I've been on safaris and things like that, but no. I haven't been to Africa, and I've been tempted one or two times to shoot in South Africa. I would love to go there. The situation is a little bit unstable right now. That doesn't mean it will be. But some people are shooting there and finding it okay. They certainly have good crews, I gather. And they certainly have good people that you can talk to who go there. It is not the least expensive place to go, so there might not be a reason to go there unless you're doing a wild-animal picture. You could probably find, location-wise, anything else anywhere else. It's cheaper than in the States, but it's still not that great unless you get a deal from the government, or there are some production companies who give you money.

MD: How about Asia?

FW: I've shot a bunch of films in Hong Kong, and I've shot in Chiang Mai (Thailand), and I've shot in the Philippines. Then, mainly in Europe. I've shot nine films in Croatia (or Yugoslavia, in the old days), and I've shot fifty-two one-hour shows for Warner Brothers in Lithuania, and I've shot four or five films there.

MD: Anything in England?

FW: Oh yes, I shot in England. I forgot.

MD: Have you ever developed a region where filmmaking was not previously being done?

FW: You know, you sort of get a place like I started with Yugoslavia on a picture called *High Road to China*. The setting was all around the world and nobody could do it, and they finally came to me and they were in trouble. The director and I, a terrific director, Brian Hutton, took a two-week tour around Yugoslavia. I came back and did the budget so that we could create the world. It was an amazing tour we did, but I also learned everything about Yugoslavia. And so we shot there, and that was the first modern film, and it spawned the industry in Yugoslavia. It started everything off, because then they did *Winds of War*, you know the ABC thing, and a bunch of other films because they saw that it could be done there. They all used my same crew, the people I had trained and everything else.

MD: Efforts are being made to open up mainland China to filmmaking. Would you go there if you had the opportunity?

FW: I'd love to. Also, I have some people in Hong Kong who would go who are very good. If I had a project that was right for mainland China, I'd go in a minute.

MD: You like to go to new locations for your own experience.

FW: Yeah, I'm bored sometimes.

MD: Do you sometimes make a decision on a script because it involves a location you've never seen?

FW: No, I make a decision on a script based strictly upon where my wife wants to go shopping. If she hears there are some special deals in Hong Kong, boom!, we're going to Hong Kong. If she hears that China's got some special artifacts she can buy, we go there. My wife's a black belt of shopping. Also, she likes food, so there have to be good restaurants. So all those factors have to be taken into consideration. My wife determines where I go.

MD: Now, I'm sure you shot in Canada.

FW: Yes, I've shot in Canada. Some stuff.

MD: Do you ever find that you come across difficulties as a result of conflicting culture?

FW: Of course. Each culture has a different problem. Between the Canadian and the American, I think it's just a matter that there aren't enough good crews up in Canada. Some of the crews, I assume, must be better than the ones I've had, but I gather that there's so much work there that I doubt anybody can get all the good crews.

 The other answer about culture shock is absolutely true. If you shoot in Hong Kong, if the art director you use is Chinese, you can't yell at him if something goes wrong. He won't show up for a week. He'll lose face. See, you have to learn the culture. In Chiang Mai, if someone took their shoes off in the temple, they'd close us down. There are cultural problems in each place you go to that you should know about. You have to go in with the attitude that they do things differently, and we just have to adjust to the way they do it.

Dealing in France my first year was the most horrendous problem I've ever had in post-production. I mean, the French were just completely different for an action series than what I had in mind. They wanted to work a thirty-two-hour week. Their whole attitude about post-production was completely opposed to ours, so we really had some big fights. But by the fourth year, they had gotten so used to the way the Americans worked that they loved it, and they'd even come in on a Saturday and Sunday. I couldn't believe it. And they got so much more work because they saw how we function. It turned them around, and us around, and it became the most pleasant place to work, from being the worst to one of the best.

MD: What should a new producer be on guard against?

FW: I have heard horror stories from many, many places. And usually it's a problem with the American producer. He goes in without the money. He promises things he can't deliver. He doesn't pay the money, so they hold the film up. It's natural, you know. Then he complains to them, "What are you doing? I can't get my money!" It's all kinds of bullshit; you're supposed to put the money in first.

In some countries you have to—you're not supposed to—but you can't function in the Philippines without a little bit of vigorish. You know, spread it around a little bit. It's expected. In some countries, none of it. In Lithuania you don't do any of that. They wouldn't think of it. Lithuania, which comes from the Russian block, is really the most honorable and best place to deal with that I've come across.

MD: Is it still a good place to shoot?

FW: Sensational. The best studio, best everything. I've shot continuously there. And nobody's even heard of it.

Seek Knowledge, Speak the Truth

MD: What would be your closing piece of advice to a producer going to a foreign land?

FW: Speak to people who have shot there. Get as much knowledge as you can get. If you go to Czechoslovakia [the Czech Republic], there are some terrific production people there, and there are

some crooks. You want to know who is who before you start. But the same is also true if you go to North Carolina, or if you go to Texas, or anywhere. I don't want to limit to the idea that there are crooks overseas. There are plenty of crooks in America, maybe more. Find out your problems before you go anywhere.

MD: Do you think producers concentrate too much upon the positive things in a country, without due consideration of the negatives?

FW: No, I don't know how you can list good or bad. I think you should just have knowledge. If you know what you're doing, it's easy. I never worry when I start a picture in a country. If there's a problem, I walk over to the guy and say, "Hey, listen." I find that the easiest way to solve a problem is to tell the truth, because rumors spread so easily in the movie business. It's unbelievable. So just tell the truth. When you're in trouble, you're in trouble. If your actor's got a pain in the neck, and he's got trouble, you tell everybody that he's got trouble, and he's back to work before you know it. You don't sit around spreading, "He's got psychological trouble with his mother-in-law." This is not a business built that way, but then, of course, I've lasted longer than most. I'm a hundred and ninety years old, so it's easy for me.

DEVELOPING THE PROJECT

A few years ago I created a series of live networking events called Let's-Do-Lunch. These events, situated in Los Angeles, are still the best means for motivated writers and filmmakers to make contact with the specific categories of film-industry professionals most necessary to advancing their projects. The concept was simple: Bring people together for a luncheon and relationships can develop. Screenwriters could get to know literary agents, managers, development executives, and producers over the cultural groundbreaker of a meal. There's something about breaking bread with another person that helps open doors to a world of possibilities.

It was interesting, however, to discover how many people, given the opportunity, were totally unprepared for it. Many of the writers had not honed and crafted their work to anything resembling professional quality. It was even more amazing to discover that most had not prepared a short, crisp pitch of their screenplay's story. The development execs, agents, and the like attended these events with the hope that they would discover the next great screenplay. They wanted to be dazzled by a writer who knew every plot-point of his story, who knew every nuance of his three-dimensional characters, who could verbally describe them as clearly as though they were actual living human beings. Instead, they usually got cardboard characters who meandered through a vague maze of a story until they reached the plot's predictable end. It was actually embarrassing sometimes to watch the glazed looks on our honored guests' faces as they tried to make sense

out of amateurish rambling. I could only hope that the ill-prepared writers would learn a valuable lesson from their mistakes and do better next time.

There is nothing memorable about mediocrity. Average is immensely forgettable, while thoroughly prepared individuals, who know what they want and clearly present their ideas, always stand out in the crowd. In the film industry you seldom have more than one chance to "Wow!" somebody; therefore, you must treat every opportunity as though it were the only one.

So, what does this have to do with producing a film in another country? Nowhere and at no time does preparation become more important than when you, as an independent producer, are introducing your film project to a potential investor or a distributor or a bank or a bonding company. There are three elements essential in order for any of these people or entities to make a decision regarding your project: script, schedule and budget, and attachments. Putting these elements together is your responsibility. If you are tenacious, detailed, willing to take risks, and lucky enough to meet the right people at the right time, you can complete your project.

Understand that the following information is not meant to teach you "how" to produce. There are other very fine books available through Allworth Press that can show you exactly how to write a screenplay, break down a script, schedule and budget, find film financing, and the like. However, this section will give you an overview to prepare you for foreign production. This overview is necessary for readers who may be new to film production, but I'm confident that even experienced independent producers will benefit from insights they had not previously considered.

Chapter 17

The Script

The screenplay is definitely the most important element to the novice filmmaker. Perhaps there are other considerations more important to longtime producers with track records, but for most low-budget (or ultra-low-budget) producers, it all begins with the script. In a moment we will discuss a form of scriptwriting that will advance the possibility of your project being completed, but for the moment let's paint the canvas with some broad strokes.

Whether you are shopping for a screenplay or writing your own, you should give careful consideration to the kind of movie you are planning to produce before you purchase or start writing. You will often hear writers say that they do not take such matters into consideration because they don't want to place limitations on their creativity. This is not an opinion restricted only to unsold writers of spec scripts, but also to certain teachers of screenwriting and successful, working screenwriters. That's fine, I suppose, if you are only a writer, but you are also a producer and you have to train yourself to think like one.

I have to admit, being a writer myself, that there is a certain attraction to the above sentiment. One of the great things about screenwriting is that at any time you can put a piece of paper in your typewriter—or open a new page on your computer—and begin an adventure in storytelling that transcends time and space and genre. If today's story doesn't satisfy, start another tomorrow. How about a sci-fi western set in a galaxy far away in the distant future? You can do it. How about a murder mystery in a fourteenth-century monastery? Or maybe a present-day action story set in Eastern Europe. Or an epic set in the Roman

Empire. You can do it. You could spend three months, six months, or however long it takes for you to pump out your masterpiece from gestation to final copy, but then what? Somebody has to be willing to *buy* (or, in this case, *fund*) what you have written with the goal of producing a movie that will find distribution and make money.

How do these four script ideas fit into the demands of the market? That's a question every producer needs to ask himself. Is there a market for sci-fi westerns? Maybe. With the *Star Wars* craze came a plethora of copycats, both high- and low-budget. But that was then and this is now. You will not have the resources to produce anything on the scale of *Star Wars* or *Outland*. But other worlds can be created, even on a lower budget. Maybe the story could take place in a post-apocalyptic desert planet, or perhaps the interior of an underground city as was done in the movie *THX 1138*. There are plenty of unique locations in this world that would fit the bill, so let's say this story is worth pondering. But also consider the huge amount of similar low-budgets of this nature that are on the market. Is your time and energy worth the effort to produce another one?

How about the murder mystery set in the fourteenth-century monastery? That's a simple one to produce, right? You find an old monastery or something that could look like one, you rent a bunch of monks' robes, and you're halfway there, right? And besides, it's a unique idea, right? Wrong. *The Name of the Rose* was a great film that would fit this description, but can you name any others? Doubtful. The aforementioned movie did not come easily for its producers. It's not a simple task to convince people with money that they should invest it in a film of this nature. But it certainly helps if you get Sean Connery to star in it. Is this idea producible at a lower budget? Yes. Should you attempt it? Probably not.

How about the epic set in the Roman Empire? If you have written a complicated story with a cast of thousands and huge assault towers and elaborate costumes and sets, forget it. The success of *Gladiator* has certainly revived the genre, but epics are produced by studios, not by indie producers who need to scrape together every penny they can find. Now if it were a low-budget sword-and-sandal script, that would be a different story.

And finally, how about the present-day action story set in Eastern Europe? Well, at least we've found one story that makes sense. Present-day means not having to deal with period costumes and props. The action genre is alive and well, and it will remain so for the independent producer. And you can film in Eastern Europe for the right price. This may not be the favorite idea of the writer who always wanted to write a Roman epic, but it's the one that makes the most sense of the four ideas presented.

A Brief Aside: If you have written a sci-fi western, and you are convinced that it will sell, and your heart is set on making it (or any of the other ideas), then go for it. Any of these films can be produced for less money outside of the United States, but your heart and mind had better be set like stone. You had better love the script, and there had better be nothing else in this world that you want more than to get that script made into a movie. Filmmaking is a grueling task that can take years and years to accomplish. You owe it to yourself and all your supporters to set your sights on obtainable goals. You may do better to knock out a few realistic projects. Once you develop a track record and gain requisite experience, the money may come looking for you and you may be in a better position to fulfill your dreams.

What comprises a realistic, low-budget, independent screenplay? Here are some basics:

Selective Genre

There are certain genres of film that lend themselves more fully to low-budget filmmaking. Character-driven romantic comedies and dramas are two examples because they generally deal more with dialogue scenes than with action. A suspense-thriller can be made on a very low budget—all those scenes of the endangered female slowly walking through the house because she thought she heard something. And what about those low-budget horror flicks with the buckets of fake blood and prosthetic limbs? Cheap. And, of course, there's the espionage thriller, the detective action flick, and the low-budget road picture.

On the other hand, avoid special effects–dominated stories, most period dramas requiring elaborate costumes and sets, recreations of D-Day, and any story that involves doing anything that *has never been done before.* Am I saying "Don't do anything original"? No. I'm saying that doing something that has never been done before on film (if there is such a thing) will probably cost a lot of money. As an independent producer, you are better off finding a new way to express something that has been done before. This is much easier to estimate in a budget.

The "Look" of the Film

This ties in with the choice of genre, yet it is an important aspect that is often overlooked by novice producers. The standard for motion pictures is obviously 35 mm film, but there are other options. Some fine films have been shot on 16mm and bumped up to 35mm. Perhaps your

film will actually benefit from a more grainy look or from being shot in black and white. And now, with the swift advancement of digital video and the ability to process it with a *film look,* or the new digital P24 process that shoots video at the same 24 frames per second as film (regular video tapes at 30 frames), we are seeing more productions shot entirely on video and bumped to film later.

The choice of look will also affect other areas of your budget. It may save you money on personnel and/or equipment costs—lighting for example. If you want a more realistic look to the film, you may opt for a 16mm shoot with a smaller lighting package and a smaller crew that is more mobile.

Another option is to spend more money on the opening sequences of the film, and less on later scenes. Audiences tend to make judgments on the quality of a film within the first few minutes (or even seconds). After they have made this judgment and get caught up by the story, they are less likely to notice a change in the look. And, if they do, they are more forgiving.

Daytime Shooting

Write the script in such a way that it limits shooting exteriors at night. Night shooting costs about 60 percent more than shooting in daylight. The crew works more slowly and may cost more due to pay differentials, lighting and camera requirements are greater, and film-processing fees are higher. Night interiors are not a problem. They can be shot on a stage or windows can be blacked out.

Small Cast

The more actors you have, the more the film will cost. You need to feed these people, house them, pay per diem, provide transportation, pay them for their acting services, and the list goes on. Obviously, we are not considering the higher price you would pay for a name actor, and his or her personal trainer, hairdresser, makeup artists, chef, bodyguards, etc. A film with only six performers, let's say Tom Hanks, Meg Ryan, Sylvester Stallone, Jim Carrey, Sandra Bullock, and Robert Redford, would cost much more than a film with a cast of 100 starring a few *familiar* names.

As best you can, limit the number of roles in your story/script that would need to be played by actors from the States. A male and/or female caught in a desperate situation in a foreign land is a scenario that works. Fill these roles with actors who are *draw* names for the inde-

pendent market. You will have to do research to discover who these names are. You can fill the remainder of the cast with local actors at a fraction of the cost. You might even find expatriate American actors living in the country of production. Check with your in-country casting director.

Or you may hire a name from another region of the world who would not only cost you less than an American actor but would also be beneficial for marketing purposes. For instance, there are a number of European actors who are big draws in Europe but are relatively unknown elsewhere. These actors can often be persuaded to take a supporting role at a lesser price in order to make themselves familiar to an American audience. At the same time, you have made your film more attractive for worldwide distribution, especially in Europe. And what if you arc able to hire a few more draws from other regions of the world? Enough said.

Now keep in mind that the above information pertains primarily to key roles. It may well be that you can hire local actors for dirt cheap. If you have anticipated this in advance, knowing where you want to shoot, and how little it will cost for a hundred bit roles and day players, then fine. Keep the battle scene with two thousand soldiers. Remember that we are discussing generalities.

Ask yourself these questions constantly as you evaluate your script: Can I eliminate unnecessary roles? (Do I really need three nurses talking in this scene, or can I just have the doctor speak?) Can I consolidate roles? (I do want the three nurses in the scene, but maybe only one nurse responds to the doctor.)

Fewer Locations

That makes sense, doesn't it? The more times you have to move cast and crew, the more time it will take and the more money you will spend. This is not to say that you should shoot your entire film in an apartment. If that were all you wanted to do, you might as well shoot it in Los Angeles or New York City or any American city.

But you should be asking yourself questions like the following during the script's development: Can I eliminate this scene? (You know, if I just open the next scene with my hero in a hospital bed with his leg wrapped in bandages, we'll know he had an operation, and I won't need a doctor and nurses.) Can I eliminate locations? (Better yet, if I skip ahead two weeks to my hero's apartment, which I've already established, and his leg is bandaged and he needs to walk on a cane and he's screaming at someone over the phone about the hospital charges, then we know he had an operation, and I don't have to shoot the interior of

a hospital at all.) Can I double up on locations? (Maybe we can use our hero's apartment as a doctor's office by moving the furniture around and renting some office furniture.) Can I shoot a scene in a previously scheduled location rather than moving to another? (You know, this dialogue scene will work just as well if we shoot it in our hero's apartment rather than shooting it on the roof of the airport.)

Fewer locations means that you find ways to limit the moves without hurting the story, but it also means being selective about the locations that you do choose. In an exotic locale you will want to exploit the look and culture to their fullest within the scene or sequence. You should always be looking for metaphors within a location, something visual that highlights or makes its own statement about your story or characters.

Fewer Pages

A screenplay page in proper format is approximately one minute of screen time. This may change according to how much dialogue there is in the script versus how much narrative action there is in the script. Dialogue scenes are generally slower; narrative scenes run faster. But we can assume that a 120-page script will run approximately two hours on film. Now here's the secret to saving 25 percent on your project's budget. Are you ready? Write a 90-page screenplay instead of 120 pages. Make a 90-minute movie instead of one that runs two hours. Believe me, an audience can love a good 90-minute movie just as much as a good two-hour film. And you only want to make a good film, right? Distributors and exhibitors will also love you because a 90-minute film can be shown more times in an evening than a two-hour film. More showings means a larger potential audience and more box office receipts.

The Dialogue Issue

Logic would dictate that money could be saved by writing more dialogue and less action. For instance, you could write a script like *My Dinner with André,* in which the two lead characters converse over dinner at a restaurant throughout the entire film. That means one location, one basic lighting setup, and longer takes with well-rehearsed actors. The danger of this approach, of course, is that you may end up with talking heads that bore your audience to death. The fact is that depending upon the type of film you are creating, you can actually save money by writing a script with less dialogue. To understand this concept, you need look no further than the silent era of films.

Silent films are a great study for the independent filmmaker. We see in them the evolution of motion pictures as a visual medium. It was the perfect synthesis between the writer of visual actions and the fulfillment of those actions by the director and actors who conveyed their meaning through physical movement and facial expressions. Silent pictures could often be cranked out in two to six days of production because nobody needed to be concerned about words. In fact, dialogue was only used when absolutely necessary because it was an *interruption* of the flow of the story. The story had to be interrupted in order for the audience to read what was being spoken.

Now here is the value to writing less dialogue in modern independent films. Many takes are unusable due to blown dialogue, so if you write a script where physical action and expression convey the meaning of the story and move it forward, you may be able to reduce your shooting ratio. Some ultra-low-budget producers have found it even better to shoot everything MOS (without sound), and then record sound separately to be synced in post-production. This allows them to get a clean take even if there is a sudden loud background noise, like a jet flying over.

Working in Reverse

I mentioned earlier that I would show you a way of writing your script that will save you money and make it more possible for you to produce your film. Well, here it is, and it applies whether you are making your film in another country or at home.

Most of us have a linear way of thinking. By that I mean we view filmmaking as a process that evolves from step A through Z without variation from the norm. Almost any book you find on the subject (even mine) will teach these steps in that order because it's the most logical way of doing things and because it's the most common way of doing things. First you get an idea, then you write or buy a script, then (if you are the producer) you break down the script into schedule and budget, then you go for the money and actors, and then find a distributor, *et cetera.* But the truth is that there is no *one way* of producing a film. In fact, you do not have to have an idea or a script to get started.

Let's look at studios for a moment. They don't start with an idea or a script; they start with the money. "We have $480 million to spend this year. We want to spend $40 million on development and $440 million on production of a slate of twelve films." These numbers are totally fictitious of course, but you get the point. They have the money and other resources first, then they find the material that fits their slate.

The first-time filmmaker is very unlikely to have all the money and

resources first, but it certainly can happen. Maybe you have a rich mil-
lionaire uncle who hands you a couple mil to do your film. (We should
all be so lucky.) But usually this is not the case and, therefore, the new
wannabe producer (we'll call him Joe) is going to start with the one
thing he can get his hands on: a script. He may even write it himself
from his own idea. And that's why there are 148,269 men and women
in Los Angeles who are calling themselves film producers, yet they have
no film to show for it. They have a script or an idea. Maybe they even
have a schedule and budget. All they need now is the money, which for
Joe has been difficult to come by because his job as a singing waiter in
a Hollywood restaurant barely covers his living expenses. If he scrapes
every penny together that he has, calls in every IOU, sells his car, maxes
out his credit cards, and takes Aunt Flo up on her offer to invest
$30,000 in his film, he has a grand total of $54,000, and he's still short
by $14 million because that's what the script he has written will require
in order to get made. Can he get his film made? Anything is possible in
Hollywood, but the odds are heavily against him.

Now let's change our production plan. Instead of starting with a
script, let's start with a trip. Joe takes $2,000 of his savings. He uses part
of that money to buy an economy class, no-frills roundtrip fare to the
Philippines or Thailand. He spends a month or more there getting to
know as many people in the local film business as he possibly can,
including the referrals he has gathered before coming. He makes some
great contacts and shares his dream to make an ultra-low-budget film.
Someone agrees to share his dream because he has about $50,000 to
spend, but what kind of film should he make?

Here's the big distinction. Joe's questions have totally changed.
When he had his first script, he had to ask questions that pertained
exclusively to that script. It would have required twelve weeks of shoot-
ing. He absolutely would have needed certain equipment. He had to
find locations that matched the descriptions, and he would have had
to add these location costs into his budget. But now Joe is not saddled
to a script, so his questions change. He doesn't ask himself, "How many
weeks will this story require for filming?" He asks, "How many weeks
can I film with this amount of money?" Instead of asking, "How much
will this special equipment cost to rent?" he asks, "What equipment can
I get for free?" Instead of asking, "How much will it cost to shoot at the
Eiffel Tower for a week?" he asks, "Where can I shoot free of charge?"
Instead of having to ask, "How much will Ms. Superstar charge if she
agrees to be in my film?" Joe can ask, "Which actors do I know that will
act in my project if I write roles with them in mind?"

Does this sound like one of those old movies with Mickey Rooney
and Judy Garland where they borrow a barn and put on a show? Sure it

does. So what's wrong with that? After a month on location, Joe has discovered that he can get free use of a deserted military base for seven days with a Hum-V and a Jeep thrown in, jungle settings on government land, a private airstrip and an airplane (as long as the owner gets to be in the film), and a fishing village will let them shoot there if Joe will pay the $300 it costs to dig a new well. Joe's local production contacts have assured him that they can furnish a small crew for about $10,000 a week. You have the use of a recognizable American actor for three days of shooting if you will pay his first-class airfare, union scale, and accommodations for a week. (You'll see how this can happen when we discuss attachments.) Perhaps you are able to purchase short-ends and other film at a discount in the States and bring it with you.

Great! Now what? Now you create a story based around what you have. Your best guess is that you will be able to shoot for three weeks maximum. That's eighteen shooting days, averaging five pages per day. Your script will employ about six days of shooting on a military base, with other locations in the jungle, at a fishing village, and a private airport. Your script will have at least one shot of an airplane and you will probably write a scene or two interior of the plane. You will be able to do explosions in the film, but only at the military base. Your script will involve the available actor for three days of shooting. You will want these to be dialogue scenes on a stage if possible, but maybe you also can use him for at least one exterior location shot. You can write the Hum-V and the Jeep into scenes, but you cannot do damage to them. The available locations and equipment helped you decide that the script will be a low-budget, present-day action piece, which will lend itself nicely to filming on 16mm film. And you can get the camera package for free if you hire a particular local cinematographer.

Too difficult, you say? Too restrictive? Is your creativity being compromised? Not at all. Every masterpiece painting is restricted by the limitations of the canvas. Limitations do not compromise art; they force the artist to be more creative with the space available. In like manner, the filmmaker must rise to the occasion. Limited resources force more creativity and it all starts when writing the script. Savvy independent producers are getting their films made today utilizing this process.

I know a writer who makes a very good living writing scripts in this manner. One day he'll get a phone call and the producer will tell him, "I need a psychological thriller in four weeks. You can use a ranch in the Mojave Desert as the main location, but I can shoot at a courthouse for one day, and I have the use of actor Robert Duvall for two days." This writer will then go to the locations for research. Maybe he'll discover that the ranch has a large greenhouse that would work great for some scenes. Maybe the hayloft in the barn sparks an idea. Maybe

there's a wine cellar in the ranch house that can be used as a different location entirely. A lawyer's office? Robert Duvall could be written into a courtroom scene and a scene at his office. And so the process goes.

A final schedule and budget are invariably a compromise between what you would like to see on film and what you can afford. You may find that the quality of the production will be enhanced if you make the major compromises during the writing of your script. Then you can do your best with what you have written, rather than diluting the story later or cheating on production quality.

Chapter 18

Scheduling and Budgeting

An acquaintance once asked me, "Wouldn't it be wonderful if we could make films without ever having to spend a penny?" My answer was an unequivocal "No!" Today, almost every American family has a video camera of some sort. These cameras are not free, but they are affordable. The tape is not free, but it's cheap. You would think that with millions of people owning video cameras there would be a huge number of wonderful video features out there worth paying money to see, yet such is not the case. Aside from the funny bloopers and blunders that people have captured by accident, and the disasters caught on tape that have spawned a variety of reality TV shows, there are precious few homemade videos that can hold one's interest, and the reason is easy to understand. If you are not constrained by the limitations of time and money and the high expectations of a paying audience, you are not constrained at all.

I've experienced this reality firsthand. I took a video camera on a recent trip with the intention of shooting only the highlights. I thought I'd done a pretty good job, until I watched the tape. So many things that seemed fascinating at the time turned out to be tediously boring later. Good filmmaking requires restraints. Restraints in time and money force the producer to be more creative and more intimately involved in every aspect of the production from start to finish.

Now this is not to say that if you have an unlimited budget your film will necessarily be of inferior quality. The box office success of the movie *Titanic* proved that the expensive, detailed re-creation of the ship paid off. But for every *Titanic*, there is a *Heaven's Gate* or an *Ishtar* to con-

sider. You can't always solve the problem of a film by throwing money at it, yet the tendency, when you have lots of money, is to attempt just that. Rather than searching for the underlying source of the problem and curing it, producers buy an expensive bandage to cover the wound and hope nobody notices.

The independent producer cannot afford such waste. Problems have to be anticipated in advance. The solutions have to be worked out before the camera rolls. And the fact that time and finances are limited forces the producer to solve the problems more creatively, oftentimes through changes in the story or script; sometimes through creative use of materials and personnel.

It's a blessing that filmmaking costs so much money. It raises the stakes. We may find this frightening, but it forces us to become intimate with the script, the schedule, and budget so that everything is as exact as it can be. And, when it finally all comes together, that's the masterpiece.

I mentioned earlier that the schedule and budget are required in order for a bank, bonding company, distributor, investor, etc., to make a judgment on whether or not to get behind your film project. These people will make judgments based upon the package that the producer brings to the table, but they will first make a judgment about you. Are you a serious filmmaker or are you a wishful thinker? If the schedule/budget has been well thought out, they will recognize it immediately. If it's a piece of garbage, they will likewise recognize it immediately. Then they will make a judgment regarding the project itself: whether the story and script are strong enough, whether there is a market for the material, whether the attached people can pull it off, and at what price.

You may be surprised to learn that some projects are rejected because the budget is too low. That's right, too low. Maybe the producer comes in with a project budgeted at $2 million, but buyers at the film markets are suspicious of any film under $3.5 million, so the distributor may insist that the budget be increased or they will not back the unmade film. Another strange reality is that sophisticated investors prefer to put their money into a higher-budget film. They know that it is more difficult for an ultra-low-budget film to be taken seriously by the distributors, the buyers, and the audience. But don't let that overly influence how you budget your film. You must schedule and budget according to what you have; if you have $5 million to work with, then lucky you. There's plenty that you can do with that amount of money. If you only have half a million dollars, then lucky you, but you'd better not have a script that costs $20 million, or you've got substantial difficulties ahead. And what if you have no money? Then work in reverse, as was explained earlier, and find a way to shoot a micro-budget film that looks like a $3-million movie.

The following materials in this chapter are meant to help you better understand the differences associated with local versus foreign production costs. First, you have a three-page film sequence in standard script format. Then we'll look at a budget for Thailand and compare it to costs in the United States.

There are a myriad of criteria that lead to judgment calls during scheduling, any one of which could drastically change the budget, so we are avoiding this confusion by making our sample scene a one-day shoot. Other fine books can teach you how to break down and schedule a script, and, fortunately, the process does not change from country to country. You will break down the script scene by scene; you will create a strip board, and you will rearrange that strip board until you reach the final shooting schedule.

A Sample Budget for Shooting in Thailand

You will notice perhaps that the sample script sequence is written in a combination of *shot-by-shot* and *master-scene* techniques. Normally, you would stick with one or the other, but this was done to clarify certain decisions that were made in the budget. You will also probably note that there's nothing terribly original about the sequence itself. This was intentional. The material has to be similar to something you have seen before so that you can visualize the quality we are going after. In this case, we are going for an airport sequence of similar quality and intensity as that found in the film *Midnight Express.* If you have never seen this film, you may wish to rent it on video.

Our sequence is the opening of the film. The film is originating in another country, but this one sequence is to be shot in the country for which it is budgeted. In other words, the sequence may be filmed at Bangkok's international airport, but the rest of the film is being shot in the United States. Or the sequence may be budgeted to shoot at Los Angeles International for a French film. Or the sequence is shooting in Vancouver, B.C., for a film originating from Germany. This was done so that the sequence stands apart from other scheduling and budgeting considerations. And now . . . "The Generic Airport Scene."

FADE IN:

EXT. INTERNATIONAL AIRPORT TERMINAL, (NAME OF CITY) - ESTABLISHING - DAY

HIGH CRANE SHOT of a passenger jet coming in for a landing. PAN DOWN on heavy traffic (buses, taxis, and other vehicles), which causes a

jam as travelers unload themselves and their luggage. The name _____ INTERNATIONAL AIRPORT appears on the sign above the terminal as

STREET LEVEL

A taxi vacates a spot and another darts into the space, nearly running over a PEDESTRIAN who angrily yells something in the local language before moving away.

JASON CAUL, a 23-year-old college grad dressed in baggy clothes, more like a leftover hippie from the 1960s, jumps from the back seat and drags out his loaded backpack. He quickly stuffs some money into the out-stretched hand of the DRIVER and rushes into the terminal. CAMERA FOLLOWS.

INT. AIRPORT TERMINAL - DAY

Jason sets down his backpack at the ticket counter line for _____ Airlines. ANNOUNCEMENTS for departing and arriving flights come over the speaker system in a foreign language. He checks his watch, looks around.

JASON'S POV

Amidst the passing travelers he sees short vignettes of other people's lives, but his view is different than reality. DISTORTED TUNNEL VISION, DISTORTED HOLLOW SOUND:

FIVE JAPANESE TOURISTS laugh amongst themselves as one passes around recently developed photos.

A LITTLE GIRL OF FOUR YEARS cries. Her FATHER picks her up into his arms. CAMERA PANS to REVEAL

A UNIFORMED SECURITY OFFICER staring at CAMERA, watching

(END TUNNEL-VISION EFFECT)

JASON - CLOSE
sweating hard.

 AIRLINE EMPLOYEE (O.S.)
 Next please.

Jason breathes heavily. His heart BEATS LOUDLY.

JASON'S POV

Still in DISTORTED TUNNEL VISION. The uniformed officer turns away and speaks into his mobile radio unit.

> AIRLINE EMPLOYEE (O.S.)
> (distorted, more insistently)
> Sir.

(END TUNNEL-VISION EFFECT)

WITH JASON

startled into awareness, He turns to find that the AIRLINE EMPLOYEE is waiting to check his ticket. He loads his backpack onto the scale and hands his ticket to the employee.

> AIRLINE EMPLOYEE
> Only one carry-on?

> JASON
> Yes.

The Employee concentrates on her work.

Jason slowly looks again for the Uniformed Security Officer.

The Officer is gone.

INT. AIRPORT, SECURITY STATION - DAY

Jason's eyes scan nervously as he approaches the baggage and metal detector. The TWO STATION SECURITY OFFICERS are backed up by two SECONDARY OFFICERS waiting nearby.

Jason places his carry-on bag onto the conveyor that passes it through the x-ray machine. He observes its movement as he puts his watch and some change into a basket and walks through the metal detector without incident.

We see the carry-on pack move into the x-ray monitor. Something looks like a gun inside the bag. The STATION SECURITY OFFICER calls over one of the SECONDARY OFFICERS.

Jason wipes the sweat from his upper lip as the Secondary Officer pulls the bag to an inspection table and opens it. But he's more interested in studying Jason's reactions than the bag.

He pulls out a small hair dryer.

Jason forces a smile and shrugs.

The Secondary Officer replaces the hair dryer and closes the bag. Jason tries to take it and leave, but the officer doesn't let go.

 SECONDARY OFFICER #1
 Please unbutton the front of your shirt, sir.

 JASON
 I'm late for my flight.

The other security officer steps closer. Jason considers the situation a moment, then unbuttons his shirt. Nothing appears to be hidden under the front, but the Officer reaches behind Jason's back.

Jason instinctively pulls away, but the Officer yells something to his partner in his native language. They pounce on him, throwing him forcibly onto the floor.

 JASON
 Ahh! Damn-it!

One officer pulls his handgun out and points it at Jason's head, while the other pulls up the back of his shirt to reveal plastic bags of heroin taped to his back in the crevice of his spine.

Bedlam. More screaming as officers converge on the scene.

We can read the anguish on Jason's face. It's more than the physical discomfort of the moment. He knows that the rest of his life has just changed for the worse.

CUT TO:

Okay, we've got the idea. Now let's set the location as Bangkok International Airport. The producer is only bringing one actor (Jason) and a Director. Everyone else is to be hired in Thailand through a local

production company. Unfortunately, a one-day shoot requires about as much pre-production time as a one-week shoot.

THAI PRODUCTION CREW

In the budget sheet that covers the Thai Production Crew you will find some persons hired for only one day, such as the sound crew, while others will be on the payroll for two weeks, such as the Location Manager. Most of the other key personnel will be on payroll from seven to ten days. The entire crew will consist of about fifty individuals. This number could be reduced by a few, but the extra hands, especially amongst the lighting and grip crews, pays off in quicker setups and increased efficiency.

Now let's talk a little bit about the number of days per crew member. The schedule is broken down into prep days, shoot days, and wrap days. The easy one to calculate is the shoot days: one day for everybody. There will be less continuity in this category as the number of production days increases. Some days might require extra help or special riggers, a second unit, stunt coordinator, animal wranglers, *et cetera*. In fact, the number of crew members needed on particular days could be one of the criteria for how you schedule the shoot.

The number of pre-production days is a little more difficult to calculate, so you will need the assistance of someone reliable to give you accurate information for your foreign filming location. Every country has different hoops that need to be jumped through, and they all require time. It stands to reason that the person on the payroll the longest is the location manager. First, the director and producer need to give detailed explanations of what they want for a location. Screenplay scene descriptions and storyboards are also helpful. Armed with this information, the location manager must scout appropriate locations (assuming there is not a separate person handling this responsibility), take photos, and complete location surveys that thoroughly describe the locations. These surveys will include information on the availability of parking; environmental factors like status of neighbors and noise; availability of restrooms, telephones, electric power, nearby restaurants; need for permits, security officers; cost to rent the location from the owner; and a host of other details. Our script calls for Bangkok's International Airport, but maybe there is a smaller airport available that could more cheaply and easily be made to look right for the sequence. All possibilities should be explored. Then, once the director and producer agree to the locations, all the paperwork needs to be handled, contracts need to be signed, and permissions granted. Our sample budget allows ten days of pre-production for the location manager. Visits to the airport will have to be made, but we might want

Thailand Production Crew

		shoot	pre.	wrap	days	rate	amount
Production	Production supervisor	1	7	2	10	190	1,900
	Production manager	1	7	2	10	160	1,600
	Production coordinator	1	7	2	10	135	1,350
	Production secretary	1	6	2	9	65	585
	Accountant	1	6	2	9	65	585
	Office P.A.	1	6	2	9	65	585
	Runner	1	4	0	5	45	225
Location	Location manager	1	10	2	13	95	1,235
	Location assistant	1	5	2	8	55	440
Asst. directors	First AD	1	7	1	9	135	1,215
	Second AD	1	5	1	7	65	455
	Set PA #1 (2nd 2ndAD)	1	1	1	3	65	195
	Script supervisor	1	1	1	3	80	240
Casting	Casting director	1	7	0	8	80	640
	Extras coordinator	1	5	0	6	55	330
Art department	Art director	1	6	2	9	135	1,215
	Set dresser	1	4	2	7	85	595
	Set dresser assistant	1	4	2	7	45	315
	Props master	1	6	2	9	95	855
	Props assistant	1	4	2	7	55	385
	Sign writer	1	4	0	5	40	200
Wardrobe	Wardrobe supervisor	1	5	1	7	80	560
	Wardrobe assistant	1	5	1	7	55	385
	Laundress and seamstress	1	4	1	6	30	180
Makeup and hair	Makeup and hair artist	1	1	0	2	85	170
	Asst. makeup and hair	1	1	0	2	65	130
Transportation	Transportation captain	1	5	1	7	65	455
	Drivers x 12	1	1	0	24	30	720
Craft services	Craft service person	1	0	1	2	40	80
	Craft service asst.	1	0	1	2	30	60
Film courier	Courier	1	1	0	2	45	90
Camera	Director of photography	1	5	1	7	465	3,255
	Steadicam operator	1	0	0	1	370	370
	Focus puller	1	1	0	2	85	170
	Loader and clapper	1	1	0	2	65	130
	Video assist pperator	1	0	0	1	35	35
Lighting	Gaffer	1	2	0	3	85	255
	Head electrician	1	1	0	2	50	100
	Electricians x 2	1	1	0	4	30	120
	Driver electrician x 2	1	1	0	4	30	120
	Generator operator	1	1	0	2	30	60
Grip	Key grip	1	2	0	3	85	255
	Crane grips x 2	1	0	0	2	30	60
	Grips x 2	1	1	0	4	30	120
Sound	Sound mixer	1	0	0	1	165	165
	Boom	1	0	0	1	85	85
						TOTAL	23,275

to question the need for this much prep time on a one-day, one-location shoot. Some productions save money by having the production manager or another member of the office staff handle most of the paperwork once the locations are selected. But in this case, we are allowing the additional time for the location manager. People don't like to get promises from one person and then have to deal with another, and an international airport means you have several offices to deal with, including the military.

The production office is the hub of the wheel that moves this production forward. It stands to reason that it should be open for a week. There will be a number of activities taking place at one time. The production supervisor will oversee all Thai government requirements and permits. These are not as extensive as they might appear, although they are necessary. They include script translation into the Thai language (forty copies delivered to the Thai Film Board), government-censor approval, completion of Film Board permission forms, completion of all location permits, preparation of all necessary work permits for foreign crew, and coordination with the local customs liaison. Likewise, the casting director will be busy selecting actors to fill the two acting roles, and there will also be premiered (or featured) extras to select, such as the father-and-daughter combo and the five Japanese tourists. This can sometimes take a few days to complete. Meanwhile, department heads are having meetings to determine their needs.

With five days left, things really start moving. The director and producer do a walk-through of the location with the Director of Photography, Art Director, Production Supervisor, and whoever else is deemed necessary to be present. There are seventy-five extras to hire. The art department needs to create signs for the airport and a fictitious airline. The DP wants to discuss the kind of lenses that will be used to create the *tunnel-vision* effect, the changing of fluorescent lights in the ceiling, and how best to film the x-ray monitor. The Transportation Coordinator not only has to arrange for the crew trucks and vans, but also for ten taxis, fifteen cars, and three buses, parking, and access. Wardrobe needs to be selected and rented or purchased. There are many decisions to be made. Unanticipated problems will probably arise, but you still have a few days' cushion.

Okay, we can understand why department heads need to come in early, but why do the camera crew, the electricians, the makeup and hair people, and the film courier need a pre-production day? Don't they just show up on the set? No. The camera crew and electricians have to select and load the equipment for the day of shooting, but in addition to this we are allowing a setup day to check lighting in the terminal. The makeup and hair departments have a number of people

to prepare for: actors, featured extras, and the star. A makeup test with the lead actor is always a wise precaution. What would happen if the star's face were to swell and get an itchy rash on the shoot day due to an allergic reaction to the makeup? Sound absurd? It has happened. And then, just as there are tests for makeup and fittings for wardrobe, it is another wise precaution to test film and camera with the proposed lighting before the big day.

And how about the wrap days? This isn't difficult to understand; the production office will need time to wrap things up. There is paperwork to complete, money to pay out. There are vehicles and props to be returned to vendors. Wardrobe has to be cleaned and returned to its source. The location has to be restored to the condition it was in when the crew arrived. You can't do these things by yourself. Don't even try.

Now let's see how the rest of the budget breaks down.

EQUIPMENT

The first budget category to consider is lighting equipment. We don't need a huge package, but we don't want to be caught short either. Your cinematographer will give you a list of what he feels is needed. You, as producer, will then question everything he requests. Our budget shows the equipment estimate at $3,062. The following attachment will clarify what this money is acquiring for us. We need specifics here so that we can compare against the costs in the United States. As you can see, the estimate is made in Thai baht and then converted to U.S. currency at a rate of forty-three baht to the dollar (the approximate rate at the time of this budget's preparation).

The next category of our budget is the grip package. We will get a substantial one. Why not play it safe and have more than we need. In addition to this, we will rent a dolly with track, a crane for our establishing shot, and a package of fifteen walkie-talkies (some of which we might use for Security Officer props).

The camera equipment is broken down into the main camera package and the Steadicam package. These need to be recorded separately because a Steadicam is considered special equipment. Attachment B details the camera package we will need for the airport sequence.

The final equipment package covers our need for sound. This looks so small and insignificant on the budget page—only one line, only $220 for the day—but it is immensely important that the equipment be quality and in superb working condition. It is also important to have a topnotch crew doing the recording. Paying a little more for a

Thai Production Budget

Lighting Equipment (see Attachment "A") TOTAL 3,062

Grip Equipment	Travel (1/2)	Test (1/2)	Shoot	Total no. day used	Rate	Amount
Large grip package	0	0	1	1	465	465
Super Panther Dolly III with track	0	0	1	1	350	350
Pegasus crane	0	0	1	1	500	500
Walkie-talkies (package for 15 sets)	0	0	1	1	135	135
					TOTAL	1,450

Camera Equipment (see Attachment "B")	Travel (1/2)	Test (1/2)	Shoot	Total no. day used	Rate	Amount
Camera package (approx., with lenses)	0	0.5	1	1.5	1,369	2,054
Universal II Steadicam package	0	0	1	1	345	345
					TOTAL	2,399

Sound Equipment	Travel (1/2)	Test (1/2)	Shoot	Total no. day used	Rate	Amount
Nagra, mixer, set of microphones	0	0	1	1	220	220
					TOTAL	220

Production Expenses	Num.	Days	Rate	Amount
Miscellaneous estimated pre-production and production expenses				650
All telephone, mobile, Internet, fax, communication costs estimate				750
Film courier costs (tollways, taxis, etc.)				150
			TOTAL	1,550

Transportation	Travelling	Working	Days	Rent/day	Amount
Van #1: production # 1	0	10	10	40	400
Van #2: production #2	0	8	8	40	320
Van #3: locations	0	13	13	40	520
Van #4: wardrobe and makeup	0	7	7	40	280
Van #5: director, producer, and talent	0	6	6	40	240
Van #6: props and art	0	9	9	40	360
Van #7: camera	0	1	1	40	40
Van #8: talent	0	1	1	40	40
Van #9: lighting and grip crew	0	2	2	40	80
Pickup truck #1: craft service	0	1	1	35	35
Pickup truck #2: art and props	0	1	1	35	35
Truck #1: lighting and grip	0	2	2	60	120
Truck #2: generator	0	2	2	60	120
Truck #3: Pegasus Crane truck	0	1	1	60	60
Estimated gasoline for vans, p.u.			59	15	885
Estimated gasoline for trucks			5	65	325
				TOTAL	3,860

Picture Vehicles	Num.	Days	Rate	Amount
Tourist buses	3	1	70	210
Taxi meters	10	1	35	350
Cars	15	1	35	525
			TOTAL	1,085

Airplane Charter	Hours	Rate	Amount
Airplane (flying)	0.5	1,842	921
Airplane on ground	1.5	526	789
Other (landing fee, etc.)		300	300
		TOTAL	2,010

Catering Service	Num.	Days	Rate	Amount
Thai crews	49	1	11	539
Drivers	12	1	11	132
Foreign crew and cast	2	1	11	22
Thai bit parts and key extras	14	1	11	154
Government censor	1	1	11	11
			TOTAL	858

Location Fee	Days	Rate	Amount
Airport runway access	1	350	350
Donations to Air Force (approx.)	1	250	250
Terminal entrance, ticket counter, metal detector	2	750	1,500
Miscellaneous location costs		250	250
		TOTAL	2,350

Casting	Days	Rate	Amount
Still film, processing, print, etc.			320
Video rental, tapes, and screen test cost estimate			180
Miscellaneous (telephone, etc.)			150
		TOTAL	650

Actors/Extras	Num.	Days	Rate	Amount
Pedestrian	1	1	35	35
Japanese tourists	5	1	45	225
Father and four-year-old daughter	1	1	45	45
Secondary officer #1	1	1	115	115
Airline employee	1	1	115	115
Station security officers and terminal officer	3	1	35	105
Other extras (crowds, officers, car drivers)	75	1	11	825
			TOTAL	1,465

Government Requirements	Days	Rate	Amount
Thai censor officer	1	58	58
Censor custom's fee for film clearance (1 baht per meter)		1 baht	75
		TOTAL	133

Art/ props subtotal	Amount
Art estimate (includes airport signs, art, props with no major builds)	2,250
Props estimate (includes security handguns X 5, luggage, etc.)	1,200
TOTAL	3,450

Wardrobe	Num.	Days	Rate	Amount
Wardrobe, main cast	1	1	250	250
Wardrobe, premiered extras	10	1	15	150
Wardrobe, security guards	10	1	25	250
			TOTAL	650

Makeup and Hair	Num.	Days	Rate	Amount
Makeup and hair artists' supplies estimate				175
			TOTAL	175

Accommodation (and office rental)	Rooms	Nights	Rate	Amount
Emerald Hotel (director and actor)	2	6	28	336
Office rental (function room with office facilities)	2	7	35	490
			TOTAL	826

good sound crew could save you multiple thousands of dollars when it comes to post. There's nothing worse than bad sound on a movie, not even bad picture. In the independent world, a grainy and dark picture might be praised as a bold creative choice, but bad sound is instantly noticeable, and there are no lies that will make it excusable. Why then did we not schedule a sound test day? Well, since we are shooting in a major production city, we will require that the equipment either belongs to the sound recordist, or that the recordist will check the gear when he picks it up. And, if something were to go wrong, we should be able to quickly replace it. Never go to a distant location without completely checking your sound equipment first. Consider yourself warned.

PRODUCTION EXPENSES

This category of expenses is difficult to accurately estimate. We are allowing $650 to cover translation of scripts, deliveries, stationery, utilities, and even the daily coffee and snacks. The higher cost will be for communications, at $750. The film courier, who delivers film to and from the set to the production offices or to the airport or to a security holding area, will actually share his toll-charge allowance with other drivers who need to use the tollways. Bangkok is a huge, congested city. It's best to avoid the traffic jams whenever possible.

Attachment "A"—Lighting Equipment (page 1)

Code	Qty.	Description	Unit Price		Period		Amount
			Wkly.	Daily	Wks.	Days	Baht
	Order	Generator					
		(does not include gas)					
	1	100KVA. Viking generator on truck		9,000		2	18,000
		Equipment					
	1	12KW. Arri with scrim set		8,825		2	17,650
	1	6KW. Arrisun with scrim set		12,750		2	25,500
	2	4KW. Arrisun with scrim set		4,290		2	17,160
	1	1.2KW Arrisun with scrim set		1,400		2	2,800
	2	4' x 8' Bank kino flo (daylight + tungsten)		2,500		2	10,000
	1	9" Mini flo kit		900		2	1,800
	2	4' x 4' Mirrors with stands		650		2	2,600
	2	Safety rails for 1.7M parallel set		100		2	400
	1	Flat dolly		800		2	1,600
		Subtotal					97,510
		Insurance Premium 10%					9,751
		Total					107,261
		VAT 7%					7,508
		Grand total					114,769
		In U.S. dollars					($2,669)

Client:

Title: AIRPORT SCENE

Shooting day

Location: DON MUANG INTERNATIONAL AIRPORT

Quote date:

Hire period: 2 days

Job no:

Order no:

TRANSPORTATION AND MAJOR ACTION PROPS

This page breaks down the transportation costs for each of the vans and trucks we will need for the duration of the production, including the cost of gas for these vehicles. The production vehicles will be needed for varied periods of time as the needs increase. Your Transportation

Attachment "A"—Lighting Equipment (page 2)

Client:			Quote date:				Job no:
Title:	AIRPORT SCENE						
Shooting day			HIRE PERIOD : 2 days				Order no:
Location:	DON MUANG INTERNATIONAL AIRPORT						
Code	Qty.	Description	Unit Price		Period		Amount
			Wkly.	Daily	Wks.	Days	Baht
	Order	Equipment					
	2	Super crank stands with wheels		1,000		2	4,000
	2	Low boy crank with wheels		650		2	2,600
	1	Crank-o-vator stands with wheels		650		2	1,300
	2	Light lift wind-up stands		250		2	1,000
	3	Combo stands		300		2	1,800
	4	C-Stand mountain leg (complete 40")		80		2	640
	2	Junior matthboom		300		2	1,200
	2	Baby boom		200		2	800
	3	2-1/2" Grip head		40		2	240
	3	4-1/2" Grip head		60		2	360
	2	Magic arm		100		2	400
		Subtotal					14,340
		Insurance Premium 10%					1,434
		Total					15,774
		VAT 7%					1,104
		Grand total					16,878
		In U.S. dollars					($393)

Coordinator will oversee the use and implementation of these vehicles as well as the major action props, which are listed in our budget under Picture Vehicles and Airplane Charter. These are vehicles that will be shown on film. A landing fee is required at Bangkok's Don Muang International Airport. We will evaluate the need for a flying airplane and an airplane on the ground later, but for now we will cover all possibilities.

Attachment "B"—Camera Equipment

Client:			Quote Date:				Job no:
Title:	AIRPORT SCENE						
Shooting day:			Hire Period: 2 days				Order no:
Location:	DON MUANG INTERNATIONAL AIRPORT						
Code	Qty.	Description	Unit Price		Period		Amount
			Wkly.	Daily	Wks.	Days.	baht
		Equipment					
	1	ARRI BL4 camera PL mount—full set		16,000		1	16,000
	1	Color video assist digital		4,500		1	4,500
	1	Pedenz color coptical unit		1,200		1	1,200
	1	Sony VDO 8 combo		1,500		1	1,500
	1	Extra 6.6 X 6.6 matte box		1,400		1	1,400
	1	Follow focus unit		1,200		1	1,200
	1	Precision speed control II unit		1,800		1	1,800
	1	Lens wide 14mm T2		2,300		1	2,300
	1	Zeiss Planar 135mm T2.1		1,100		1	1,100
	1	Set of ND3,6,9 filters 4 x 4, 6.6 x 6.6		2,100		1	2,100
	1	Set of ND3,6,9 grads filters 4 x 4, 6.6 x 6.6		2,500		1	2,500
	1	Set of Polarizer filters 4 x 4, 6.6 x 6.6		1,800		1	1,800
	1	Sachtler Studio II head bowl with tripod set		1,800		1	1,800
	1	Set of 85, 85N3, 6, 9 filters 4 x 4, 6.6 x 6.6		2,100		1	2,100
	1	Canon 180mm T3		1,100		1	1,100
	1	High Class lenses T2.1 16,24,32,50,85mm		3,800		1	3,800
	1	Angenieux 25-250 mm T3.5 HR		3,800		1	3,800
		Subtotal					50,000
		Insurance Premium 10%					5,000
		Total					55,000
		VAT 7%					3,850
		Grand Total					58,850
		In U.S. dollars					($1,369)

CATERING

The breakdown is straightforward. You add up the number of people, multiply that by the cost of each meal, and multiply that by the number of days. We've added a couple extra meals under Thai Bit Parts and Featured Extras just in case we have visitors or have to upgrade people. This is not a bad price per person when you consider that it pays for two hot meals a day (breakfast and lunch) and craft services (comprised of snacks throughout the day and a coffee and drink cart). Meals will consist of three or four Thai-food selections and three or four Western dishes.

LOCATION FEES

This is not an all-in-one price. Some airports charge a fee for runway access, as this one does. Some charge additional fees for changing locations within a complex. Note that we have to pay an extra day's fee for the terminal because we are pre-rigging. Also, there is the generous donation to the Air Force. This donation is more than grease to make the gears run smoothly; we should expect to get security for the night before the shoot. In other locations we would have to hire people to guard the set for the evening. And we throw another $250 under miscellaneous. One never knows when one might have to pay an unexpected fee.

CASTING AND EXTRAS

Selecting our actors and featured extras is going to incur nominal expenses during the casting process. These are covered under the Casting category. The rates we pay our local talent will vary according to what they do. Since there are no union rates in Thailand, we go with what the market will bear. Our Taxi Driver can be selected on the set from amongst those hired with their vehicles. The taxi drivers are already being paid $35 for the day, so we might have to throw in an extra $10 from petty cash, or we might be able to get a driver to do the bit for free if we merely add him to the meals with cast and crew. We could also select the Pedestrian from amongst the other extras, but let's not. By casting the bit we can be sure to dress the person the way we want. The Japanese Tourists will cost us $45 each simply because they are not Thai people. The Father and Daughter combo will cost us $45. We are basically hiring one man and giving him a $10 bump for bringing his daughter. The Uniformed Security Officer in the terminal, and the two nonspeaking Station Security Officers will get $35 each, but we might bump it up by $10 for the officer involved in tackling Jason to the

ground. The action probably does not warrant hiring stunt people or a stunt coordinator. The two roles of Secondary Officer #1 and the Airline Employee require actors who do dialogue. They will be paid accordingly, at $115. You will not find the salary here for the actor playing Jason. He has a separate deal.

I'd like to point out one more detail concerning cost savings before we leave this section. We've listed seventy-five people to portray Other Extras, yet they have not been included in our catering numbers. They will be released to find their own meals at their own expense, or they can partake of the snacks we provide along with a large supply of cooked rice and the like. This might sound uncaring when you consider that they are only receiving the equivalent of $11 per day, but you must keep in mind that we are in a different economy altogether. Eleven dollars American currency equals 473 Thai baht for one day's work. A minimum monthly wage for restaurant workers, hotel maids and housecleaners, and retail salespeople working six or seven days a week is about 3,000 to 4,000 baht. A college graduate can expect 5,000 to 7,000 baht. Suddenly, that 473 baht for a day's work doesn't sound quite so bad, does it?

THAI CENSOR

The Thai censorship board requires that one of their employees be on the set throughout the shoot. You must pay the piper, as the saying goes, but the price is very reasonable. The production company will also have to pay a one-baht-per-meter customs clearance fee on the film that is shot.

ART DEPARTMENT AND PROPS

Unless we have arranged for some product placement with a major airline, we will have to create our own signs and graphics for the ticket counter and for the logos on the airplanes. Perhaps we will have to cover existing signs to block them out of shots. Fortunately, we do not have to build any sets that would inflate this subtotal. Props are also minimal, just handguns, security badges, and lots of luggage (extras can be asked to bring luggage), including Jason's backpack and carry-on, and the contents that we see in the x-ray machine and during the bag inspection.

WARDROBE

We will have a selection of clothes for the Premiered Extras, or we may ask them to bring choices from home. We will definitely need a uni-

form for our Airline Employee. Security uniforms need to be rented. Our largest expense here will be for Jason's wardrobe, but why must it be $250? Keep in mind that we need duplicates of the same outfit. The character Jason is being tackled and forcibly searched. This could tear clothes and will definitely wrinkle them.

MAKEUP AND HAIR

Nothing specific is needed but we will allow $175 for supplies (also called a "kit fee").

ACCOMMODATIONS AND OFFICE RENTAL

The Director and Actor will need to be housed for six nights each in a comfortable hotel. You, being a foreign Producer, will also need a room in the same hotel, but we have not added this into the budget because we don't know how long you will be in Bangkok, although it will likely be since before pre-production. Office space must also be rented for the week.

CUTTING COSTS

Now I will be more specific in my cutbacks. Presumably, you have hired the best from a selection of local producers. You feel comfortable that he is competent and generally honest. This does not mean that the local producer is not padding the budget in order to get more of his people work or to get more money for himself. This is business. The producer is going to start high, anticipating that you will come back with a reduced price.

The problem arises in your lack of knowledge. You may not know the limits to which you can cut back without making your production suffer. One way to remedy this problem is to ask specific questions of the local production company candidates during your first visit. You should be able to discern average costs from your multiple responses. Never hire the cheapest guy, and seldom hire the most expensive, unless you know he is the best for your needs and you already know that he can be worked down to a more reasonable price. Ask how many days of pre-production will be needed for the various positions. This puts the local producer candidate in a defensive position if he really wants the job. He knows that he is competing against others and will, therefore, be less likely to excessively pad the budget. Another advantage to preliminary questions is that you have a gauge by which to judge the integrity of the local producer. If you receive one price when you are considering a producer, and you get a differ-

ent price after you've hired him, you know where you stand and can respond accordingly.

You want to avoid a situation where the local producer (or department heads) gives you a set price for the entire production shoot from start to finish. The likelihood that you will be taken advantage of is too great. The producer may hire the cheapest he can find (possibly for too few days, inexperienced crew members, antiquated equipment, *et cetera*) so that he can pocket more money. You will probably come to regret it later when you see the dailies. Keep a close eye on all expenditures. That's part of your job.

I would question some of the favorite areas for padding the budget. That would include any category comprised of guesses, such as the Production Expenses category in our sample budget. The Casting Expenses also seem a bit high considering the work required and the economy in Thailand. And finally, I would question the $3,450 figure for Art/Props. An airport already looks like an airport. Signs definitely need to be made, and plenty of luggage needs to be acquired, but I'm not convinced that this much needs to be spent. The background performers can bring luggage.

Your main concern, where crew is concerned, should be the number of pre-production days. Certainly, some of the production staff and department heads may require a week of prep, but not all. You will probably find that most of these folks can comfortably be cut back by two or three days, and some can be eliminated altogether. As one example, why do we need a Seamstress/Laundress? We are not making wardrobe. The Wardrobe assistant should be able to do this work. If there is an urgent need to get some clothes sewn or laundered, you hire a Laundress/Seamstress for a day or just have it delivered to a laundry service. You should question the necessity of many of the assistants for pre-production and production. But again, you don't want problems on the set due to lack of preparation, so be careful.

You also want to reevaluate the necessity for various equipment rentals, and the number of vehicles and vehicle days needed. Transportation is a favorite area for padding a budget. Are so many production vehicles needed? Can the number of picture vehicles be reduced? Could two tourist buses work just as well as three? Why is a van needed for seven days for Wardrobe/Makeup? Does the Prop/Art department need a van for nine days when the first tech walk-through of the location happens only five days before production?

Another cost-cutting measure is to look into weekly or monthly rates. You should reasonably expect to get six days of work for four or five days' pay on most positions. This may vary in certain foreign locations, but most people are willing to take weekly rates if it guarantees

the job. Weekly rates on most equipment generally go for three to five times the daily rate (four days being most common). Monthly rental is about twelve times the daily rate.

The next cost-cutting measure is to rethink the script. The high crane shot panning down to the front of the airport is very cinematic, but it's also very expensive. Your shot requires special equipment, as well as a landing aircraft. Ask yourself what you are trying to accomplish with the shot. What does this bit of action tell us? Well, it tells us that we're at an airport, and that's about all. Is there a less expensive way to say the same thing? One alternative, if you wish to keep a landing aircraft in the sequence, is to use stock footage and cut to the front of the airport. By doing this, we will save $500 on the rental of a Pegasus Crane, plus we will be able to reduce the crew list by two crane grips, and we will be able to eliminate the $2,010 aircraft charter and landing fees altogether. That $2,600 alone reduces our budget by about 6 percent, not taking into consideration the expense of the stock footage. An alternative is to take a shot of a landing aircraft from the roof of the airport. This will save on the cost of stock footage, but you then have to deal with the problem of recognizing the airline.

But even the landing airliner is not entirely necessary. As soon as we see the front of the airport, we see its name. We see people with suitcases. We hear announcements over the loudspeaker system. Can there be any doubt as to where we are? The airport is not the star of the scene, Jason Caul is the star of the scene. We meet him outside. We see his manner of dress and make a judgment about him in our mind. We know that he is late by his actions, and we see his hurried attitude change to caution as he enters the terminal. Could we eliminate the outside action and go directly to seeing him inside the terminal? Yes, we could. This would save money on picture cars and drivers and possibly extras, but we are not going to start in the terminal. The director wants that outside shot. Maybe it helps to set tone or timing and makes the production look rich, and he wants it. So does the producer.

Budget U.S. and Comparison

Now that we have a budget for Thailand, we need something to measure it against. This is going to be difficult in some respects. Budgets come in all shapes and sizes. Dynamics change according to the location in which a film is shot. Distinctions can be made between high, low, and medium versions. There are differences according to union versus nonunion. Work ethic and techniques may increase or decrease the size of the crew, depending upon the country. The following budget is

typical, but not definitive. Equipment may be equivalent, but not the same as in Thailand. Fortunately, we have the scene as written (comparable to *Midnight Express*) to give us some commonality.

The budgets presented here are by no means exhaustive. We have left out post-production costs, costs of film and developing, costs of certain box or kit rentals, many above-the-line costs, and more, but they are adequate for our purposes of illustration in this book. You may wish to use the long forms available through Enterprise Stationers in Hollywood or one of the fine motion picture budgeting programs available for your computer when you break down your own project. These will give you far more detail and make your budget more precise.

The following top sheet summarizes the differences in our two budgets. A side-by-side comparison is valuable because we can instantly see the categories with the greatest savings, as well as those where the savings are negligible.

Once again we will start with the crew list. Our total of $55,450 is more than twice that which had been estimated for the Thai crew. That's not a bad savings, but perhaps it is not as much as you had anticipated. Let's look at this more closely. I have budgeted the U.S. crew as nonunion and have taken the lowest figure of the price range. That means the U.S. crew is going to consist largely of members with less experience, unless you are willing to pay more. The rates are adequate for a typical music video shoot. Feature shoot rates are generally higher, and commercial shoot rates are higher still. The Thai crew is far more likely to have experienced members that have worked together in the past, which translates into increased efficiency. Also, it is very unlikely that you will be able to crew entirely nonunion and film at a location like LAX without drawing much attention from the unions. You will be pressured to make concessions and hire at least a portion at union rates. You may be forced by liability concerns to hire a stunt coordinator and stunt performers, and you will certainly need a set nurse. Your budget will be upwardly affected with each concession you make, even if you are able to get low-budget contract rates (for which this production will clearly not qualify). The fringe benefits will increase your costs above the posted rate per crew member and actor. This is not something you have to deal with in Thailand. Your savings on crew in Thailand far exceed the amount reflected in our comparison.

Rental per item is not greatly different than that which you find in Thailand for grip and sound equipment. Lighting and camera can be the exception, but you should be able to reduce this U.S. estimate somewhat through a package deal. We start seeing some real differences when we get to transportation, picture cars, and the airplane charter. You may have noticed that we added a honey wagon (portable dressing rooms and restrooms) to the transportation list. You might get

Los Angeles Production Crew

		shoot	pre.	wrap	days	rate	amount
Production	Prod. super. and line prod.	1	7	2	10	450–900	4,500
	Production manager	1	7	2	10	300–550	3,000
	Production coordinator	1	7	2	10	150–325	1,500
	Production secretary	1	6	2	9	150–250	1,350
	Accountant	1	6	2	9	150–250	1,350
	Office P.A.	1	6	2	9	100–175	900
	Runner (intern)	1	4	0	5	75–150	375
Location	Location manager	1	10	2	13	250–500	3,250
	Location assistant	1	5	2	8	100–225	800
Asst. directors	First AD	1	7	1	9	400–750	3,600
	Second AD	1	5	1	7	175–400	1,225
	Set PA #1 (2nd 2ndAD)	1	1	1	3	125–250	375
	Script supervisor	1	1	1	3	200–450	600
Casting	Casting director	1	7	0	8	250–450	2,000
	Extras coordinator	1	5	0	6	150–250	900
Art department	Art director	1	6	2	9	300–600	2,700
	Set dresser	1	4	2	7	150–250	1,050
	Set dresser assistant	1	4	2	7	100–200	700
	Props master	1	6	2	9	200–450	1,800
	Props assistant	1	4	2	7	125–200	875
	Sign writer	1	4	0	5	150–250	750
Wardrobe	Wardrobe supervisor	1	5	1	7	200–500	1,400
	Wardrobe assistant	1	5	1	7	125–200	875
	Laundress and seamstress	1	4	1	6	75–150	450
Makeup and hair	Makeup and hair artist	1	1	0	2	200–500	400
	Asst. makeup and hair	1	1	0	2	125–200	250
Transportation	Transportation captain	1	5	1	7	200–400	1,400
	Drivers x 12	1	1	0	24	100–250	2,400
Craft services	Craft service person	1	0	1	2	125–225	250
	Craft service asst. (intern)	1	0	1	2	75–150	150
Film courier	Courier (intern)	1	1	0	2	75–150	150
Camera	Director of photography	1	5	1	7	750–1,500	5,250
	Steadicam operator	1	0	0	1	500–750	500
	Focus puller (First AC)	1	1	0	2	300–450	600
	Loader and clapper (2nd AC)	1	1	0	2	200–350	400
	Video assist operator	1	0	0	1	175–450	175
Lighting	Gaffer	1	2	0	3	350–550	1,050
	Head electrician	1	1	0	2	300–525	600
	Electricians x 2	1	1	0	4	250–475	1,000
	Driver electrician x 2	1	1	0	4	250–475	1,000
	Generator operator	1	1	0	2	250–475	500
Grip	Key grip	1	2	0	3	350–550	1,050
	Crane grips x 2	1	0	0	2	300–525	600
	Grips x 2	1	1	0	4	250–475	1,000
Sound	Sound mixer	1	0	0	1	250–450	250
	Boom	1	0	0	1	150–250	150
						TOTAL	55,450

Los Angeles Budget

Lighting Equipment (see Attachment "A") TOTAL 7,533

Grip Equipment	Travel (1/2)	Test (1/2)	Shoot	Total no. day used	Rate	Amount
Large Grip package (with truck)	0	0	1	1	450	450
Hybrid dolly with track	0	0	1	1	275	275
Chapman drane	0	0	1	1	787	787
Walkie-talkies (package for 15 sets)	0	0	1	1	150	150
					TOTAL	1,662

Camera Equipment (see Attachment "B")	Travel (1/2)	Test (1/2)	Shoot	Total no. day used	Rate	Amount
Camera package (approx. with lenses)	0	0.5	1	1.5	2,438	3,657
Universal II Steadicam package	0	0	1	1	450	450
					TOTAL	4,107

Sound Equipment	Travel (1/2)	Test (1/2)	Shoot	Total no. day used	Rate	Amount
Nagra, mixer, set of microphones	0	0	1	1	250	250
					TOTAL	250

Production Expenses	Num.	Days	Rate	Amount
Miscellaneous estimated pre-production and production expenses				1,500
All telephone, mobile, Internet, fax, communication costs est.				1,000
Film courier costs (tollways, taxis, etc.)				150
			TOTAL	2,650

Transportation	Travelling	Working	Days	Rent/day	Amount
Van # 1: production # 1 (7-passenger)	0	10	10	75	750
Van # 2: production # 2 (cargo)	0	8	8	70	560
Van # 3: locations (car)	0	13	13	35	455
Van # 4: wardrobe and makeup (cargo)	0	7	7	70	490
Van # 5: director, producer, and talent	0	6	6	75	450
Van # 6: props/ art (15 ft. Cube truck)	0	9	9	85	765
Van # 7: camera (15 ft. cube truck)	0	1	1	110	110
Van # 8: talent (15-passenger)	0	1	1	90	90
Van # 9: lighting/ grip crew	0	2	2	75	150
Pickup truck # 1: craft service	0	1	1	69	69
Pickup truck # 2: art and props	0	1	1	69	69
Truck # 1: lighting and grip (10-ton)	0	2	2	450	900
Truck # 2: generator 4 x 4	0	2	2	110	220
Truck # 3: crane truck	0	1	1	110	110
Honey wagon (with driver)	0	1	1	500	500
Estimated gasoline for vans, p.u.			59	15	885
Estimated gasoline for trucks			6	65	390
				TOTAL	6,963

Picture Vehicles	Num.	Days	Rate	Amount
Tourist buses	3	1	700	2,100
Taxis	10	1	250	2,500
Cars (adjustments to extras)	15	1	25	375
			TOTAL	4,975

Airplane Charter	Hours	Rate	Amount
Airplane (flying)			0
Airplane on ground (combined with flight time)			4,000
Other (landing fee at LAX)			2,500
		TOTAL	6,500

Catering Service	Num.	Days	Rate	Amount
Crew	49	1	25	1,225
Drivers	12	1	25	300
Foreign crew and cast	2	1	25	50
Bit parts and key extras	14	1	25	350
General extras	75	1	10	750
			TOTAL	2,675

Location Fee	Days	Rate	Amount
Airport runway access	1	1,000	1,000
Donations to Air Force (approx.)	1		0
Terminal 2 LAX (prep day)	1	750	750
Terminal entrance (shoot day)	1	2,800	2,800
Misc. location costs (terminal screeners, electricians, security, businesses, parking)		4,000	4,000
Permits		1,200	1,200
		TOTAL	9,750

Casting	Days	Rate	Amount
Still film, processing, print, etc.			N/A
Video rental, tapes, and screen test cost estimate			N/A
Miscellaneous (telephone, etc.)			N/A
		TOTAL	0

Actors/Extras	Num.	Days	Rate	Amount
Pedestrian	1	1	150	150
Japanese tourists	5	1	150	750
Father and four-year-old daughter	2	1	150	300
Secondary officer #1	1	1	500	500
Airline employee	1	1	500	500
Station security officers, terminal officer	3	1	150	450
Other extras (crowds, officers, car drivers)	75	1	90	6,750
			TOTAL	9,400

Government Requirements	Days	Rate	Amount
Censor officer			N/A
Social worker (for children)			N/A
		TOTAL	0

Art and props rentals and purchases	Amount
Art estimate (includes airport signs, art, props with no major builds)	2,500
Props estimate (includes security handguns X 5, luggage, screening machine, etc.)	1,500
TOTAL	4,000

Wardrobe	Num.	Days	Rate	Amount
Wardrobe, main cast	1	1	500	500
Wardrobe, featured extras	10	1	40	400
Wardrobe, security guards	10	1	115	1,150
			TOTAL	2,050

Makeup and Hair	Num.	Days	Rate	Amount
Makeup and hair artists' supplies estimate		2	75	150
			TOTAL	150

Accommodation (and office rental)	Rooms	Nights	Rate	Amount
Holiday Inn, LAX (director and actor)	2	6	109	1,308
Office rental (function room with office facilities)	2	7	250	3,500
			TOTAL	4,808

Insurance	Amount
Auto	600
Liability	900
Equipment	1,000
TOTAL	2,500

Attachment "A"—Lighting Equipment (page 1)

Client:			Quote date:				Job no:
Title:	AIRPORT SCENE						
Shooting day:			Hire period: 2 days				Order no:
Location:	LOS ANGELES INTERNATIONAL AIRPORT						

Code	Qty.	Description	Unit Price		Period		Amount
			Wkly.	Daily	Wkly.	Days	U.S.$
Order		*Generator*					
		(does not include gas)					
	1	100KVA. generator on truck		220		2	440
		Equipment					
	1	12KW. Arri with scrim set		795		2	1,590
	1	6KW. Arrisun with scrim set		525		2	1,050
	2	4KW. Arrisun with scrim set		375		2	1,500
	1	1.2KW Arrisun with scrim set		150		2	300
	2	4' X 8' Bank kino flo (daylight + tungsten)		100		2	400
	1	9" Mini flo kit		50		2	100
	2	4' X 4' Mirrors with stands		34		2	134
	2	Safety rails with 1.7M parallel set		55		2	220
	1	Flat dolly		150		2	300
		Subtotal					6,034
		Total					6,034
		Tax 8%					483
		Grand total					6,517
		In U.S. dollars					($6,517)

Attachment "A"—Lighting Equipment (page 2)

CLIENT			QUOTE DATE :				JOB NO
TITLE		AIRPORT SCENE					
Shooting day:			Hire period: 2 days				Order no:
Location:		LOS ANGELES INTERNATIONAL AIRPORT					

Code	Qty.	Description	Unit price		Period		Amount
			Wkly.	Daily	Wks.	Days	U.S. $
	Order	Equipment					
	2	Super crank stands with wheels		50		2	200
	2	Low boy crank with wheels		40		2	160
	1	Crank-o-stands with wheels		40		2	80
	2	Light lift wind-up stands		25		2	100
	3	Combo stands		7		2	42
	4	C-Stand mountain leg		6		2	48
	2	Junior matthboom		35		2	140
	2	Baby boom		25		2	100
	3	2-1/2" Grip head		3		2	18
	3	4-1/2" Grip head		6		2	33
	2	Magic arm		5		2	20
		Subtotal					941
		Total					941
		Tax 8%					75
		Grand total					1,016
		In U.S. dollars					$1,016

Attachment "B"—Camera Equipment

Client:			Quote date:				Job no:
Title:	AIRPORT SCENE						
Shooting day:			Hire period: 1 day				Order no:
Location:	LOS ANGELES INTERNATIONAL AIRPORT						

Code	Qty.	Description	Unit Price		Period		Amount
			Wkly.	Daily	Wks.	Days	Dollars
		Equipment					
	1	ARRI BL3 camera PL mount - full set				1	508
	1	Color video assist digital				1	306
	1					1	0
	1	Sony VDO 8 combo				1	108
	1	Extra 6.6 x 6.6 matte box				1	41
	1	Follow focus unit (provided with camera)				1	0
	1	Precision speed control II unit				1	78
	1	Lens wide 14mm T2				1	123
	1	Zeiss Planar 135mm T2.1				1	65
	1	Set of ND3,6,9 filters 4 x 4, 6.6 x 6.6				1	75
	1	Set of ND3,6,9 grads filters 4 x 4, 6.6 x 6.6				1	75
	1	Set of Polarizer filters 4 x 4, 6.6 x 6.6				1	25
	1	Sachtler Studio II head bowl with tripod set				1	72
	1	Set of 85, 85N3, 6, 9 filters 4 x 4, 6.6 x 6.6				1	48
	1	Canon 180mm T3				1	78
	1	High Class lenses T2.1 17.5,27,35,50,75mm				1	525
	1	Angenieux 25–250 mm T3.5 HR				1	130
		Subtotal					2,257
		Total					2,257
		Tax 8%					181
		Grand total					2,438
		In U.S. dollars					($2,438)

Film Budget for Sample Script—Top Sheet

Calculated in U.S. dollars

Film Title:	AIRPORT SCENE	Producer:	
Production Co.		Line Producer:	
Budget Summary + Totals		THAILAND	USA
Production crew		22,490	55,450
Lighting equipment		3,062	7,533
Grip equipment		1,450	1,662
Camera equipment		2,399	4,107
Sound equipment		220	250
Production expenses		1,550	2,650
Transportation		3,860	6,963
Picture vehicles		1,085	4,975
Airplane charter		2,010	6,500
Catering service		858	2,675
Location fee		2,350	9,750
Casting costs		650	0
Talent		1,430	9,400
Government requirements		133	0
Art and props		3,450	4,000
Wardrobe		665	2,050
Makeup and hair		175	150
Accommodation (and office rental)		826	4,808
Insurance		N/A	2,500
	Grand subtotal	48,663	125,423
	Total budget	$48,663	$125,423

along without one in Thailand, but in the United States it is a necessi-
ty. The other item worth attention is the landing fees at LAX. They
range from $2,000 to $3,000. Much depends on the time of year, the
kind of aircraft, and where you want to park it.

The U.S. catering costs are much higher than in Thailand. You
can't get away with bowls of rice in Los Angeles. A cost of $25 per
person is still low for hot meals, snacks, and beverages. The $10 per
general extra is very low. We can get boxed lunches from a major super-
market for about $3 each, but you still have to provide beverages and
snacks.

Location fees are considerably higher at LAX. Each terminal
there has its own set of requirements and rental rates. I have chosen
Terminal 2 as an example. You must actually pay more for runway
access, and you must hire screeners to cover every door to the tarmac.
The high sum of miscellaneous location costs may surprise you, but
there is more to consider than in Bangkok. Terminal 2 will require
some of its own personnel to be on the payroll. The minimum, if you
do not opt for runway access, is two police at $46.75 per hour, one
house electrician at $57.78 per hour, and one house supervisor at
$51.37 per hour. You will also have to pay for parking at LAX. It can be
provided for $25 per vehicle of five tons and over, $10 per day for other
production vehicles, and $5 per vehicle in an airport-adjacent lot for
personal vehicles. You will have to pay for your own security personnel,
and you will have to compensate some private businesses within the ter-
minal. All things considered, $4,000 for the day's miscellaneous loca-
tion costs might be much too low. The regular location fee at LAX
Terminal 5 is $9,000, with screeners provided for free.

You might be wondering why there are no casting costs listed in
the Los Angeles budget. There are a couple ways to do casting. You can
hire your own casting director and accumulate the charges, or you can
hire a casting house to do all the work for you. Most people find this
much more convenient. To cover their services, the casting house may
charge a flat 15 percent on whatever the nonunion talent receives
(around 10 percent for union). This comes to about $1,500 based on
our production's talent costs. This is less than the amount we listed in
the crew list for a casting director and assistant, so we don't need to list
anything further under Casting.

Look at the huge difference between talent in Thailand and tal-
ent in the United States! And this does not include 21.25 percent in
fringe benefits (around 30 percent if you're going SAG). The amounts
per person in the budget are based on a ten-hour day.

No particular government requirements are listed for the U.S.
budget. Art department and props are about the same. Wardrobe

rentals will be considerably higher than in Thailand, but makeup and hair supplies will be about the same.

Next comes the huge difference in charges for accommodations. I have chosen a Holiday Inn near the airport as our sample—not the most expensive hotel by any means, but serviceable as a base of operations. And finally, I have added insurance costs. There is no need for liability insurance in Thailand, and the equipment insurance is covered by a 10-percent premium on the rental costs. It is different in the United States, where you usually must cover rentals with a separate policy. A full insurance package in the States will cover negatives and faulty stock, cast insurance, general liability, property, workmen's comp, and errors and omissions.

Now that we have all our subtotals, we can add them together and know how much the production will need, exclusive of the expenses we purposely ignored. The sum of about $48,000 will cover the entire production in Thailand, with a competent crew and plenty of room to cut the budget. Our total for the same production quality in the U.S. is 2.5 times as much at $125,000, and we know that this is at a bare-bones minimum. We could reasonably be looking at $150,000, and much higher, for a union shoot.

This comparison will not be the same for every country. In some places the budget might only be 10 percent lower than in Los Angeles. In others there could be even greater savings than in Thailand. The purpose of this exercise was to demonstrate a way of thinking about our budgets and scheduling so that we stretch our dollar as far as it can go without sacrificing quality. In fact, we may get better quality at a lower cost.

Chapter 19

Attachments

You have to be careful about attachments to your film. They can either give your project wings or tie a millstone around its neck. Novice producers sometimes make the mistake of thinking that any attachment is better than none. Then they are surprised to learn that nobody likes what they have put together.

Let's say that you have Director A excited about your project. He signs on to direct the film, and then you learn that nobody wants to work with Director A for whatever reason. How are you going to get that director unattached? And, even if you do, how will you kindle interest in another director who learns that Director A used to be attached? And how will you excite the people who have already rejected your project because of the previous bad attachment?

The same holds true if you get the wrong actors attached, but new producers are prone to ignore reality when an actor says he likes the role and would be willing to play it. Part of this unreality stems from how difficult it is to get anyone interested in what you are doing unless he can see an immediate benefit for himself. So, if the producer succeeds in getting an actor interested, he is apt to clutch at that straw. The downside is that the actors who are easiest to approach are often not worth attaching.

Valuable actors usually maintain a team of people to field offers and keep away the pretenders. Managers and agents are the primary line of defense, but there are also personal assistants, secretaries, security guards, and others standing in the way. All of these people have a real (or imagined) interest in keeping certain people away from their

employer. In the process, they sometimes hurt their employer by limiting opportunities. More than one actor has changed representation for this crime. A great script may be sent to the agent or manager for consideration by the client, but because there won't be a big payday, the actor never sees the material. Or perhaps the agent has never heard of the independent producer, or there isn't any upfront money, so phone calls don't get returned. To be fair, agents and managers are busy people, but their income is a percentage of the client's income, and this often is the motivator behind decisions. Money talks.

Fortunately, the past decade has seen the emergence of strong-willed, star actors who have stood up against the norm, taking more control over their careers. Stars like James Woods, Robert DeNiro, and Bruce Willis have been willing to take cuts in pay and/or smaller roles in the independent arena. This has emboldened an entire crop of actors who are willing to do the same. Actors like Kate Winslet, Cameron Diaz, Johnny Depp, Kevin Spacey, Samuel L. Jackson, Tim Robbins, Joan Allen, and Nick Nolte, to name just a few, go back and forth between studio films and independents. Some have formed their own production companies in order to find those projects that might otherwise fall through the cracks.

Independent and *free* are synonymous words. Actors experience the freedom to control their own careers and consequently stretch themselves as actors by accepting roles the studios would never give them. In so doing, they prove themselves to be more versatile. They garner critical acclaim and Academy Awards (the independents have controlled the Oscar totals in the past few years), which in turn makes them more valuable to the studios. It has taken a while to accomplish, but the entire motion-picture industry is changing its attitude toward the independent market. Even the managers and agents are starting to change in their thinking, and this can only help everyone involved.

Another change has evolved over the past few decades. The careers of actors are no longer strictly dictated by national appeal. We are now involved in a global community, where as much as two-thirds of the total income generated by a film comes from sources other than U.S. theatrical distribution. Actors have international careers, and this may affect their choice of roles. They may be more open to accepting a role in a film shot overseas that might enhance their name value in particular territories. As one example, consider the eagerness of American actors to appear in English-made films, especially period and Shakespearean stories. The independent producer should likewise consider prospective attachments from a global mindset.

Standard Operating Procedures

Before we look at the more creative means of getting an attachment, let's discuss the usual way it occurs. The players in the industry already know each other. Producers with successful track records or studio deals or distribution deals with reputable companies don't have to prove anything to the agents, managers, and actors. If such a producer makes an offer, it will be taken seriously. There will, of course, be contracts to sign, but certain good-faith assumptions are made from the outset. This changes according to the demand for the actor or the credibility of the producer. The star actor who is much in demand may require a "pay-or-play" contract in order to guarantee availability, which means the actor is going to get paid whether or not the film goes into production on schedule. The actor's reps may also require some form of pay-or-play from a producer who still has something to prove, in their opinions.

Major casting directors can be very helpful in such a case. They already know the actors and their representatives, and they can act as go-betweens to add credibility to a project. After all, the casting director already believes in the project and is being paid. However, you will have the same problem as before if the casting director has no stature in the field, either because he is known to work on inferior films, or because he has not yet established a reputation.

Other factors that lead toward attachments are listings in the trade papers for "go" projects. These tend to increase the momentum of a project, as do listings in the Breakdown Services, which are delivered to most of the subscribing agencies and management companies. Also, there is the word-of-mouth that arises from the attention of trackers and other sources. Word does spread quickly, and it is conceivable that rumors of a great part being available could prompt agents and managers to start calling you, rather than the other way around. You might get a good B-level actor or supporting actor signed to your film at a reasonable rate through the Breakdown Services. Managers need to keep their clients happy and working. Sometimes they will call and submit actors for consideration just to keep them busy; nothing wrong with that. Maybe you can get a good attachment at a bargain price. Or maybe you can get a letter of interest that will help you down the line.

A *letter of interest* or *letter of intent* is not a contract or even a promise, but it can influence investors to take a project seriously if they know that certain actors are interested in making the film. The fact that it is not an attachment has both positive and negative aspects. On the plus side, the letter should not cost the producer anything except the time and effort it took to get the actor's attention. It adds credibility to the project without necessarily being an attachment. On the negative side,

the actor is also not obligated to the film. This can be a trap if the investors promise funding on an "if-come" basis. If you set up the financing based on the actor starring in the film, then the actor backs out, you may have to go back to step one and start the process all over again. It happens all the time. It's incredibly frustrating, but that's part of the game.

The Other Paths

Many would have you believe that the above methods are the only way to get folks attached to your film. Well, such is not the case. There are numerous ways. But all of them start with the same precondition on your part: you must do research first. This is going to require access to certain resources. If at all possible, you should subscribe to the *Daily Variety*, or at least to the weekly version, and/or to the *Hollywood Reporter*. Things move so quickly in the film business that you absolutely must stay informed. The production charts will give you valuable information, as will the articles. Get to know the names, and collect published photographs of important people so that you might recognize them at a festival or party.

The *Hollywood Reporter* also publishes two special reports every two years. The special "Directors Power" issue comes out in the even-numbered years, and the "Star Power" report comes out in the odd-numbered years. Both can be accessed online through the publication's Web site for a fee. This is probably the best bet for an independent producer because there are more listings online than in the print editions. You can check the bankability of more than eight hundred directors internationally, and the same for more than five hundred male and female actors. They are listed on a scale of one to a hundred, and you should be able to gauge the value of these people as attachments on your film, both in the United States and overseas.

You will also find the *Academy Players Directory* to be an indispensable resource. It will give you the photos and credits of actors and actresses in various categories. You will use this tool as a means of narrowing down the selection of possible actors for your roles. The directory also gives you their contact numbers and/or their representative's numbers.

The Directors Guild of America publishes an annual *Directory of Members* that will provide you with credits and contact information. Its value is self-evident.

You should, if possible, get your hands on issues of the trades surrounding the American film market. You'll want to go through the credits to find actors who keep showing up in the major roles. This will

help you determine who has been considered valuable as attachments within the past two years. *Le Film Francais* publishes a products guide for the AFM. You might also try the Web site for the American Film Marketing Association (*www.afma.com*).

Also available, but considerably more expensive, are the industry guides offered through the *Hollywood Creative Directory*. The company publishes directories related to production companies, agents and managers, distributors, new media, and film buyers. You can also subscribe to them through the Internet (*www.hcdonline.com*).

I might at this point mention some alternative methods of getting addresses. Almost anything can be found on the Internet these days, even addresses of many actors that would be great in your film. You will have to use a bit of ingenuity as you navigate the Web for this information, but a thorough examination of online White Pages and search engines might be a good place to start. Another idea is to purchase a mailing list from a publication that would likely be subscribed to by actors. Or consider the possibility of buying one of those star maps they sell on Sunset Boulevard in Hollywood. Not all of the information is accurate, but some is. Public records are also available through various governmental offices. Perhaps you have a friend with a real estate license who can look up titles on properties. Keep in mind, however, that many people in the public eye are already aware of such tactics and have taken precautions. Subscriptions and property may be listed under a false name or a corporation name in order to preserve the recipient's privacy.

The above resources should be sufficient to develop a "hit list" (from most to least desired) of whom you may want to approach with your project. Don't worry; this is a good hit list. I hesitate to even use the term. You just want to get them a script or have a conversation with them. But before you make the attempt, you must do further research. It's not enough that you expect the attachment to be beneficial. You must try to confirm the attachment's value. The best way to do this is by consulting your personal contacts within key sectors of the industry. Producers, development executives, acquisition executives, distribution executives, and casting directors must all know the value of actors. If you have contacts within these ranks, including their assistants, you can get valuable feedback. They may be aware of certain facts that are beyond your scope, such as the director who notoriously goes over budget, the actor who is "hard to work with," or the actress who cannot be bonded for whatever reason. The best contacts for learning the value of line producers are production companies, bonding companies, and entertainment lending institutions.

Making Contact

The best approach is always through the established methods, but following the rules does not always bear fruit. Sometimes, a producer has to break the rules in order to get what he wants.

We are entering a touchy area here. There is a fine line these days between being persistent and being a stalker. Too many actors have been attacked by mentally disturbed fans to ignore the threats they pose. Yet, you must be persistent if you hope to accomplish anything. My only advice is that you think everything through several times before you act, remembering that the method by which you reach your goals is at least as important as the goals themselves. They can either establish you as a creative individual or as a crackpot.

Information has value. You must be as willing to share it as you are to receive it; otherwise, your sources will dry up. Therefore, I highly recommend that you become a social animal. Join organizations that promote community. Attend events at which you can meet people and establish relationships. This puts you in the game. The more people you know, the more sources of information you have. There is a theory of six degrees of separation that suggests that you can reach anybody if you utilize the contacts of enough people. You might know somebody who knows somebody who knows the person you are trying to reach. If you put the links together properly, you can get to that person. Because of this, you should keep a thorough database containing every contact you make: name, address, phone number, where you met, how you met, and any other pertinent information.

You can also gather information from other sources. I have read articles that revealed important information about people I wanted to meet. *Daily Variety* publishes its annual restaurant guide. Many of its articles disclose where stars regularly dine. I have also read articles that gave me the name and location of favorite gymnasiums where actors work out. Become a member. Volunteerism is yet another means to make contacts. Some stars participate in fundraising events. I once bowled with several actors I might never have otherwise met, through participation in a charity fundraiser.

Interestingly, I have made some incredible contacts on flights to Canada. Recently, on a flight to a shoot in Canada, I met two recognizable character actors. On my return flight, I met a producer on the way to Los Angeles for a meeting, and there was another person across the aisle reading a screenplay with the letters CAA (Creative Artists Agency) printed on every page. None of these people were involved in the production that sent me to Canada. The first-class cabins of flights between Los Angeles and Vancouver have truly become an interesting place.

A first-time producer might consider taking an industry job that

gives access to information and people. Some low-paying positions (or internships) at production companies grant access to all the companies' contacts. Please note that I am not suggesting that you steal a Rolodex. I'm saying that some positions at some companies give you access to information, and that access is considered part of your compensation. You may have heard stories about the mail-room positions at some studios. It is a terrible job, unless you intend to make your living from the industry and become a producer or writer or director or . . . The position gives access to addresses you might not otherwise get, and you will make direct contact with people in production.

Kiss up to the gatekeepers. The secretaries and assistants run the entertainment industry. I realize that the producers and executives think they run the show, but this is a myth. Ask any secretary or personal assistant. They have the power to keep you away, and they have the power to let you in. You definitely want to be on good terms with these people. Develop friendships. Send them personal notes or invite them to lunch.

Hire a casting director, or, better yet, hire an assistant casting director with the promise that he or she will be the casting director for your film. Resist the offer to make the casting person a co-producer on the film. It seems like a reasonable request, considering she is helping you make attachment contacts, but where does it end? Your casting person is already becoming an attachment in order to get attachments.

Try throwing some parties. Invite your contacts to a place where they are sure to meet people who can move their careers forward. Then make sure it is totally memorable. You might not get the people you want there the first time, but you might do better the second time around. One gentleman I met was very bold. He invited a star actor that he didn't know to a cocktail party with the promise that she would meet another popular actor. He then called the other actor (whom he also did not know) and invited him with the promise that he would meet the female actor. It was a move that could easily have blown up in his face, but he was lucky, and the night was a huge success. Seldom is anything worthwhile achieved without some degree of risk.

Whatever your plan may be, it comes down to your own creativity and hard work. You must think outside of the box. I love the story I read about a screenwriting team that created their own heat and made a big spec sale through faxes. They sent a fax to the top people at CAA touting this great screenplay that should be represented. The thing that made it work was that the fax was ostensibly being sent to another competing agency, as though it had been intended for William Morris Agency and was sent to CAA by mistake. Of course, WMA received the same kind of fax that was ostensibly intended for CAA. Try that same stunt today and it will certainly fall flat because it has already been

done, but at the time it was a clever and original idea for which the writers will always be remembered.

The Glue That Binds

Let's assume at this point that you have narrowed down your hit list. You have made inquiries about certain actors' market value, and you are ready to approach them, but you still must weigh their value against what you have to offer. The glue that sticks them to your project might not be money at all. It might not even be the acting role. It's up to you to find the proper adhesive and lay it on thick.

Actors who have their own production companies may be the most accessible to new material, but they also might be the worst choice for an attachment. Many of the big names are already booked so far into the future that the film might never get made. The other potential glitch is that many of these companies want creative control over the project, or they are obligated to go to a studio with the project. But assuming that none of this applies, you might be able to make a worthwhile co-production deal with the actor's company so that they get a portion of the proceeds.

THE BACK-END DEAL

When an actor gets a percentage of the producer's gross or net, or a "first dollar" percentage, this is called a "back-end deal." The actor may sign on to a film for a reduced fee (or even scale) in exchange for partial ownership of the film. This is worth consideration in many instances, especially if the actor can help get the film financed.

THE BUDDY DEAL

Another worthy consideration is that an attached actor will likely be able to bring along other noteworthy actors. You may even wish to sign a lesser-known actor to a role in exchange for delivering a bigger name in another role. If you are already a personal friend of noteworthy actors, all the better. Maybe they will help you get the project off the ground out of friendship.

THE VACATION DEAL

You have the advantage of producing your film in another country, maybe in Europe or even an exotic location. Some actors keep an eye

open for these kinds of films that might fit into their busy schedule. You might be able to sign actors on the basis that they will get a free vacation if they work for minimum on the film. Of course, this means you can't work them like a dog, and you do have to make their participation worth their time, but the costs might be considerably less than if you were hiring them for a Los Angeles shoot where the motivator might only be money.

THE CROSSOVER

Some television actors may be willing to take a role on an independent film for a small price just to break into motion pictures. The difficulty here is to recognize who will be taken seriously by investors and by a motion-picture audience. Tim Allen proved his box-office power when he starred in *The Santa Clause,* but others have tried to cross over and failed miserably.

A second type of crossover is from stage to screen, but this is far more difficult to justify because of the world's limited recognition of names from theater. It can still happen, however.

A third kind of crossover is from foreign films to American independent films. There are a wealth of possibilities here that can assist in the financing and marketing of a film. What is important to recognize is that actors may be willing to attach themselves to a film for many different reasons. They might want to stretch their talents and gain recognition for their acting abilities outside the studio system. They might want to break into the motion-picture field from another acting arena. They may get into a film out of friendship or in order to own a part of the film or for a vacation, and for a variety of other reasons.

THE OPTIONED ACTOR

It's common knowledge that a script can be optioned, but few consider optioning an actor. Under this scenario, a valued actor might be persuaded to attach to a film in order to help it get financed. Naturally, this presupposes the availability of seed money. Perhaps the actor has a going rate of half a million dollars per film. You might have to put up 10 percent of that money to attach the actor for a period of time. If the film is set to go before the end of that time period, the actor will perform in the film and receive the remainder of his due, or a full half million. If the film is not ready to go, the actor walks away with the fifty thousand. This kind of deal makes time your enemy. It is definitely a risk, but it can pay off.

THE MENTOR DEAL

Here is another creative consideration that is similar to an option deal, but relates more to directing and producing than to acting. Let's say that you are a first-time producer/director who wants to make his own film. You might have great difficulty raising money or getting a distribution deal when you don't have a track record at all, but you might be able to reassure investors if you have a powerful producer/director as your mentor. This scenario pays the mentor to help you put the project together. Payment might be in the form of a fee or a percentage or both. The deal does obligate the producer/director to take over production under prescribed conditions, like if your director has a heart attack in the middle of the shoot. This assurance may be sufficient to get the money and a completion bond. If the conditions kick in, they have someone competent to finish the film and protect the investment.

Other Attachments

Some attachments don't mean much. Anyone who is below the line is relatively insignificant (under most circumstances), and you don't want to add that to your prospectus (see the introduction to Part 5, Marketing and Distribution). If you must attach someone below-the-line (let's say as a condition for getting an actor, or director, or screen rights), you can probably keep this to yourself until the film is ready to be crewed.

Even some above-the-line attachments hold less weight than others. The cinematographer, though crucial for making a film look rich, holds little cachet by himself when packaging a project. You can have a movie that looks terrific, but that won't get people to dig into their pockets to buy the ticket. I have yet to hear somebody say, "I've just got to see this movie because _____ is the cinematographer." You would probably not want to sign a cinematographer before you have a director anyway. Your director has a huge say in how a film should look. It is his vision that is translated to the screen thanks to the skills of the cinematographer. Still, a reputable cinematographer will never hurt a prospectus. He could enhance the viability of the project and the creative team as a whole.

The script is more important than the writer. Rarely will the name of the writer be a draw to see a film, but it can occur, especially when a writer has put together a string of novels or screenplays that have made money. Stephen King is a recognizable name that will draw people to a horror film. Likewise, the names Tom Clancy and John Grisham can draw an audience, but their draw is based on their novels, not a screen-

play. Few have gained enough name recognition through screenwriting to draw an audience, largely because a screenwriter is only as good as the audience response to his most recently produced screenplay. A great script is what is really important, whether it is written by an experienced pro or a first-time writer. The Hollywood system, unfortunately, does not believe this. If it did, there would not be an A-list of top writers and rewriters. You are an independent producer. Be independent. Don't worry so much about the writer. Worry about what is on the page.

Directors, on the other hand, are an important attachment. Besides the financial advantages that may accrue by hiring a director from the location country (see more on this in the next chapter), some of them have the clout to get a picture made just because they want to make it. Their names mean something at the box office and to the distributors. Just as there are actors who are particularly in demand in the independent market, there are directors who are desirable. Your mission is to find a director who is right for the script and will, at the same time, inspire confidence in investors and distributors (they will be looking at the numbers resulting from the director's past films) and bankable actors who are willing to work with him or her.

The top directors are much in demand, just as top actors are in demand. They get their films completed on time and usually within budget. Sometimes their films get critical recognition or audience recognition. Getting them to say yes to your film will not be easy even if you have money to offer. You may be able to offer them more creative freedom than a big studio, but that could boost your production budget, and it doesn't always influence them to sign on. Many of them head their own companies and find their own material to produce.

The independent producer should look for three key things in a director: he must be affordable; he must get his films completed competently and on time; and he must have the sensibility that matches the project at hand. There's no need to explain the first two traits. We understand why investors would want them in their director, but the third quality could use a little explanation. Some directors are better with character drama; others are better with action. Some are wonderful with suspense but terrible with comedy. You need to find a director who can give his best in the genre you are producing. The director should understand the story and know the direction he wants to take it. He should have the energy to undertake the grueling task. His vision should be in line with your expectations. He should work well with actors to bring out their best performances, and he should get the most out of his crew without destroying morale. These are some of the sensibilities to which I refer. It is doubtful that you will find someone who embodies all that is required, but you must do your best.

More of these sensibilities are sacrificed with a low-budget as opposed to a higher-budget film. If you don't have much money, you might have to settle for a less experienced director, even a first-timer. But there are ways to enhance this director's value in a package. Perhaps you could choose a first-time director who has worked twenty years as a film editor. This person may not be the best at working with actors, but I bet he knows how to shoot economically because he already knows how the film will cut together. He will have a learned and instinctive understanding of what is important in every scene. He probably won't waste his time and your money on superfluous angles that end up on the cutting-room floor. He might be best suited for an action picture with minimal dialogue and least suited for a character drama.

Maybe you can find an experienced assistant director and give him his first crack at directing. He will probably have all the people skills to keep his crew running efficiently, to keep the project on schedule, and he might not do badly with the actors. The danger with him is that he might be too efficient at the sacrifice of creativity.

A writer as director is risky. The writer will certainly know the story better than anyone, but this may work to your disadvantage. It may limit his vision. He has visualized the scene done a certain way, and he might be closed to other creative options introduced by the actors. His visual limitations will probably also carry over to the angles he chooses and to the editing process. And he may have no experience in working with the crew or actors.

A cinematographer as director will make the film look great, but this might greatly slow the pace of production. Story might also suffer at the hands of a cinematographer, as might his work with the actors, but he will probably work pretty well with the crew.

The actor as first-time director on an independent film is probably the best choice. He or she already knows how to work with actors. Story and character are important elements of preparing as an actor, so this person might do well with a character drama or a romance, something that goes to the inner motivations of characters. There is a long list of actors who have done exceptionally well in the role of director. Penny Marshall, Robert Redford, Tim Robbins, Kevin Costner, Ron Howard, Tom Hanks, and Clint Eastwood are just a few examples. They are trained to know what is important in a scene. They are open to subtext and metaphor, and they probably know from experience how that scene should be shot in order to give it the fullest effect. There are hosts of actors out there who would jump at the chance to direct if it were presented to them. The extra advantage is that they can bring actors with them.

If you must go with a first-time director, whether or not he is coming from a related filmmaking role, you need to back him up in the

areas where he is most likely to be weak. For most of these people, the absolute essential is a first assistant director who knows the ropes. An experienced first AD can be a tremendous help in keeping the crew and cast working like a well-oiled machine. He is the confidante and moral support of the director. He can also be the whip when necessary.

But directors aren't the only ones who need backup. Quite often a package that carries an inexperienced producer and/or director needs insurance in the form of a line producer, someone with a track record for getting films in the can on time and on budget. If you are a new producer, this is an absolute must. Show-runners are much in demand, so you had better have something to offer in exchange for their name attached to the project. If they set the pounding hearts of anguished investors at rest, they are well worth the expense.

NOTE: In regard to foreign production, much of the value of having an American line producer or assistant director may be lost. They will most likely not have the experience or expertise to deal with the crew and the intricacies of foreign production in your particular location. But you must take your production a step at a time. If you must have an attachment to support yourself or your director in order to get the financing, do it. You can always make that person an overseer of a local AD or line producer who has a better grasp of the intricacies involved with crew and production in the location country.

Chapter 20

Financing Your Film

Go to any event where independent filmmakers congregate and you will find a seminar on film financing. It will usually be the most attended seminar at a film festival or market. You will hear panelists tell their experiences in raising money. You will hear from film lenders who assure their audience that they have the best rates and are completely supportive of independent filmmakers. Perhaps you will be given handouts that illustrate the various models of financing films. Entertainment attorneys may be on hand to direct you through the maze of possibilities and offer their assistance at a price. But for most of the attendees, the seminars may be as close to the real money as they will ever get.

Acquiring the money (not just empty promises) to make a film is frequently more difficult and time consuming than anyone imagines. Filmmaking is simply too expensive to be taken lightly, yet the attitude of many aspiring directors and producers is often no different than that of a hobbyist who wants to build a model airplane that flies. They think in the back of their minds that getting the money for their pet project will be no more complicated than stopping by a bank to make a cash withdrawal. After all, anyone who hears about the film is going to be knocked over by the ingenuity of the concept and the passion of the filmmaker. That's assuming an awful lot, as they soon discover. The real world can soon discourage to the point of surrender.

Making a film costs far more than building a model airplane. If the airplane crashes and burns on a first-flight attempt, no problem. It's a disappointment, of course, but it's not the end of the world. Another can be built and another and another until they figure out

how to make it fly. But a film that crashes and burns has far-reaching consequences. A trust is broken. Private investors can be devastated, though someone hopefully had explained that investing in a film is risky. Bank executives will have to explain why they approved the loan. It can be a genuine mess for everyone involved, so you can understand the reluctance of people to part with the kinds of money we are discussing. Now, I'm not talking about the no-budget film that was produced on a shoestring, although even shoestrings can be expensive to a person without shoes. We're talking about hundreds of thousands of dollars for a small film for video or festival release, and millions for anything approaching mainstream theatrical feature quality.

This chapter will outline four purposes of funding, the various sources of financing for a project of significant budget—enough to involve lending institutions, distributors, and other players—but we will also discuss some creative means of funding an ultra-low-budget film.

Seed Money/Development Money

A great deal of time and expense goes into the pre-production of a film. The money that finances the venture from the beginning is seed money. Some independent producers find general partners (a *joint venture*) to pay for the expenses of the company: office space, salaried employees, utilities, office supplies, etc. Others prefer to work on a per project basis. In either case, an initial investment of money is needed to pay for the screenplay, development, communications, employee salaries, producer's living expenses, optioning of mentors or actors, and to raise financing. If you don't have a track record, this can be the most difficult money to raise because you have nothing to prove it will be used wisely and effectively.

Production Financing

This money is easy to understand. It is everything required for the production of the film. It may include everything from pre-production through post, or it may only cover the costs of getting the film in the can.

Completion Funds

Sometimes, a producer has enough money to get the film shot but not enough to finish post-production. This does not necessarily mean that

the producer spent the money that was intended for post (though this can happen). Perhaps the plan from the beginning was to get the film to a work-in-progress state with a rough cut or a trailer that could be used to raise additional funds. Completion funds might be easy to find if the product looks good and you are a dynamic salesperson, or they might be difficult to find if what you produced shows little potential. In either case, the money will probably have a higher cost compared to the production funds. The producer is in a disadvantageous position because the investors are on the line, and the lenders know it.

Prints and Advertising

It is conceivable that a film can get completed but that there is no money left to make film prints and to pay for advertising. P&A money is frequently fronted by the distributor and will be reimbursed out of the producer's share of profits, but that doesn't help if you are self distributing. However, this money can be the easiest to get for reasons that will be explained at the end of this chapter.

The Studios

Independent producers do take projects to the studios. There may be a number of reasons for this. It's a sure bet that the studios have money. A project set up at Fox or Warner Brothers or Universal will carry ego weight, hopefully guarantee a payday for the producer, and, at the very least, will reduce the financial risk to the producer. Since the majors have their own distribution, the producer can be confident that there will be a worldwide distribution deal and that there will be money invested for prints and advertising once the film is ready for release. The negative side of this coin is that the studio will do what it perceives to be in its best interest. The studio execs will exercise a degree of control over the production (including final cut), and they will have the final say in the release campaign. They sometimes don't have the patience or vision to let a film build an audience, so, if they conclude that the film will not make a profit, they may put it in *turnaround*. If the film is already completed, they may cut their perceived losses by shelving it or just giving it a token release. They are in a position to do this because they make a large slate of product. It is highly unlikely that an independent production company controlling its own product through financing outside the studios would give up on a film so easily.

More Industry Financing

While not every film is financed from within the film industry, most will at least have a portion raised from the inside. The distributor's fronting of prints and advertising money is one example, but there's nothing to prevent the distributor from investing more than this portion, or even the entire budget, and there are certainly sources other than the distributor.

The larger agencies that package above-the-line talent are also capable of financing the film through their own sources. This has resulted in some controversy over the years because the agencies are essentially doing the work of a producer, which could be considered a conflict of interest, but this should not intimidate the independent producer. Just be aware that there are laws regulating such activity where the talent agencies are concerned. Powerful talent management companies also have the ability to raise money for packaged projects. The difference is that managers can legally participate as producers on a project.

Foreign and domestic presales are another means of raising financing for a film. The domestic deal is most likely to occur in television and cable, where a certain amount of money is put into the approved project in exchange for the premiere being on the cable or broadcast network. The foreign presale—difficult without a guaranteed domestic release—involves foreign territories that agree to pay a certain amount for licensing rights to a picture before it is made. The bankable contracts, along with a letter of credit from the purchasing distributor, can then be used to acquire further financing from a lending institution. We will discuss presales further as they relate to the film markets.

Co-productions are a sharing of the risks and the benefits. There could be several entities involved in a co-production, and they don't necessarily need to be other production companies. Some postproduction houses may enter into a co-production deal where their share of investment is in services to complete the film. Film labs have also been known to come in as equity participants. This might be an ideal situation for the low-budget filmmaker to explore. In many cases, you're going to want to do your post work in the United States, but making a deal overseas is not out of the question. Michael Sellers, president of Quantum Entertainment, has formed a profitable partnership with a major media company in the Philippines. His interview, found later in this book, is enlightening in this regard.

A co-production with a foreign entity is quite a bit more complicated; however, it may open up tax incentives. In Canada, for instance, there is a ten-point scheme by which an American production can qualify for tax rebates and other government incentives. The scheme

assigns one point to each of ten key individuals involved with the film. The Executive Producer and Producer each get one point, as do the writer, director, cinematographer, actors, and others. Seven of the ten key points must be held by Canadian citizens. An American producer can therefore bring a lead American actor and perhaps have a script written by an American writer. If everyone else is Canadian, his project should qualify. But Canada is not the only choice for this form of finance. Other countries may also refund or subsidize a large percentage of the below-the-line costs when there is a partnership with an in-country company. The incentive to the foreign partner could be in the form of direct payment, distribution rights for the partner's territory, or profit participation in worldwide distribution.

If you decide to go into a foreign co-production, you need competent legal representation in both the laws of the participating country and in international law. These entertainment attorneys (as well as foreign sales agents) often additionally have access to independent foreign money sources. Even then, there are substantial hazards. A foreign co-production can work out wonderfully, but you must be careful.

Certain banks and other lending institutions specialize in financing films, but such lenders generally prefer to finance against assets. This can be accomplished in various ways. A money source can put up hard assets as collateral, or other bankable assets can be put up.

The "negative pickup deal" obligates the distributor to pay the entire cost of the film upon delivery of the negative. Of course, the film must meet the standards of the negative pickup agreement, which may be quite complex. The agreement can be used as collateral.

The "distribution guarantee" assures payment of a designated amount of money to the producer at a certain period of time in exchange for the right to distribute. Presales fit into this category. The banks are going to look seriously at the producer's ability to deliver and the distributor's ability to pay. A smaller distributor with less credit standing may have to pledge other assets, such as their interest in other films, bonds, or stocks.

Another option is for the distributor to *guarantee the loan*. This is the quickest way to get approval from the bank, assuming the distributor has the ability to repay the loan if it defaults.

Sometimes, the bank provides a portion of the funding from a more speculative position. The most common scenario is for a production that has equity investors at the front end and a domestic distribution deal that provides the back end. The bank then comes in and fills the gap, hence the term "gap financing." The same can also happen with foreign presales as the front capital, but in either instance your foreign sales agent, who must have a good reputation with the banks, has to show sales projections that exceed the amount being borrowed.

Money from Outside Sources

You are probably familiar with the hilarious Mel Brooks movie and stage musical *The Producers*. What makes it funny is that it is so close to the truth. Independent producers often have to go through their share of blue-haired ladies to raise money, and they do enter into partnerships with the investors who will own a percentage of the production. But please, do not be like Max Bialystock and give away more than 100 percent! You won't get away with it. The standard when a single investor finances an entire film is to give that investor 50 percent of the profit points, plus return of the investment capital and interest per annum, and the producer keeps the other 50 percent. With multiple investors, and shrewd bargaining, the producer should be able to keep an even higher percentage for himself.

The limited liability company (LLC) and the limited partnership (LP) are favorite legal structures for filmmaking. Standard corporations have a tax disadvantage for investors and the corporation, but the LLC is taxed like a partnership while limiting the members' liability to the amount of their investments. The LP goes one better. Investors also have limited liability, but profits go directly to the investors without being taxed at the corporate level. The general partners maintain full control of the project. State laws vary in different aspects, including the total number of investors who can be involved in a limited partnership, but it is well worth looking into.

Alternative Financing

Creative people come up with creative ways to finance ultra-low-budget films. Some of these are clever, effective, and harmless. Others are risky and/or illegal. My admonition is this: Don't give in to the Dark Side. Whatever you do, do it in such a way that you can hold your head up high afterwards.

Self-financing is the best way to go if you don't want to risk other people's money. That might sound like a silly statement to some, but think about it. Do you really want to risk Grandma's retirement fund on your venture? How would you feel about yourself if things don't turn out the way you'd hoped? Never accept money from people who cannot afford to lose it all. That includes you. If you can't afford to lose all the money you put into the film, along with the interest, then you should not self-finance. That said, let's assume your willingness to empty your bank accounts, sell your car, and max out your credit cards. You will have complete creative control over the project. You will do more of the technical work involved because you can't afford to pay

others to do it. You will receive 100 percent of the producer's net profits. You will receive all the glory if it's a great film and all the blame if it is not. Self-financing is the purest form of filmmaking.

A close cousin to self-financing is the creative alliance between two or more self-financing partners. The object is to find other aspiring professionals for a collaboration. You pool your money, share creative input, risks, and benefits. Perhaps you can afford to put in $10,000 as producer. You find an actress who is willing to come in with the same amount in order to get her first starring role in a feature. A cinematographer with his own equipment and some raw stock is willing to come in with ten grand. A director wants a feature credit and comes in with the same amount. You now have a $40,000 budget. Of course, you are also increasing your expenses for making the film overseas. You must pay transportation, lodging, and meals for four people instead of one. This will cut into that $40,000, but it can still be done. As an example, let's look at Robert Rodriguez's *El Mariachi*, which was filmed in Acuna, Mexico.

Rodriguez had already produced a number of no-budget videos and *Bedhead*, an award-winning 16mm film, by the time he decided to produce *El Mariachi* on a paltry budget of $7,225. He partnered with his friend Carlos Gallardo, who played the lead role and provided part of the budget through the sale of some land he owned. Rodriguez provided the rest of the budget from personal savings and a literal sacrifice of his body to medical science. He earned $100 a day for thirty days as a human guinea pig for testing a new drug that lowered cholesterol. The final product won film festivals, including the Audience Award in the dramatic category at the Sundance Film Festival. A distributor picked it up and $213,000 was added in post-production enhancements. The film grossed $2.04 million in the United States, a true filmmaking success story. Self-financing alliances can be rewarding experiences in many ways. For further information about *El Mariachi*, including a printed budget for the film, you might want to visit one of the fan websites, such as (*www.rodriguez.freewebsites.com*).

Another similar financing option involves selling acting roles. Some indie producers have already broken ground for this kind of venture in America and abroad. One enterprising company has been formed with the enticing question "Who Wants to Be a Moviestar?" Their Web site (*www.whowantstobeamoviestar.com*) explains how an amateur can obtain the opportunity of a lifetime—if he comes up with the winning bid for the role in auction. But acting roles don't have to be sold in auction. How about set prices: a leading role for $25,000; a supporting role for $15,000; a featured role for $10,000; a day player for $4,000; and a part as an extra for $1,000? Set whatever prices you think the market will bear, but understand the limitations you are putting

yourself under. You will not have a SAG film, because the Screen Actors Guild prohibits members from participation in a film where investment is a condition for employment. You will probably be tempted to add more roles to generate more money. You will have amateurs and bad actors paying for roles, which will hurt the quality of the film. You may be in conflict with state and federal laws if this were considered a public offering, which would be difficult to avoid. The previously mentioned company sidesteps some of the problems by calling the payment "sponsorships." The bidder cannot purchase the role for him or herself, but can sponsor the role for a friend or relative under prescribed conditions.

Cash grants are available for independent film production from social organizations, private foundations, media organizations, private research funds, and government agencies. The National Endowment for the Arts (NEA) hands out grants every year. Some are outright, and some are matching funds (a certain amount will be given conditional on the amount raised separately). The fact that grants do not require repayment is definitely attractive, but there are several problems associated with them. They require extensive research and paperwork (start at your local library or at the Foundation Center). Each application must be tailored to meet the requirements of the grantor. The grantors generally require samples of previous work. The time required for approval can extend from six months to more than a year. And many grants set conditions that cannot be fulfilled outside the United States. Therefore, the producer who is considering grants as part of the film-financing plan should approach organizations that have a stake in promoting their people or country. For example, a Philippine/American social organization might be approached concerning a film to be shot in the Philippines, but the film will have to deal acceptably with an issue that is important to the organization.

Money can also be raised through intermediaries. Professional fundraisers can help you raise money for a project, but they expect to receive a percentage of that money (a finder's fee) as their payment. The percentage to be kept by the fundraiser is negotiable. You will figure this percentage into the proposed budget. Should you decide to go this route, make sure the fundraiser has the skills and contacts to make your time worthwhile. Don't waste effort with someone who has never raised money for a film.

Scams

If you do a Web search on the subject of "film financing," you will find a plethora of sites. Some of the sites are legitimate in that there may be

genuine contacts and money available. Some may be fundraisers. Some expect a different form of compensation as a participating partner. But understand that nobody does something for nothing. Investors with money to invest in films do not need to advertise the fact.

Tapping into an Internet fundraiser might be fine as long as you are able to secure the finances and deliver the compensation after the funds are raised. Think twice before getting involved with anyone who requires payment in advance. This is likely to be a scam or, at minimum, a waste of your time. And be careful that you do not allow someone to use your legitimate dream and hard work to take advantage of other people. Remember that you may not be the target of a con artist; you might be the patsy.

I'm certain by now that you have noticed a recurring theme throughout this study. No matter where you look for money or whatever means you employ, it's going to cost money to get money. Investors want interest and points. Banks and lenders want interest on their loans, charge fees, and sometimes want points. The completion bond will add 3 to 6 percent to the budget. Your attorney must be paid. Foreign sales agents and fundraisers want a percentage of the money they raise for your project and possibly points as well. Distributors are going to deduct money from sales to pay off the prints and advertising before you see a penny of profit. The actors sometimes want a percentage of the receipts. Everybody wants a piece of the action. Now it's easier to see why most films are financial losers for the producer. At minimum, it will take many years before the producer breaks even. Are you still certain that you want to do this?

Financing in Reverse

Here is yet another opportunity to achieve your goal by breaking away from linear thinking. I mentioned earlier in this chapter that prints and advertising money might be the easiest to get. That's because P&A is the last money that has to be handed over, and it is the first money that has to be paid back.

The P&A investor does not have to hand over the money until the film is complete. Other investors have to be concerned that their investment may never yield results. They are speculating on the filmmakers' actually getting the movie shot and through post-production, but the P&A investor is not making such a speculation. His agreement with the producer is based on a completed film. Even if the P&A investor is the first to sign on, his commitment is on an if-come basis. If the film does not get made, the P&A investor does not deliver the money. The completed film itself acts as collateral. The if-come conditions might

also include a guarantee of distribution. That's assuring for this investor. Don't you agree? He already knows the film is complete and that it will be distributed to generate income.

The P&A investor is also the first to get his money back. As revenue flows in the producer pays back this money out of his gross. Therefore, a film that does not live up to expectations in the box office, even if it is an overall failure, is likely to pay back the P&A investment in full.

The third benefit is its simplicity. The producer is essentially taking a hard-money loan that pays back principal and interest within a designated period of time. The time period is less of an obstacle here because the money is arriving when the film is ready to start generating income. Because the elements of time and speculation have been greatly reduced, the producer should avoid paying points to the P&A investors. They are already being rewarded with a higher rate of interest on the loan because of the level of risk. This is not to say that there are not circumstances where points might be offered, but this should be an exception based on dire necessity, and not the rule.

How can we use these facts to our advantage? You find an investor who wants to get into filmmaking and has the money, but is afraid of the risk. Naturally, you approach for seed money first. If that doesn't work, you try production funding. If the investor is still hesitant, present him with the opportunity to provide the P&A money. Once you get a commitment (in writing), start approaching other equity investors or go directly to distributors.

Investors will be comforted by the fact that someone else has already committed to the film with money, and that money is significant. Let's say that you have a $2-million budget for production, but you already have one million dollars for P&A. You can use this as a selling point for development or production financing. The ideal situation would provide you with seed money so that you can start packaging and getting more money, but this might still be difficult without a domestic distribution deal. Perhaps you can get an if-come commitment. If you get domestic distribution, you will get the production money.

Now you go to the distributors. You have a script, a schedule and budget, and maybe a bankable attachment. You also have money available for production if the distributor agrees to take on the film, and, to sweeten the pot, the distributor does not have to put up the money for prints and advertising. That's a pretty attractive deal. It may be attractive enough to get you a better distribution deal than had you come in empty-handed. Of course, the deal might be contingent on other provisions, but you are well on your way. You can return to the previous investor(s) to solidify the commitment and get the money into your

production's escrow account, or go to additional investors with a distribution deal in hand. With equity investors, distribution, and prints and advertising money, you are able to approach the banks. And all of this is made possible by working in reverse.

Let me warn you, however, that nothing is as simple as it sounds. I have presented you with a viable scenario by which you can raise the money for your project, but it should not be regarded as the best way, just another way. You must ultimately decide what is best for your film.

Chapter 21

A Step-by-Step Outline to Producing Your Film

Many of us may feel overwhelmed by the volume of details involved in the production of a film. More than one would-be producer has been discouraged by details, but, at its core, filmmaking is not as complicated as it seems. This brief chapter is meant to simply recap the information in the previous four chapters so that you can see the process as a whole, and, I hope, find it less intimidating. It will also give you a path to follow. You can deviate from the path and still arrive at your destination, but you may find your journey less stressful if you stay on track.

There is more than one way to produce a film. The usual way is to find a story first and then try to figure out where to shoot it. An alternative, especially for a low-budget production, is to already know where you can shoot a film on the cheap, already know what is available to you at your price, and then write the script to match what you have. Either way you go about it, you will need a script. All the better if you have a script and storyboards so that you can match the visuals to your potential locations. Remember that if you are getting a script from another person, you must pay at least one dollar. This makes it a "work-for-hire" so that you have control over the material and can make changes. The fact that it is a work-for-hire must be stated in the written agreement between the producer (commissioner) and the writer (independent contractor).

There are other necessities without which you cannot get a production off the ground. You will eventually need lead actors, a director, etcetera. This will not be possible, except with great difficulty, until you

have the financing in place. This, of course, is where producer Fred Weintraub starts. But let's assume that you are not a producer with a track record or resources anywhere near that of Mr. Weintraub. In most cases, you will need a budget and schedule in order to attract money, distribution, and actors. That's not a great problem if you are making your film in the United States, but what do you know about the costs of film production in Swaziland or Lithuania?

It's time to start your research. You must make a short list of the countries where the project (the script) is viable for production and either hire a location scout to do the work, or hire a producer in your country of choice, or, even better, make the trip yourself.

How do you decide which countries to visit? Get on the Internet. You will want to visit as many Web sites that might be helpful as you can possibly find, but definitely visit the Web site of the Association of Film Commissions International (*www.afci.org*), contact the appropriate commissioners and other leads, and visit the country's Web sites if it has one. Often there are photos on the site and other information that will help. Send for further information by mail. Request a production guide. You want a list of film titles that were shot in that locale within the past five years. Also check filmographies for the names of films that are similar in plot or location to the script you have. Where were they shot? Then, visit the Internet Movie Database (*www.imdb.com*) and read the credits. Who produced the film? Who was the production manager, the location manager, and so on? You will need to reach someone who has actually had experience working in those countries.

You've narrowed down the list, but there are still too many choices. Next stop, the U.S. State Department's Web site. Drastic events in the past couple of years have made a certain amount of caution necessary. Since the terrorist attacks on the World Trade Center buildings, it has become abundantly clear that there are factions throughout the world that hold strong anti-American feelings and that no location is totally safe. Still, there is no sense in tempting fate. Avoid countries where it is reasonable to expect trouble, and check the status of countries that you might consider low-risk. You may be shocked to discover the country you most liked is currently in the midst of a civil war where all foreigners are in danger. Okay, scratch that country off your list and concentrate on the remaining locations.

Call anyone with direct information regarding filmmaking in those countries. Ask for referrals to local producers, location managers, equipment-rental houses. Then call your other contacts to inquire about the referrals' reputations (you may find that someone who was an asset on one film turned into a detriment on another). Likewise, contact the film commission, if there is one. They may give you referrals or feedback about the referrals you already possess.

Contact your referrals and tell them about your project. Are they available and interested? Yes? Send them a script (if available) and make your travel arrangements. Read everything you can find about the local culture, religious beliefs, dos and don'ts. Buy travel guides and read them cover-to-cover. Often they contain great pictures and other useful information, like availability of accommodations, restaurants, and the like. Be sure to pack a 35mm still camera or a digital camera, and use a 50mm lens for the most realistic view of the locations you shoot. Likewise, a video camera is also a great tool.

You've made it to the first country. You want face-to-face meetings with the local expert. It's time for discernment. Keep it casual. How do you feel about the person? Take differences in culture into consideration, but do not disregard your feelings. If the person makes you feel queasy, there is probably a good reason. Can you really do business with this person? Notice I did not say "trust." Trust is earned. But can you do business? Can he really get you the permits, access to the right people, community cooperation? Visit a couple locations that might be right for the film. Is he close or crazy? Take a look at some of his work if available: films he has worked on, sample budgets and schedules. Bleed him for every bit of information you can get without hiring him. When you've learned as much as you can learn, move to the next contact or the next country and start all over again.

So, this next country doesn't have a film commission. Okay, stop by the local government offices for tourism or business development. Contact studios where local films and TV are produced. Talk to anyone who might shed light on the subject. Look for expats from your home country. They are a great resource. Perhaps you may wish to hire tour guides, but be careful—they may be less than sincere.

You will want to gather the same kind of information at every location you visit.

1. Weather patterns at various times of the year (a specific time if you know when you will be shooting). Also, the course of the sun, length of days.
2. Housing possibilities, restaurants, and the kinds of food available.
3. Is production equipment available? What shape is it in?
4. Is there government cooperation?
5. What kind of local craftspeople are available and at what price?
6. Immigration, visas, and work permits. Are immunizations necessary for visiting cast and crew? (Check with embassy in the United States.)
7. Customs. How difficult is it to bring in equipment, and from where? Costs?

8. Government fees, permits, and restrictions (explosives, weapons, etc.).
9. Stability of local government. Stability of currency, and ease and quality of banking.
10. Local tax incentives and production rebates. Co-production opportunities.
11. Censorship. Can the film be shot without pre-approval? Can the film be sent out freely?
12. Power voltage and frequency.
13. Infrastructure. How easy (or difficult) is it to acquire the simple things?
14. Are medical facilities available?
15. Transportation. Traffic (travel times)
16. Local insurance and liability laws.
17. Miscellaneous (Anything else you can think of that might pertain to your project).

You have visited the potential host countries. If you have made your decision and are able to do so, return to the country of choice and hire the person who is going to help you make it happen. Work on a local budget and schedule. Now go home. You have work to do. Save all your travel expense receipts so that you can reimburse yourself (and pay yourself) later.

Get the money together. You may wish to get a letter from a film bonding company, should your budget and financing require one. It's never too late to get further advice. Bonding companies are there for you.

Step by step. Agreement by agreement. Do the work of the producer. When you are close enough, set a start date for shooting and get your completion bond. Have your local hire send you constant updates. If you are not getting what you want and need, then it's time to reassess. Otherwise, move to the next step. Get your local locations locked in and get back to the country for the final weeks of pre-production. When you have done everything you can do, make your film.

Obviously, this is a short outline of what you need to do. Every project will have its own unique problems that need to be solved, but that's the nature of the challenge you have elected to undertake. You are a producer—so produce.

MARKETING AND DISTRIBUTION

\mathcal{I}s it better to release your motion picture in the film festival circuit, or should you set up private showings for distributors? Should you "four-wall" a theater, or transfer to VHS tapes? Is this a direct-to-video, or is it something that will find a home in pay television? And what about the foreign markets? Your prospectus should contain a plan for marketing and distributing the film. This chapter may help you decide what that plan should be.

Marketing your film does not begin after the film is made. The prospectus itself is a marketing tool. You need to sell someone, or several people, on the idea of financing your project. A well-prepared prospectus impresses the reader with its thoroughness. It's one thing to excite someone with the idea (the story, the people involved, the visual style, your slant as to why an audience would want to see this film, examples of similar films that have become blockbusters and made their investors happy); it's another to dazzle them with detail (the specifics of the business venture, like the rights and obligations of the participants, accounting practices, tax consequences, distribution of revenues/profits and losses, and budgets and timetables).

Domestic Distribution

Investors will be most interested in how you intend to market/distribute to the public. The ideal situation is for the producer to already

have a good domestic distribution deal in place (not a small accomplishment when you consider that less than 5 percent of the annual crop of films made ever find domestic distribution). Investors rightfully find it comforting to know that there is already a means for recouping the investment and making a profit, especially when they realize that the revenues from foreign sales hinge on there being a domestic release. They also are comforted by the fact that in most cases, the distributor is advancing the money for prints and advertising. This advance has to be reimbursed from the producer's share of the profits before the investors get their money, but at least someone else is putting that money on the line. One alternative, of course, is to do your own distribution by "bicycling" your film from town to town and "four-walling" (self-advertising and paying for the use of the theaters), but you will likely find this practical for micro-budget films only, and you will also find it tediously difficult. Some have made a profit through self-distribution, but many more go broke.

Unfortunately, with so many films being acquired after they are made, there's only a slim chance of getting an acceptable domestic distribution deal before production begins. Such deals usually go to producers with successful track records or with a package that is too attractive to pass up. On rare occasions, however, individuals can land a co-production deal with a company that also does distribution. The company will either take over the project as its own, or it will just put money into the project and help steer from a distance. If this deal is struck with a major studio like Warner Brothers or Universal, you are no longer an independent producer. There are mini-majors like New Line Cinema and Miramax who grant more creative freedom to their filmmakers, but don't kid yourself: If they are putting money into the film, they will (they must) exert a degree of control. Though these companies maintain some autonomy, they are both now owned by conglomerates that own studios, Time Warner and Disney, respectively. The smaller the distributor, the more risk it assumes by investing in your project. Do not let this overly concern you. Even if you lose control of your current film, it may be your launching pad for creative freedom in the future.

Some distribution deals do get signed before production begins, but there is no one set way in which this may occur. My personal experience involves a situation where two founders of a distribution company were friends with a young documentary director. They asked the director what they could do to help him make his feature directorial debut. The answer was obvious. The distributor provided one-third of the budget and a domestic distribution guarantee. This opened the door to financing from a private investor for another third, and a bank to gap-finance the remainder.

The previous example involved a personal relationship before the film was conceived, but most filmmakers aren't so lucky as to have pre-established relationships with executives who are able to advance a project. It is your responsibility to create as many new contacts as possible. Nobody will champion your film if you do not champion it yourself. This means you must attend film festivals, seminars, parties, and other events that will put you in contact with people in the industry or people with money who would like to be. Persistence and visibility are key ingredients. Share your dream with enough people and you will have a greater chance of seeing it fulfilled. And it certainly won't hurt you to help others with their dreams; though, along the way, you may have to tread through a morass of charlatans, inert glad-handers, and self-seeking opportunists. Consider this a minor cost of doing business.

Knowing When to Say "No"

Beware the distribution deal that is not a deal. Distribution of films is a competitive business, so it shouldn't surprise anyone to hear that there are people employed to *track* the films in progress. When the trackers learn that certain actors have agreed to work in a film, it is duly noted and recorded. If an announcement appears in the trades regarding your project (especially a start date), you will receive phone calls, and every bit of information will be recorded for future reference. And some may even try to get you committed to them in a manner that does not commit them to you. Why not? Why shouldn't they make you commit to giving them first chance at the film if it's not going to cost them anything? Some have mistakenly considered these promises as distribution deals and caused themselves grief in the process. Even worse, a neophyte producer may be seduced into signing an unfavorable distribution contract that obligates the distributor to little but obligates the producer to very much.

Producer Patrick Roddy (see his interview in the following chapter) mentioned a particular filmmaker with whom he is acquainted, who signed one such unfavorable deal. The distributor guaranteed domestic, home video, DVD, and foreign. The film was signed away for twenty-five years, with no advance monies, under the pretense that the producer would share in moneys collected. Of course, the distributor was entitled to reimbursement of expenses related to the distribution, such as cost of the trailer, press kits, fees for going to the markets, charges for insurance, and a host of other charges that made it impossible for the producer to ever see a penny of profit. And, to make it even worse, the contract included a clause that allowed the distributor

to extend the contract for an additional twenty years simply by giving notice. Essentially, the producer gave away a film in which he had invested sweat, tears, and creative energy.

Don't let that happen to you. Do the math to make sure the distributor is not going to expense out all the sales, leaving you with nothing. Be especially cautious about signing away worldwide rights in all media. It is generally preferable to have multiple distributors: one for domestic, one for foreign (or both combined), another for auxiliary markets (airlines, cable, TV), and yet another for home video. The producer might sign an all-encompassing contract thinking that a bad deal is better than no deal at all. Perhaps he thinks that it will help him get the money, but it could accomplish the opposite. Serious, savvy investors will read the contract or letter of intent that you have included in your prospectus. And they may not invest in your crop if you've already sold the farm. This is not to say that all pre-production distribution deals are unfavorable, but caution is definitely in order. For an in-depth discussion of the kinds of distribution deals that are possible, I suggest that you consult books written on the subject. There, you will discover the difference between a flat-rate contract and a first-dollar participation contract, as well as the numerous details that differentiate favorable deals from unfavorable ones.

We will assume, for now, that you are starting from scratch. You've put together a prospectus that states your intention to get domestic distribution, but you do not have it currently. Under these conditions, you will have to persuade prospective investors that you can get domestic distribution once you have a work print. The means by which you intend to accomplish this feat should be defined. There are several routes to take, but here are the most common.

Chapter 22

Self-Promotion

It is possible for a producer to create heat around his own project. One way is to lie to all the trackers who call to get information, but this is likely to result in the wrong kind of heat. You are much better off if you are honest but discreet. Being honest does not mean having to reveal everything. Instead, develop a campaign that releases tidbits of new information at the ideal moments to pique interest. Gypsy Rose Lee became the world's premiere striptease artist because of how much she left to the imagination, not because of how much she revealed.

There's nothing wrong with being friendly. Trust is another matter. Trackers always have an underlying interest that could, intentionally or unintentionally, create roadblocks between you and your ultimate goal. Some may pretend that they are doing you a favor by allowing you to send a video copy of your film once it is complete. This is actually a disservice to you for their convenience. They want you to supply a videotape so that they can comfortably turn it off after ten minutes if they don't like it. Sending them a tape also means they will see a cropped version of the film you intended for the big screen, thus making your presentation lose impact. And never show them a work in progress! You are better served keeping a little mystery in the relationship. Tell them that they will receive an invitation when you set up the screening. This may not be what they want, but it is in line with what you want, and it is ultimately to their benefit. Don't forget that you are the one with something that they need. Keep that reality in mind and you will be a stronger negotiator when the time comes.

Screenings are the way to go. Find a theater in Los Angeles or

New York that will rent for a low sum and send out the invitations. Then, get on the phone and call everyone—not just the distributors and trackers—but friends, colleagues, family members, everyone. You want a mixed audience if possible (industry and those not in the film industry) that will be positive and encouraging. But do not lose sight of the fact that you are trying to attract a distributor. If Trimark wants a private showing in one of their screening rooms, gladly accept.

One of the most common mistakes indie producers make in regard to screenings is forgetting that they only have one opportunity to impress the distributors, so they go cheap. Maybe they find a theater that can be rented for very little money for an 11:00 P.M. screening on a Thursday night, then they are surprised when none of the execs they invited attend. Let's be serious. After working a fourteen-hour day, would you want to attend a film of dubious quality until one in the morning? Or perhaps you can screen the film at 7:00 P.M.; that's better. More of the execs will attend, but they'll be exhausted, unable to concentrate, possibly hungry, and will probably walk out or fall asleep before the film is over. A weekend screening also has its drawbacks. The execs have been working all week and screening films. Now they have to give up part of their weekend as well? Take the advice of a successful event producer: schedule your screenings for lunchtime during the middle of the workweek. That's what I did with the Let's-Do-Lunch events, and I was always able to get executives there. It means an added expense of preparing a simple meal for them, but it's well worth the effort. The execs can justify the screening as work-related and get fed in the process. In any case, your prospectus to investors should explain your plan and why it will work.

One more point about finding a distributor. Don't be anxious. There are many distribution companies out there. Take your time and be selective. The biggest distributors are not always the best for your film. Some smaller distributors specialize in certain genre or niche films, or in different kinds of distribution (theatrical, educational, nontheatrical, home video, airlines and cruise ships, etc.). If they happen to specialize in the kind of film you have made, they might be the right choice. They already know from experience what will work best for your product. Getting multiple distributors, each specializing in particular areas of distribution, will often work out very well.

How to Do Your Own Distribution

An interview with Patrick Roddy, independent producer and Resource Coordinator for IFP-West. Mr. Roddy also runs his own foreign sales company, Arch Image Studios.

MD: What have you seen work for industry screening of independent films?

PR: Well, I think it's just a matter of finding out who the target audience is. When I say "target audience," I don't mean the people who will eventually watch the film, but the people who potentially will distribute the film. And then connecting some sort of campaign to get them there, whether it's like a postcard mailing, a fax campaign telling them where you're going to screen it and what it's about. I think a lot of people when they make a film are not realistic about who this market is for. They make a small-budget film with no-name talent and it's a genre piece. You know, it's not appropriate to send an invitation out to everyone in the industry because MGM might not be interested in that kind of movie—it's too small, not the right thing. Whereas, maybe Lion's Gate, Trimark, or Roger Corman's company—it might be their cup of tea. So you have to find out what's appropriate and what's not.

MD: Who do you want to get from the targeted companies?

PR: You need to find out who the acquisitions person is, and that's really simple by just calling and asking them. Or you can find that information in the creative directories and a lot of books. The acquisitions people want to find films, so one should not be afraid or be intimidated in trying to contact them.

MD: Is a screening the best way to go, or does sending a tape work just as well?

PR: I would always try to do industry screenings. You want to get more people in the room. You want the competition. You want everybody to think that everyone else has seen it. Those are good things. They are also more reluctant to walk out. If you just send a tape, they might just watch the first five minutes and stop. You have a better chance of them seeing the film in its entirety, or at least a majority, if you have an industry screening.

MD: Tell me about the no-budget film you produced and marketed.

PR: Well, the film itself was a low-budget horror film that I wrote, produced, and edited. I raised the funding from private investors.

MD: And the budget was . . .

PR: The cash budget was about $35,000, and there was a lot of deferred salaries, and special deals, and things like that, freebies and stuff. No-name talent of course, a non-SAG, non-union picture. It so happened that about the time I was finishing the film I had been working for Roger Corman's company, Concorde New Horizon, as an assistant to the gentleman who ran their foreign-sales division. So I had a great opportunity to see how they went about marketing and selling their films in the foreign market. It really seemed more like a business of widgets. It's just a product they sold. Each territory had a set amount they would give for it, and it didn't matter what kind of film it was, like who was in it or quality. Roger's films are all about the same in that anyway, so there was always a certain dollar amount that it would get, film X, Y, or Z. It was interesting to see that it was just a commodity and people would buy it or sell it.

I had talked to some people about my particular film and submitted it to some places and really couldn't draw up enough interest in people to sell it to the foreign markets, so I took it upon myself to start my own foreign-sales company. I knew some other filmmakers who had made some films that weren't going anywhere, so I called them up and acquired their films as a representative, and then I had six films that I could take to the American Film Market. I got the listings of potential buyers, again identifying the kind of distributor, because in the foreign-market end there are high-end buyers, and mid-range, and I don't want to say low-end, but buyers that deal with a certain kind of film. I was able to identify the companies that might be interested in this kind of film and the other films that I had acquired, which were a couple horror films, an action picture, and things like that.

MD: You didn't rent a room at the AFM, so how did you approach the buyers?

PR: The great thing is that I have a base here in L.A. They saw that I have an L.A. phone number and an L.A. address, and really I just followed the same strategy as Roger Corman's company. They have a new line of films. They notify all their potential buyers and do a fax campaign. "These are the films we have. These are the synopses of the films. We're going to be in room such and such. We'd love to schedule a meeting with you." That's a lot of the work that I did when I was there (at Corman's company), just faxing and getting requests back from the buyers and scheduling a meeting with them. I just followed that same strategy with the films I had, and I got calls back. People would call and want to

know what room I was in. I couldn't tell them, so I'd say "Just meet me in the lobby." I did that, and actually some of the buyers were sellers as well, so I had a badge and I'd just go up to their offices.

There's still an opportunity, and you see this a lot at the market, where people rent some office space down the street at a hotel, just not at the Loews.

MD: And what were the results with your $35,000 film?

PR: We at least covered the expense of the film, and it's still an ongoing process. That's another thing I've realized. If you do this on your own, the film will have a life. It's all a part of my life. Every year I can keep selling this film. On the foreign sales that I've done, it's not sales in perpetuity. They're just licensing periods, so after the seven years or five years, I can sell them again to that region if I so choose. It might be packaged with a bunch of other films, like a TV package, but there's always going to be opportunity to generate revenue.

Chapter 23

Festivals and Film Markets

What is the point of making a film if nobody sees it? It doesn't matter whether you produced it as a propaganda piece or as a showcase for your talent or strictly to make a buck. Nothing will be accomplished if you do not get an audience. Film festivals and the film markets are, without a doubt, the discovery grounds for new film product and the keys in marketing and distribution to a broad audience.

Festivals

Film festivals are held throughout the year, and throughout the world. Many of these festivals were founded for no other reason than to generate income or to generate recognition for the city in which they are held, but some were genuinely founded for the love of the art of filmmaking and a desire to advance filmmakers' careers. The producer who launches his film in one of the former festivals may very well win an award, but no distributor may see the film. If you are fortunate enough to be accepted into one of the latter festivals, particularly the notable ones, like Sundance, Toronto, New York, Los Angeles, Cannes, Seattle, or even Telluride, your film might be viewed by many execs and find distribution even if it does not receive an award. There are no certainties, of course, that your film will ever be accepted into any noteworthy festival. Each year, thousands of films are submitted to Sundance, but only a few are accepted for screening, and fewer of these are accepted into the actual competition.

You should definitely do everything possible to get your film into the largest festivals held in the region where it was filmed. If your film was shot in France, get it into a festival there. If shot in Brazil, get it into the festival at Rio de Janeiro. It may be financially advantageous down the line when you are trying to sell to foreign territories. Foreign distributors like to know that a film is representative of the culture in which it is filmed. Getting it into a local festival creates this impression—all the better if the film wins awards. Also, it creates an awareness of the film in the country where it was filmed, which may facilitate a far more favorable distribution deal in that region. If it sells locally before it sells to the rest of the world, you can use that as a selling point to other territories.

Will your film have an advantage in American film festivals because it was made in an exotic locale? Possibly. It depends largely on the kind of film it is. The festival competitions show preferential treatment to art-house features, not genre pieces, unless there's something absolutely unique about the film that sets it apart. That uniqueness will not be generated by explosions or nudity or any of the other conventionalities. It must be generated by the characters, the story, and its execution in an unfamiliar environment. Allow the backdrop to be a Muslim enclave in the vast plains of India rather than the usual farmhouse in California's Mojave desert, or the back streets of Lima, Peru, rather than the slums of New York City, and people will at least be intrigued enough to give it a look. Make the hero of your story someone we have not seen before in an occupation we know nothing about. The struggles of an idealistic American gun manufacturer who must risk his conscience and life by smuggling weapons to rebel forces of Southeast Asia in order to rescue his captive, opium-addicted sister would make a far more compelling story than yet another "life is tough in an inner city street gang" story, where an average guy has to compromise himself in order to pay the debt for his crack-addicted sister. You see, there is nothing original in life's experiences, but we can make a story seem original if we brace it with unusual characters in unusual settings. The following example should clarify.

One of the most intriguing independent films of the 2000/2001 season was the biographical art film *Before Night Falls*, written and directed by Julian Schnabel. The film centers on the life of gay writer Reinaldo Arenas, who lived under the oppressive Castro regime in Cuba until he made his escape to the United States during the Mariel boatlift. The irony of Arenas's life is that after he finally made it to New York City, where he found literary freedom, he contracted AIDS and soon died. Since most of the story took place in Cuba, which is obviously closed to any film of this nature, a location had to be found that could represent Cuba prior to its current state of decline. That repre-

sentation of Havana and surrounding regions was amazingly recreated in Veracruz, Mexico. The resulting film won accolades and awards at festivals (including Sundance) throughout the United States, especially for the brilliant performance of Javier Bardem as Arenas, but there were many reasons for its success.

The film was thought-provoking; the director made the most of what he had; the producer Jon Kilik even bolstered the unfamiliar names of the cast by bringing Sean Penn, Johnny Depp, and Michael Wincott in for cameo roles. But another overlooked contribution to its success lies in the fact that we had the opportunity to see an interesting, tragic character struggling for freedom in an unfamiliar environment. Everybody knows about Cuba, but very few people know what life was like in Cuba. I conjecture that the film would not have been as overwhelming a festival success had it been the story of a gay writer living in New York City who dies from AIDS. That story is already too familiar.

Films do get discovered at festivals, and if you hit the jackpot, you may even get a bidding war started over your masterpiece, but festivals will more likely only be a step in the distribution plan of your film. The distributors themselves use the festival circuit to build word-of-mouth about films they already have in their fold. You can do the same.

The Film Markets

There are four major film markets that attract the foreign buyers for independent features. Each market has its own flavor. Milan (MIFED) and Manila, both in October, are heavily weighted by the foreign-language films, though Milan can also be a profitable market for the low-budget independent producer. The Cannes Film Festival, held in April, has become the queen of the glamour markets. It is dominated by the majors and high-ticket independents. Studios send their top execs and movie stars to the luxurious event to hype their products, and airfares aren't the only major expenses they incur. The cost of a hotel room, if you can find one, is enormous. Food and local transportation can easily drain one's pocketbook. But if you want to be seen, that's the place to go. It is more than a festival. The buyers and sellers are there to do business in the privacy of rented suites, while the press covers the screenings and other events in the limelight. Get your film accepted into the competition, and you have already accomplished an amazing feat. But Cannes is not the place for genre films; it's the place for art-house independents and larger-budget films with star power.

There are other markets that are geared more for television. NATPE (National Association of Television Program Executives) meets in early January and is well worth a visit if possible. The trades cover it

very well, if you cannot. MIP TV meets in mid-April and is probably less significant for your purpose.

The main market for genre fare takes place in Los Angeles in late February or early March. It's called the American Film Market (AFM), and, if Cannes is the glamour queen of film markets, the AFM would have to be considered the blood-and-guts alternative. It's all business. Seminars are held, a few luncheons or cocktail events, but mostly it's all about shopping for product. Buyers from all over the world migrate to Los Angeles with loads of money, and they are expected to return home having spent it all on films they can distribute in their territories. This is the place to be if you have a low-budget genre piece. Horror flicks utilizing buckets of fake blood are screened alongside thought-provoking dramas. Erotic thrillers are at home with family films; action films with romantic comedies. The AFM may have attained a negative reputation due to the nature of some of its product, but there is a simple reason why that product is available: people buy it. It might be cheese and crackers compared to the caviar of Cannes, but there's a demand for cheesy films, and the AFM caters to a wide variety of tastes. We will look into the AFM in detail shortly because it is such a vitally important market for our purposes, but for the moment let's stay in the context of marketing our films to investors.

The ideal situation is to have your film already signed by an American distributor for domestic and foreign release, provided that the distributor sells at the AFM and/or other film markets. The nice thing is that you, the producer, do not have to pay for the expenses at the markets. The distributor will rent the suite or booth, pay all expenses for staff and transportation, advertising in the trades, slicks, food, and lodging. The producer is usually responsible to provide the videotape of the film so that it can be used to impress buyers at the suites. Of course, the distributor is immensely motivated to do a wonderful job selling your film and the others the distribution company represents, because the company will keep a portion of the money that is generated by the sale to foreign territories, perhaps 30 to 40 percent of the revenue.

That's all fine if you have a worldwide distribution deal, but what if you don't? Well, there are still three options: Rent a suite and bear all the expenses yourself (not at all recommended); get signed with a company that acts exclusively as a sales agent; or join a cooperative. If you don't have experience in the marketing of films to foreign buyers, don't attempt the first of these options. You won't know you've been cheated until it's too late. Experienced foreign sales agents, on the other hand, know how to close all the loopholes and, more importantly, they know who the swindlers are. More may be required of you if you hire a foreign sales agent. You will have to pay the agent a prearranged percentage of the money raised as a fee and possibly give him points in

The American Film Market. Photo by Mark DeWayne.

the film, but you will be much better off in the long term. The third option of joining a cooperative is a relatively recent phenomenon, but it seems to be working. Organizations like the Film Artists Network represent their members' work with co-op members splitting the costs and providing necessary materials for the film markets. It's a terrific option to consider if you are a micro-budget filmmaker or if you've had absolutely no luck obtaining distribution by other means. There are additional benefits as well, such as volunteers to help you in preproduction and postproduction, loaned equipment, and facilities for screening to your peers.

No matter which route you take to getting a distributor, the prospectus should clearly map it out. The investors want to know that you know what you want to do. They also have a right to know the risks involved. You have an obligation to fully advise them of the financial risks, or you may be held liable should the worst-case scenarios present themselves.

The American Film Market

How does the AFM work, and why is it so important to you? Like any other market, you have buyers and sellers of product. Some of the sellers purchase their products from the manufacturers and then resell them. Others manufacture their own products and sell them. You might want to think of the sellers as wholesalers, because the buyers *(sub-distributors)* will also sell to the consumers in their "territory," which is usually a geographic region of the world. You might want to think of these buyers as wholesale/retailers. There are usually multiples of these competing in each territory and, like any other business, they set limits on what they will pay for their products based on how much money they expect to make from the consumers, but these limits are also influenced by the amount of money their competitors are willing to pay in order to control the product. The foreign distributors gain exclusive rights, for example, to release a film in their region. The other distributors in that territory will have their own line of product. Each territorial distributor will sell to the retail stores *(exhibitors)* who sell to the consumers (*moviegoers*).

So, each foreign buyer scrambles to find the best films, and lock up the rights to distribute those films in his territory for the least amount of money. Meanwhile, the sales agents, the producers, and the worldwide distributors of the films are looking to get the best price for their product, which might mean they will resist first offers until a better offer comes along. Waiting might work to their benefit, and the price might go up. On the other hand, there might not be a better offer and the original buyer may have spent his available money on something else by the time the seller realizes this. Such is the nature of the AFM: Everyone has something to gain, and everyone has something to lose. It makes for an exciting game all around.

The value of a territory is not an entirely arbitrary amount, however. Estimates for all rights in each major territory are published in the trades prior to the commencement of the AFM. The estimates are largely based upon inquiries of the sellers and buyers in these territories, the state of the economy in the regions, the previous year's profits or losses amongst the sub-distributors, the trends as dictated by sales at Milan and Manila four months prior, and numerous other factors. Below you will find the estimates, as published by the *Hollywood Reporter,* for the year 2001 American Film Market. There are additional territories that are not listed here, but this covers most of the world.

You should be able to discern a pattern amongst some of the territories that set a price based upon a percentage of a film's budget. Germany/Austria is clearly looking at 10 percent of budget, while smaller territories like Israel might offer 1 percent or less. Yet, even

2001 AFM Licensing Rates

Budget	$750K–$1M	$1M–$3M	$3M–$6M	$6M–$12M
Europe				
France	$25K–$60K	$60K–$150K	$150K–$350K	$350K–$1M
Germany/Austria	$40K–$100K	$100K–$300K	$300K–$600K	$600K–$1.2M
Greece	$5K–$10K	$10K–$15K	$15K–$25K	$25K–$50K
Italy	$50K–$70K	$70K–$200K	$200K–$400K	$400K–$800K
Netherlands	$25K–$50K	$50K–$90K	$90K–$150K	$150K–$400K
Portugal	$5K–$15K	$15K–$30K	$30K–$60K	$60K–$90K
Scandinavia	$40K–$70K	$70K–$100K	$100K–$300K	$300K–$450K
Spain	$50K–$100K	$100K–$175K	$175K–$300K	$300K–$600K
United Kingdom	$40K–$80K	$80K–$200K	$200K–$350K	$350K–$750K
Asia/Pacific Rim				
Australia/New Zealand	$25K–$50K	$50K–$100K	$100K–$200K	$200K–$350K
Hong Kong	$10K–$20K	$20K–$30K	$30K–$40K	$40K–$100K
Indonesia	$5K–$10K	$10K–$20K	$20K–$25K	$25K–$40K
Japan	$35K–$90K	$90K–$250K	$250K–$500K	$500K–$1.3M
Malaysia	$5K–$15K	$15K–$25K	$25K–$40K	$40K–$60K
Philippines	$5K–$20K	$20K–$35K	$35K–$60K	$60K–$90K
Singapore	$10K–$20K	$20K–$30K	$30K–$50K	$50K–$90K
South Korea	$30K–$90K	$90K–$175K	$175K–$400K	$400K–$800K
Taiwan	$15K–$40K	$40K–$90K	$90K–$175K	$175K–$350K
Latin America				
Argentina/Paraguay/Uruguay	$15K–$35K	$35K–$75K	$75K–$125K	$125K–$175K
Bolivia/Peru/Ecuador	$5K–$10K	$10K–$20K	$20K–$50K	$50K–$75K
Brazil	$20K–$50K	$50K–$100K	$100K–$175K	$175K–$300K
Chile	$15K–$30K	$30K–$50K	$50K–$90K	$90K–$125K
Colombia	$5K–$10K	$10K–$20K	$20K–$50K	$50K–$90K
Mexico	$25K–$50K	$50K–$100K	$100K–$200K	$200K–$350K
Venezuela	$5K–$10K	$10K–$20K	$20K–$40K	$40K–$80K
Eastern Europe				
Czech Republic/Slovakia	$5K–$15K	$15K–$30K	$30K–$75K	$75K–$125K
Former Yugoslavia	$5K–$10K	$10K–$15K	$15K–$25K	$25K–$50K
Hungary	$5K–$15K	$15K–$30K	$30K–$75K	$75K–$125K
Poland	$10K–$20K	$20K–$40K	$40K–$100K	$100K–$150K
Russia	$10K–$25K	$25K–$50K	$50K–$100K	$100K–$200K
Other				
China	$10K–$20K	$20K–$40K	$40K–$60K	$60K–$150K
India	$5K–$15K	$15K–$30K	$30K–$60K	$60K–$175K
Israel	$5K–$10K	$10K–$20K	$20K–$40K	$40K–$75K
Middle East	$5K–$15K	$15K–$35K	$35K–$65K	$65K–$100K
Pakistan	$4K–$10K	$10K–$15K	$15K–$30K	$30K–$40K
South Africa	$10K–$20K	$20K–$30K	$30K–$60K	$60K–$120K
Turkey	$5K–$15K	$15K–$40K	$40K–$80K	$80K–$175K

these limits may disappear, if they believe a film has the potential of becoming a breakout hit. The buyers will offer a price that takes into consideration the qualities of the film in genre, story content, production value, star power (if any), and the factors already mentioned. What is important to know is that the selling to territories is an almost immediate return on investment for you, the producer. It will take time for the money to get to you, but it will come if you've sold to legitimate buyers. Of course, there will be bargaining. The buyers might downplay the value of the actors involved while the sales agents exaggerate the budget in order to get a higher price; but let's suppose that you've made a film for a million dollars that looks like it should be in the one- to three-million-dollar category. You could feasibly get 50 percent or more of your production's budget back if you make sales to some key territories and a number of smaller ones. And this is not taking into consideration any deals you might make for television, pay TV, and other auxiliary markets.

The wise course of action is to make outright sales to the foreign territories. Percentage deals and flat-rate deals are impractical because you and your distributor have no way of confirming the revenue from the theaters overseas. You should utilize your share of this capital to start paying back your investors, but some producers use it to help finance their next project. It really depends on the arrangements you made with your investors and distributor.

WHAT SELLS?

I explained earlier that certain genres are easier to produce at a lower price in foreign countries, and that we should consider the kind of film that will sell. You narrow down the field of possibilities until you discover the film that you should make. One of the criteria that we should consider is the amount of product available in a particular area. Let's look at the breakdown according to genre of the 2001 AFM. The following reflects the debut films at the market:

Action-Adventure	170	Adult Erotic	12
Animation	7	Children/Teen	17
Comedy	178	Documentary	3
Drama	329	Family	24
Horror	52	Music	3
Romance	61	Sci-Fi	20
Thriller	191		

The total number is 1,067 films of which 507, nearly half, are in the comedy and drama categories. I point this out because if you make

a film in one of these categories, you might expect to face more com-
petition, but that largely depends on the sub-genres or mixed genres
into which they fall. Comedy is a broad term that encapsulates teen
comedy, dark comedy, romantic comedy, action comedy, gross comedy,
and other mixed genres. Drama might include dramedy, court drama,
cop drama, family drama, and so on. You could potentially enter a
hybrid genre that has little competition or have a film that fits nicely
into a niche, and this could boost foreign sales for you. Also, there is a
definite demand for drama and comedy. Drama is especially prominent
in cable and television—though straight drama is harder to finance—
so, if your marketing plan is aimed for cable and television sales, you
might want to produce a film that is attractive to that market. But you
are still in a competitive category, and your film had better stand out.

Am I suggesting that you should make a film in the categories
with the least competition? Am I suggesting that you should produce a
musical or an erotic adult film? No. Musicals can be very difficult to
produce and there's a limited market and a lower potential return.
Erotic adult fare has similar problems. It may be easy to produce, but
there is also a very limited market. "What?!" I can hear your shock
through time and space. We've all heard that sex sells, but does it sell
to foreign markets? Most foreign buyers are squeamish about erotic
material for three simple reasons: (1) hardcore and erotic adult video
is already easily available to those who choose to buy or rent it or log on
to it through the Internet; (2) most countries are sensitive to erotic
material anyway, and (3) the distributor can only air the material on TV
or cable at narrowly specific hours of the evening, if at all. The sub-
distributors want to attract a large audience, not alienate it.

Well then, what about family, children/teen, and animation?
They should be acceptable, though animation could be of any genre.
You could do quite well at the AFM with fare fit for a general or young
audience. There is a relatively small amount of competition in these
genres and there is a demand. Foreign buyers love to be able to buy
something without worrying about censorship issues like nudity and
language, so well-made family films get plenty of action. Many of the
studios are setting up family-oriented networks for cable, satellite, and
TV domestically and abroad. These networks need product that is *high-
concept*, commercial, and entertaining. There is no reason that lower-
budget and mid-range films of this nature should not sell, unless they
are produced in a way that has no foreign-market attraction. I applaud
you if you wish to produce family fare, the world needs more of it, but
I advise you to give it international appeal, and I warn you that family
films involving animals and child actors do have their own inherent
headaches and added expenses, which may not be beneficial to the
micro-budget producer but will be minor if the budget is $3 million or

higher. Another advantage to the genre is that star names are not necessary in order for the film to be a hit. You might bring in a name to play a lesser role that only involves a few days' shooting, but that's not an absolute necessity. Teen movies usually have a harder edge that might make them more difficult to place, but they still can draw an audience if they appeal to that demographic, and it's always possible to hire actors over eighteen to play teenagers. As for animation, I wouldn't suggest that you get yourself involved unless you already have a background in animation or are an experienced filmmaker. There are just too many things that could go wrong along the way.

Many people think that documentaries are the way to go. Video is an accepted format so that production costs are relatively low, and, if the documentary concerns a cause or makes a *statement*, the financing may be acquired through grants or contributors who also believe in the cause. But documentaries can be very difficult to produce. They require a tremendous amount of preparation, and yet your plan can fall apart unexpectedly. It's not as though you have a script that everyone will follow. You can't force interviewees or planned events to be poignant and exciting; but, if you're ready and willing to shoot five hundred hours or more of tape, you should be able to put together a feature length documentary. Now, ask yourself how many documentaries get a theatrical release and make money. Those who produce documentaries as a mission have their reward, but those who produce them for profit face a tough road.

Romances can find buyers, especially well-made period romances with recognizable actors. They do not have to cost a lot either. The United Kingdom is quite adept at bringing in romances at a reasonable budget (mid-range)—they certainly have all the required costumes and gothic castles.

This brings us to the genres that I find most appealing for the low-budget producer. Action, thrillers (including suspense), sci-fi, and horror are your staples. Buyers know that they can fill out a weak slate with a number of inexpensive movies in these categories, and their expectations are not as high as with some of the other genres. This can work to your advantage. Learn how to make them well and inexpensively overseas and you should find a way to survive in the world of independent filmmaking. Companies like Troma and Full Moon Productions have streamlined their operations and found formulas that work best for them. Troma does not worry about theatrical release. They produce their horror films on budgets of $250,000 to $500,000 and only release them on video, cable, DVD, and in foreign markets. Full Moon Productions goes for a slightly higher quality by shooting overseas on budgets of around $600,000. Production value does make a difference. Even video sales can be tricky unless there is visible quality, which can

be gained in domestic productions at budgets of one to two million. Go overseas to shoot and Full Moon's $600,000 makes perfect sense. That's horror for you, but the same goes for action films. There's always a steady stream of action buyers. Make it at the right price and with the right elements, and you can do fine. These are my choices, along with family films, as being the most logical genres in which to delve.

RECOGNIZING THE TRENDS

Back in the 1970s, theatrical product ruled the film markets. In the 1980s, video became king, and many independent producers made direct-to-video product because there was such a demand. Then came the 1990s. Satellite and TV were the new hot sources of revenue until they started making more of their own product. Today, we have gone full circle. Theatrical product is once again controlling the markets. Trends happen. Recognizing these trends and following them will not guarantee that you will have the right film for the right time, but it's sure better than fighting against the stream!

Some trends are long term, like the ones just mentioned. Others are shorter term and can be predicted according to current political, economic, and social factors. The years 2000 and 2001 are prime examples. Those in the know should have anticipated what would happen at the AFM during these years. Year 2000 was a time of world-wide prosperity. The stock markets in Europe and the United States were going strong. Corporations were making big money from inflated stock prices and new public offerings. The German buyers swooped down on the American Film Market with hordes of cash to buy up whatever they wanted. This drove up the prices of product and made life very difficult for the Asian buyers whose economies were still trying to recover from their collapse of the years before. All of this changed by the time the 2001 AFM came around. The Japanese markets found renewed vigor in the intervening twelve months, while the German distributors were reeled back because the stock market's bubble burst and because of their previous year's under-performing film-product investments.

There were a few other factors that influenced the 2001 AFM. One was the incorporation of independent production companies and distribution entities by the majors. Most of the studios are now geared up with their own art-house and lower-budget divisions. The success of companies like Miramax and New Line at the Academy Awards in recent years, not to mention their box office success, convinced the higher powers to get involved. The major studios would love to control both ends of the spectrum. They would love to provide the big studio blockbusters as well as the smaller films for the niche markets. Thus far,

they have not succeeded in this endeavor, and it is doubtful that they ever will. As soon as smaller independent producers come under the influence of the studios, they lose part of what made their pictures work. The studio bosses lean toward a studio mentality. If anyone is going to be changed in their thinking, it will be the independents that now have access to more money, material resources, and talent.

The studios also influence the foreign distributors and the exhibitors. They can refuse to give exhibitors one of their big block-busters unless they agree to also take their smaller films. What this does is lock up more screens, and this means there are fewer screens available to the truly independent features. With fewer screens available, the buyers become more selective. The prices set by the studios for their films are also higher, which means there is less money available for independents. Hardest hit are the mid-range films. It is becoming more and more difficult to get theatrical release without name actors and directors attached, yet the price demanded by the major independents for such films is hard for the buyers to justify right now.

You might think that the above factors would have thrown a wet blanket on the market, but such was not the case. Year 2001 was a seller's delight. Price depends on supply and demand. The largest influence on this year's AFM was the fear that supply would disappear due to the impending strikes by Writers Guild members and the Screen Actors Guild over their new contracts with producers. Nobody knew for certain that there would be a strike, though most anticipated that there would be, and nobody knew how long a strike would last if it took place. Hundreds of films were rushed into production to beat the deadlines set by the guilds. Television prepared a slate dominated by reality shows for the new season. But these preparations could not completely satisfy the needs of the networks and studios for new product during a pro-longed strike. The result was that much product was gobbled up domestically at rates that were not affordable by the foreign buyers. This drove up prices for what remained. By the end of the market, some product that was clearly direct-to-video was being purchased at theatrical prices.

What does the future hold? The concerns about the guild strikes will be ancient history by the time the 2002 AFM rolls around, and hopefully there will be some rebound to the world's economies. In the next few years (in this writer's opinion), we can look forward to a return to normalcy in the market in the theatrical arena and new opportunities elsewhere. The sale of DVDs is growing tremendously, and we might expect it to become a more important source of revenue. New opportunities should also open in the pay-per-view arena. Consequently, the cost of making independent films should start to decrease with the emergence of better technology in digital filmmak-

ing to satisfy these market demands—all the better if you produce such
films overseas at lower cost. My selection of top genres could remain
the same for years to come, although sci-fi could see a softening in
demand. There seems to be too much of it that is too similar, especial-
ly the futuristic outer-space kind. Horror is also a genre where you
could see softening. People will always want to get scared, but there are
an awful lot of bad films being made in this genre. On the positive side,
I do foresee an increased interest in supernatural thrillers and a trend
toward increased demand for family fare over the next few years. I hope
this is not just wishful thinking.

Do not be concerned that the death of independent filmmaking
is imminent. Such doomsday dialogue has been going on for decades,
and the AFM is still going strong. There will be challenges, just as there
have been in the past, but such challenges have always been countered
by the creation of new markets and refined models of film production
and distribution. We who have chosen this creative career are an ingen-
ious and adaptable breed.

AN INTERVIEW WITH AN EXPERT

The following interview was conducted at the American Film Market
with Mr. Michael Sellers, film producer and president of Quantum
Entertainment. After completing his degree at the New York University
Graduate School of the Arts, Mr. Sellers entered the film industry in
1977 and served in a variety of production capacities before assuming
the role of producer in 1990. Since that time, he has produced six fea-
ture films, all of which have been completed on time and within budg-
et and which have generated significant profit for the producers and
investors involved in the projects. Quantum Entertainment was found-
ed in 1992 with the express purpose of creating, producing, and dis-
tributing a series of modestly budgeted, high-quality feature films for
the worldwide marketplace. The company has specific expertise in the
area of mid-range budget ($2–$10 million) features.

MD: How can you increase the price you receive from a territory by
shooting in a foreign country?

MS: When we get ready to do a film offshore there are two aspects of
it. One is to bring the production costs down, which is the obvi-
ous part that everyone thinks about. The second is to see if there
is a way to enhance the market value of the film in a particular ter-
ritory. For example, if we're filming in India or the Philippines . . .
is there a way, through clever use of some aspect of local con-

Marketing slicks. Copyright
Quantum Entertainment.

tent—whether it's actors, locations, or a storyline that works in that local territory—to make that film worth more in that territory? Say, for example, that you save 10 percent on your production costs and you enhance 10 percent on your sales in this process, then you've got a 20-percent advantage, and that's a competitive advantage. Now that second part of enhancing the market value doesn't always apply if you do a film that has no relationship to the country where you're filming, where you're simply using studio facilities or whatever else . . . but that's one that people don't often consider the possibilities of, and we think that's important.

Increasing the market value in the country is something that's hard to do unless you're in line with a really good local partner in that country. In the case of the Philippines, our local partner is the top broadcaster, so they have a very strong market position in that country. If they get behind a film, they promote it strongly. That was a key consideration in our ability to raise the market value of the films—or two of the films—we've done in that country. By getting that strong local broadcasting—they not only are broadcasters, but they do local theatrical movies and so on—getting them fully involved and behind it really gave it a big push in that country and caused it to perform far better than your average low-budget independent film.

MD: Could you give us an example of how the price you receive from buyers in the country of production would increase?

MS: Normally, we would, for example, take a film and—in this case we're talking about the Philippines, so let's use it. Normally, the Philippines would bring you about half of one percent or a maximum of one percent of your budget. So if you make a film for $2 million, you're getting somewhere between $10,000 and $20,000 as a licensing fee from the Philippines. That's not very much obviously. We did a film called *Goodbye America,* which involved a story about U.S. Navy personnel in Subic Bay with Filipinos at the time of a tumultuous departure of the U.S. Navy after ninety-five years of being there, and so the story had American elements and Filipino elements. To the rest of the world it was a Hollywood movie set at a U.S. naval base in the Philippines, but in the Philippines it was a movie about the Philippines and about things that were interesting to the Philippines. We were able to get $300,000 from the Philippines for this film, whereas, we would otherwise have gotten maybe $15,000, so that was a big help to us. We did not get it just in the form of a licensing fee, but rather, through our more complicated joint-venture relationship with the local

company; we were able to participate with them in the theatrical release and the television revenues, and so on, in the Philippines. We look for that. We're doing the same thing in India and sometimes in Eastern Europe. It's an important thing to consider, but you really need to have that strong local partner.

MD: In general, is there a market value to having a film that was shot in a foreign country?

MS: Typically, the product that people are buying is what they perceive to be a Hollywood movie or an American movie shot on location somewhere. The elements that make it an American movie are the cast. We call it an American movie. It may have an international cast representing different countries, but these are people who are kind of accepted in the international marketplace of film stars, so that gives it a certain identity.

When you go to these territories, you have to look at how you can maximize the savings that you're going to get. If you go to this country and you're trying to do a film which doesn't take advantage of the unique aspects of that country, are you really getting extra value? Let me explain. Most films don't make use of the local setting that much. If you go to the Philippines, the movie for some reason will be set in Central America or it will be set in Thailand. If you go to Thailand, it will be set somewhere else. Yet, when you come up with a film set in that location, all of a sudden there are so many more things that are available to you in terms of production value. So our inclination is to try and configure some stories that take advantage of that locale and make it an organic part of the story. We feel that that gives us greater production value and, therefore, the film appears to be bigger and have more put into it, but it doesn't always work that way.

The other thing that's important to do is to know what that country does well, what you can get at a bargain rate in that country. Not every country is the same. If you're going into Eastern Europe, they have a lot of studio-type facilities there and fixed sets. If you understand what they have and they can just modify those sets for you . . . A friend of ours did a film where most of the film took place on a ship, and the sets were already in place over there, and they actually wrote a story to fit the sets that already existed. So they got this production value at very little cost. When we go to use the Philippines, they are very good with stunts, sets, and special effects, so if we have a film that takes advantage of any of those elements, or all of those elements, then we gain sort of a maximum leverage. An action-oriented film, for example, with

good stunts and good special effects would be something that does very well. Basically, it becomes a kind of equation where we look at how we can gain the maximum advantage. If I'm doing a drama, I can shoot it in New York City and do it pretty well and inexpensively, but if I'm shooting an action picture, obviously I want to go offshore where a lot of these things become cheaper . . . It's also important to consider the additional costs that you incur by going offshore—the travel, the lodging, and so on—but what we find is that those things are easily offset by the savings.

Another thing that I think important is to be conscious of who you really need to take from here in terms of your crew. There's a tendency to want to take too many people from the States because as soon as you hire your DP, he wants to bring his first AC because he's not sure that this foreign focus-puller is going to be able to get it, and he's got to have his gaffer and so on. Pretty soon you have four guys. You thought you only had to take a DP, and now you've got a DP plus four people. What I've found is that sometimes, if you stick to your guns (as long as you've got a solid partner in the country), most of what they're insisting on is either (a) they've got their buddies they want to take with them; or (b) it's just the fear of the unknown. Once they get over there, inevitably, the gaffer is okay, the AC is okay, so you didn't need to spend that additional $80,000. I mean, by the time you take four people, have them work for six or seven weeks, lodge them, feed them, give them their airfares and per diems, that's a pretty large chunk of money. So be aware of what's necessary and what's not. We are very conscious also of trying to establish a relationship with the local partners. We're helping them to develop their capability too, so we play to that as well, and we're sincere about it. Therefore, we want to use their people as much as possible.

MD: Does having local scenic landscapes from foreign-shoot locations work to your advantage when you come to the AFM to sell, or does it really matter?

MS: You'd get a lot of different opinions on that depending on the country you're talking about. If it's a country that has kind of a nice profile as an exotic, attractive location, it can help you. In other cases it can hurt you. If the country has a reputation for cheap, lousy films having been made there, the minute they know that you've gone there to shoot: number one, they figure you didn't spend very much money so the buyers will try to use that as a bargaining aspect; and secondly, their impression of the film may go down. Our feeling is that we've followed the route of

being open about where we film, getting the maximum production value for the dollar, and using the locations that have worked for us. But there are a lot of people who feel otherwise, that you should disguise where you shoot, and we've done that too.

Because we have a long-term partner in the Philippines, we did two pictures set in the Philippines, and then we were getting a little buyer's fatigue . . . So when the next picture came up to do with that partner, we did one which did not have any relation to the Philippines. We actually had a film that, believe it or not, started in Eastern Europe, went to Mexico, to London, and finally to an island in the Pacific, and yet we shot all of this in the Philippines, with the exception of some second unit. We went for a couple second-unit days to each of these places. We got great production value. Buyers loved it, and the film sold out worldwide. It's called *Doomsdayer,* and it did very well. You would never know it was shot in the Philippines. So we have done that, and we've done it in India, because India has a very specific kind of a look and there may be a limitation on how many kinds of stories you can use that actually take place there. And also because our partner in India is a studio that wants to market itself as a place where you can go and shoot anything.

MD: What is happening in the 2001 AFM market? Are the buyers looking at any particular budget ranges as being undesirable? Do they even ask you about the budget?

MS: Oh yeah, they do. That's one of the sad parts of the industry right now is that a lot of the buyers act like they're buying it by the pound. They want to know your budget, and then they'll make an offer based on your budget; of course, film has value added based upon the skills with which it has been assembled. It puts a producer or seller in a dilemma because, if I spend my money wisely, under that scenario (let's say I'm a German buyer and I'm going to give you 10 percent of what you've spent), where's the premium that I get for having spent my money more wisely? We don't like that, and we've resisted it. Fortunately, we've grown to the point where we don't get that question too much anymore because they know I don't like it. What I tell them is "Look at the cast. If this has got a theatrical-level cast, then you know that it cost me at least $4 million to make, maybe $5 million. That's what it basically costs to get theatrical. And, if it doesn't, then you know we spent less than that, and that's all I want to tell you. Look at it and tell me what you think and tell me what you think it's worth." I don't like to lie about it, but I also don't want to be put at a dis-

advantage. Generally speaking, they are looking for more upscale product . . .

MD: Something to compete against the studios?

MS: Yeah, and what they're really looking for, I think, from the independents is something which sort of. . . They know it's not a studio picture, but maybe it's almost there. Something at least at the level of an HBO original, something like that. That's what we find is a good opportunity. The other area that's an opportunity is horror, as far as being done on a lower budget without stars. There seems to be interest, not in every country, but it's a hot ticket, and I would basically recommend it for independent filmmakers who are either just getting started or trying to look for an entry point. It's quite interesting. It's a little harder to pre-sell horror because usually, in the low-budget area, you don't have cast attachments, but if you can somehow get a movie made, there seems to be more of a market for it . . . and there's more of an upside, people getting excited about it; whereas, in the area of suspense and action, it's a more stable market. We can pre-sell. With our action pictures and suspense-thrillers we can usually cover like 70 percent of the budget just by pre-selling it to certain territories, not so with horror. On the other hand, horror has the potential to do very well, and the suspense-thrillers and actions make a profit, but don't shoot through the top of the charts. Again, I'm talking about films that are made in the budget ranges of under $4 million. So we're not talking about theatrical release, but almost.

MD: Of the three (horror, suspense, and action), which would you recommend to the independent producer who wants to make his first film overseas?

MS: Of those three, horror and suspense are much easier to shoot, meaning to say that production requirements are less demanding. You can shoot them in a fewer number of weeks. You may have certain things like prosthetics, but generally speaking, if you just think about the physicality of what you have to shoot, they're easier. Action you have to work a lot harder at a lot more things. You have to have some second-unit stuff. You've got to really be able to put together the special effects and stunts and all that kind of stuff. We sort of specialize in that and have done well at it, but to a first-time filmmaker I would say, "Be very careful, and if you do decide to go that way, make sure you're aligned with the right people to make sure you don't get into trouble, because you can

get into a real nightmare." But I would say suspense is consistent-
ly pre-salable, and action as well. Save every penny that you can.
Don't shoot longer than you have to. You have to keep a tight rein
on the costs.

 Those are the three. Other than that, there's family, but fami-
ly goes really soft every now and then—family dramas and stuff
like that. Comedies—just don't even think about it. I mean, it's
really hard to sell internationally unless you have a deal already in
place. It's kind of a non-starter. There's obviously the art film, the
sort of a Sundance-type thing, which is a good market.

MD: But this isn't the place to be selling that.

MS: No, no, no. But other than R [Restricted], that's the other place
where you can spend a small amount and have an upside, but it's
really not . . . If you're passionate, and you have this film that you
must make, and your uncle and his dentist friends are going to
give you $400,000 to go make it, then probably you want to make
it in your hometown. You don't want to go offshore to shoot that
kind of a picture.

Part Six

ADVANCES IN TECHNOLOGY

\mathcal{I}t used to be that filmmakers would never consider video for their projects unless they were making pornography or an ultra-low-budget direct-to-video release, but things have changed. The impact of digital video cannot be overstated. As the technology improves, we are seeing increased interest from distributors, exhibitors, and moviemakers. Forrester Research, in a recent report, predicted that revenues from digital cinema and video-on-demand (VOD) will reach $6.5 billion by year 2006. The move to digital has already begun.

Chapter 24

Going Digital

There were only about two hundred screens equipped with digital projection systems in April 2001. That number should be closer to a thousand by the end of the year, and by 2006 it is anticipated that one-third of the nation's screens will be digital. It would seem that the only things currently slowing fulfillment of these predictions are the financial woes of exhibitors, which have caused the closure of screens and the bankruptcy of certain theater chains, and the concerns of studios over piracy of product, but these concerns are temporary.

A more fundamental question is whether or not the revenue from digital projection justifies the investment. Theaters could benefit by charging for advertising and premium sporting events, but there is certainly no guarantee that this will prove profitable. People see enough commercials at home. They go to cinemas for a unique experience. If that uniqueness is lost, so may be the audience. People might stay at home to utilize the competing entertainment resource of video-on-demand, which is already coming into our homes through digital cable. We should see VOD popularity broaden over the next few years as cable infrastructure increases, technology advances, and new players get into the game.

There are additional, practical reasons (beyond revenue) why the industry is embracing this technology. We are actually reaching that point where high-definition digital video can compete against film in presentation. There are still flaws, of course. There are still motion issues, color and tonal issues, and the like, but we are getting closer every day.

Digital means that the production quality attained can be sustained indefinitely at lower costs. Film degrades. Prints are expensive to duplicate, and they accumulate grime and scratches from the projector with every showing. Light and heat cause further degradation. All of this alters the impressions left on the audience. Your creative team makes artistic choices that are intended to evoke feelings in the audience. Color, use of light, sharpness, sound all affect people on a subconscious level. As the quality of these features change due to degradation, the artistic intent can be compromised. Not so with digital. Once you get what you intended for release (taking the differences between video and film into account during production and post), you can rely on the quality being the same for the hundredth showing as it was for the first.

Formats and Standards

There are numerous formats to consider if you choose to tape and edit video rather than shoot film for your project. You can choose amongst Hi-8, S-VHS, Beta SP, Mini DV, Digital8, DVCAM, DVCPRO, Digital Beta, D1, D2, D5, HD, and less desirable formats. High definition is definitely the way to go if you can afford it. Unfortunately, the cameras are too expensive for the ultra-low-budget filmmaker, and you have to consider the availability of hi-def equipment and service in foreign countries. A producer with sufficient money will more likely want to shoot film anyway.

The two primary video standards are NTSC and PAL. There is one other, SECAM, but this is seldom used. NTSC is the common standard employed in the United States and certain other countries, but most of the world operates PAL. You must confirm the common standard of your shooting location before you make a final decision. Do not take NTSC equipment to a country where everything is PAL. If a camera goes bad, you might have problems replacing it.

Each standard poses challenges in conversion to film, but, ultimately, the question of which standard to use comes down to aesthetic choices by the filmmaker. PAL delivers slightly better resolution because its numbers of pixels is higher than NTSC. There may also be fewer problems with strobing and flicker-effect because the shutter speed is slightly lower. And it can be a simpler transfer process in that it runs at 25-frames-per-second, which is only one frame off film's 24. Solutions are to clip one frame per second or to let the scene run slightly longer, but this creates new problems. At film speed, it will appear jittery and will run slower. This facilitates a corresponding problem with sound that many filmmakers find disconcerting. These timing issues

persuade many filmmakers to reject PAL for comedy projects, where timing is vitally important.

Shooting NTSC will reduce resolution, but if shot at 60-fps (30 frames interlaced), it will convert to film at 24-fps with less motion artifacts. Should you choose NTSC, do not shoot in progressive mode. Progressive mode means that a full frame is being recorded each time, rather than a field (half a frame) that is then interlaced with another field. Therefore, if you shoot thirty frames NTSC in progressive mode, you will have to lose six full frames of motion information in order to get down to film's 24 frames. Those frames are significant chunks of motion information, and their absence will be noticeable. But, if you shoot 60-fps interlaced, you have a larger over-sampling of data that will synthesize down to a smoother conversion. You are losing less motion information with each extracted frame.

Camera

Cameras change constantly. New features are added, technology advances, and manufacturers' standards may fluctuate, so it would be inappropriate to recommend any brand or model. If you want better resolution, more versatility, or if you want to reduce aspect ratio problems by recording true 16:9 images, you will have to choose a larger, more expensive camera. If mobility is a concern, or if you wish to remain inconspicuous, you may want a small professional/consumer camera. The decision is ultimately up to you. I will, however, make this general statement: Provided that you are in a country where you can easily get support, rather than buying a $4,000 camera that will be outdated in a couple years, you may consider putting that money into the rental of a high-end video camera that will give you better results for your current project. You may find that it gives you more versatility in changing lenses and the picture will surely be superior. For a project taping in a country with less professional equipment and service, you are better prepared by taking a prosumer model that can be easily replaced with a camera of comparable quality in-country. Taking a backup camera is another good move. The cheaper the camera, the more difficulties you will discover in the transfer, but you will have to weigh this reality against the demands of foreign production.

Cinematographer

Some cinematographers can be packaged with their own cameras and lighting. This not only can save money, it also suggests expert familiar-

ity with the use of the equipment to get the best results. Of course, you cannot assume this. Ask questions. View samples. Independently consult with others. You definitely want a cinematographer with vast experience in video, not just film.

Transfers

The problem currently is that the majority of movie theaters are geared for projecting film. A movie shot on video must therefore be transferred to 35mm film for projection purposes. This process is a little like mating a kangaroo with a walrus. They are entirely different animals, but if you circumvent enough incongruities, it can be done.

Choices of format, standard, camera, and cinematographer are only the first in a series of decisions that will affect the quality of your final product. You must decide which transfer facility to use and the method by which the transfer will be made. The amount of money you have available for this postproduction headache may be a factor in both decisions. The image recordation can be achieved through kinescope (the cheapest of the four methods), by laser recorder, or by use of an EBR (electron beam recorder) or CRT recorder, which not only looks great (adding an organic look that often helps the product) but also has the advantage of being able to expose any film stock except possibly 5244, which needs the brighter light source of laser. The cost differentials can be significant. Kinescope ranges from $100 to $300 per minute of film, EBR and CRT from about $300 to $550 per minute, and laser from $350 to $1,200 per minute. Laser recorders are very expensive, and this means higher costs to you, but the final results may be no better than you would get by EBR and CRT.

You should choose your transfer facility before you shoot. The facility is your best friend for making the final product match your high expectations. The technicians can advise you on the best production equipment to use and how to optimize the process through proper lighting and camera settings to accomplish your purpose. Every facility differs in its recommendations according to the hardware and software that it uses. Before you make your final decision, make certain that everyone understands exactly what is included in the price and get it in writing. Always have the facilities do tests on samples to be shot in the manner you expect to shoot in production. Some facilities do better work than others. Some are better with certain formats and standards than with others. Include sample titles and transitions. Project the results. Small flaws will be magnified when projected on a large screen. Factor customer service into the equation. A high level of communication must be maintained between the filmmaker, transfer facility, and

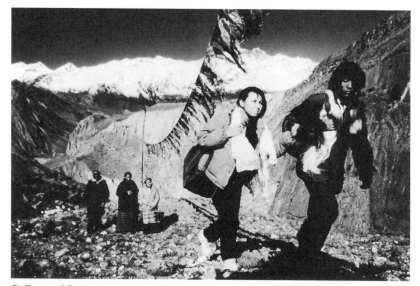

Dolkar and Dorjee must say goodbye to their family and homeland as they walk out of Tibet across the Himalayan Mountains in Windhorse. *Photo by Will Kerner, courtesy of Paul Wagner.*

the film-processing lab. Finally, select a transfer facility with something to lose if they do you wrong. They should have a reputation based upon experience in the field and, in my opinion, should be located in a major center of filmmaking. I would only select a facility in the United States, Canada, or Europe.

Once you select a facility, plan on four to six weeks in postproduction to complete the transfer process. Make sure that you have the money set aside for the process and do not cave in to the temptation of robbing the postproduction budget to patch holes during production. Be sure to stick with the game plan. Shoot the entire film in the same manner. By that I mean do not change anything that will cause the transfer facility to change its setup for transfer. This will cost you delays and additional money. And most importantly, do all your editing and correcting before you hand the facility the video master. The transfer facility is not there to compensate for laziness on your part. The master you give them should be the best you can make it.

A Case Study

While exploring the halls of the 2001 American Film Market, I became aware of a little film entitled *Windhorse*, which was shot on video and

Clandestinely lining up a shot in Chinese-controlled Tibet in front of the centuries-old palace of the Dali Lama. Photo by Will Kerner, courtesy of Paul Wagner.

transferred to 35mm. The film is not about Native Americans as the title might suggest. Rather, it concerns the oppression of the Tibetan people and their Buddhist religion since the Chinese Communists' takeover in 1950. This isn't the first time that filmmakers have undertaken this politically charged subject matter. The films *Seven Years in Tibet* and Martin Scorsese's *Kundun* both focused on the life of the Dalai Lama when he was young, but these films were backed by big budgets and were shot outside of Tibet. Veteran documentary producer/director Paul Wagner shot *Windhorse* on a miniscule budget of $200,000, plus deferrals, and did it secretly within Tibet to show the true political situation today.

Mr. Wagner brought his own cinematographer and chose two different video cameras for the production. He used a Sony 16:9 DVW-700WS Digital Betacam for the work done in neighboring Nepal, where he could get away with a broadcast-quality camera, but when he went into Tibet he took a less conspicuous Sony DCR-VX1000 DV camcorder so that he could appear like nothing more than a tourist. Postproduction was done in the United States. Mr. Wagner was kind enough to grant the following interview.

MD: You are an accomplished documentary producer, so you know about working with video, but did you have any concerns that a

dramatic work would not find acceptance from an audience and the buyers if shot on video versus film?

PW: Many, if not most, of the buyers (much less the general audience) would not notice that it was shot on video once transferred to 35mm film. Yes, they might note that it was funky-looking or looked very low-budget, but only more savvy and thoughtful viewers would understand that it had been shot on video. This was particularly true in early 1998 when we were one of the first digital video-to-film projects released. Indeed, I've shown videos projected for larger audiences, and even then it doesn't occur to a general audience that they're watching video rather than film. Please note. I'm not in any way suggesting that the video looks like film or is *as good as* film; just that most people don't think about it until it's called to their attention. Perhaps, because I've worked for many years in Washington where video and film have been integrated technologies for a long time, this aspect of shooting on video (digital or otherwise) and going to film never seemed particularly risky or problematic—simply a solution to creative and budgetary challenges. We actually promoted the fact that it was shot on video because that was part of what made the film unique and an unusual project—on the cutting edge technically and creatively.

MD: The clandestine way that you had to shoot made video the obvious choice, but would you have shot on film had you been in a country that was not concerned about censorship?

PW: The budget wasn't there for a film shoot of any kind—even 16mm—so it made the choice of video simple. We had only raised half of a $300,000 budget prior to the shoot and could not have bought the plane tickets to Nepal and Tibet and the film processing with that money. Of course, if we had had the full budget raised and could have saved on the cost of the video-to-film transfer on the back end, maybe we could have covered 16mm processing and transfer. But without the upfront money it was a moot point. The low front end on video is definitely one of the factors that has made it a medium of choice for spec dramas and docs, where the hope is to get the project to a rough cut so as to attract finishing money. The willingness of many festivals, most notably Sundance, to screen video has accelerated this.

MD: What kind of editing system did you use on this project? How long was the editing process, and did you encounter any unforeseen problems in post?

PW: We used an Avid to cut the show. When they first came out, I worked out a relationship with a local humanities office to purchase and share one. We've used it on several of our films over the last ten years. The editing took several months—January '97 to September '97. Then we screened a video version as a work in progress, got feedback, and edited more, did the special effects shots and online and color work, and transferred to 35mm. Throughout this time, of course, we were slowed considerably by the lack of money and the time taken to raise money for the completion. The screening of the work in progress was a huge help in that regard, because it attracted significant additional investment. We just finished the film in time to première at the Santa Barbara Film Festival where we won Best U.S. Film and Best Director awards.

MD: In regard to the screening, how did you find money sources?

PW: We had several investors and raised production financing based largely on people's interest in (and commitment to) the Tibetan political and cultural issues. Once we were able to show a cut of the film, several of those people re-upped for more money, and we also found others willing to come on. All the contacts were personally made by me or other of us connected with the making of the film.

MD: What did you do about sound for your shoot?

PW: We shot with two different cameras, as you know. For only one scene shot undercover in Tibet did we use the sound recorded by the Sony 1000 DV. We did also record a lot of sound wild on a hidden DAT recorder that was used to excellent effect as ambience in many scenes. All the rest of the dialogue was recorded with a professional mike, through a small mixer, and directly to the Sony 700 Digital Beta camera. Obviously, the camera mikes, although of decent quality, are not placed for acceptable pro recording.

MD: What final word of advice would you give an aspiring filmmaker seeking to produce his first film in a foreign land?

PW: Film in a country where it's legal to film . . . just kidding. Remember the electrical outlet adapters. Don't believe that you really understand the culture you're filming.

Chapter 25

Concluding Remarks

Of all the information gleaned from this book, one bit of advice should now be well entrenched. You have read it in almost every interview, and common sense itself dictates that if you are undertaking a complex project in unfamiliar territory, you must get people on your team that know how to circumvent the obstacles or plow right through them. You must ally yourself with or hire a local producer or UPM in the country where you intend to shoot your film, someone who knows what he is doing and whom you can reasonably trust.

Unfortunately, this is not always a simple task. People tend to exaggerate (or blatantly lie) about their ability to deliver in order to get a job. Some producers have gotten themselves into quite a fix when they discovered, too late, that they had hired the wrong guy. This can happen even when the local producer has a good reputation with other visiting production companies. He may do great when there is lots of money in the budget and the film is of a certain genre, but he might not be quite as valuable when there isn't extra money available for solving problems.

The best way to avoid making a costly mistake is to get someone on your team who is accustomed to both ends of the spectrum: someone with many industry contacts who knows how production works in the States and, at the same time, knows how to work with the film community in foreign countries. A small amount spent in the early stages on an active consultant will reap great savings by the time the film is completed.

Reserved Productions is here to help. The author's consulting

services cover everything from script preparation to financing to location scouting and management (including location surveys and local producer evaluations) to distribution assistance. Fees can be based on the entire project or on a portion thereof. Contact Mark DeWayne directly by e-mail (*info@reservedproductions.com*) or through the Web site *www.reservedproductions.com*.

Appendix

(Inclusion in this appendix does not necessarily constitute an endorsement by the author.)

Resources

DIRECTORIES AND RESOURCES

AIVF Guide to Film and Video Distributors; AIVF Guide to International Film and Video Festivals, Kathryn Bowser. Association of Independent Video and Film. (212) 473-3400.

American Cinematographer Manual; American Cinematographer Video Manual. The ASC Press, P.O. Box 2230, Hollywood, CA 90028

Academy Players Directory. Academy of Motion Picture Arts and Sciences, 8949 Wilshire Boulevard, Beverly Hills, CA 90211. (310) 247-3000.

Breakdown Services, Ltd. 1120 S. Robertson Boulevard, Third Floor, Los Angeles, CA 90035.

Directors Guild of America Directory. Directors Guild of America, 7950 West Sunset Boulevard, Los Angeles, CA 90056.

Enterprise Printers and Stationers. 7401 Sunset Boulevard, Los Angeles, CA 90046. (323) 876-3530.

Film Stock Exchange, Inc. 1041 N. Formosa Avenue, Santa Monica West, Building #15-D, Los Angeles, CA 90046.

Guide to Location Information. Association of Motion Picture and Television Producers, 8480 Beverly Boulevard, Los Angeles, CA 90048.

Hollywood Creative Directory. 3000 W. Olympic Boulevard, Suite 2525, Santa Monica, CA 90404-5041. (800) 815-0503.

Industry Labor Guide. 14806 Weddington Street, Sherman Oaks, CA 91411. (800) 820-7601.

Pacific Coast Studio Directory. P.O. Box V, Pine Mountain, CA 93222-0022. (661) 242-2724.

Sponsors: A Guide for Video and Filmmakers. Goldman and Green. Center for Arts Information, New York City. Available through AIVF.

Studio Film and Tape, Inc. 1215 N. Highland Avenue, Hollywood, CA 90038. (800) 824-3130.

The International Motion Picture Almanac. Quigley Publishing Company, Inc. 159 West 53rd Street, New York, NY 10019. (212) 247-3100.

U.S. Copyright Office, Register of Copyrights, Library of Congress. Washington D.C. 20559-6000. (800) 726-4995.

TRADE PUBLICATIONS AND BOOKS

American Cinematographer. ASC Holdings Corp., 1782 N. Orange Drive, Hollywood, CA 90028.
Daily Variety; Variety. 5700 Wilshire Boulevard, Suite 120, Los Angeles, CA 90036.
Film and Video. P.O. Box 3229, Northbrook, IL 60065-9645.
Filmmaker. 501 Fifth Avenue, Room 1714, New York, NY 10017.
The Hollywood Reporter. 5055 Wilshire Boulevard, Los Angeles, CA 90036-4396.
IFC Rant. Independent Film Channel. Subscribe: (877) NOW-RANT.
The Independent. Association of Independent Video and Film, 304 Hudson Street, New York,
 NY 10013.
Making Independent Films: Advice from the Filmmakers by Liz Stubbs and Richard Rodriguez. New
 York: Allworth Press, 2000.
Millimeter. Penton Publishing, Subscription Lock Box, P.O. Box 96732, Chicago, IL 60693.
Premiere. P.O. Box 55387, Boulder, CO 80323-5387.
Producing for Hollywood: A Guide for Independent Producers by Paul Mason and Don Gold. New
 York: Allworth Press, 2000.
Production Weekly. P.O. Box 15052; Beverly Hills, CA 90209.
Screen International. 60 Pineapple Street #6A, Brooklyn, NY 11202.
Videography. P.O. Box 0513, Baldwin, NY 11510-0513.
Videomaker. P.O. Box 3780, Chico, CA 95927-9840.

ORGANIZATIONS, GUILDS, AND SOCIETIES

Alliance of Motion Picture and Television Producers (AMPTP). 15503 Ventura Boulevard,
 Encino, CA 91436. (818) 995-3600.
American Society of Cinematographers (ASC). 1782 N. Orange Drive, Hollywood, CA 90028.
 (323) 969-4333.
Association of Talent Agents. 9255 Sunset Boulevard, Suite 930, Los Angeles, CA 90069. (310)
 274-0628.
Association of Talent Managers. 12358 Ventura Boulevard, Suite 611, Studio City, CA 91602.
 (310) 275-2456.
Association of Film Commissioners International. 7060 Hollywood Boulevard, Suite 614, Los
 Angeles, CA 90028. (323) 969-4333.
IFP/East. 104 W. 29th Street, Twelfth Floor, New York, NY 10001. (212) 243-7777.
IFP/Midwest. 676 N. LaSalle, Fourth Floor, Chicago, IL 60610. (312) 587-1818.
IFP/North. 401 N. Third Street, Suite 450, Minneapolis, MN 55401. (612) 338-0871.
IFP/South. P.O. Box 145246, Coral Gables, FL 33114. (305) 461-3544.
IFP/West. 1964 Westwood Boulevard, Suite 205, Los Angeles, CA 90025. (310) 475-4379.
International Documentary Association (IDA). 1551 S. Robertson Boulevard, Suite 201, Los
 Angeles, CA 90035. (310) 284-8422.
International Film Financing Conference (IFFCON). 360 Ritch Street, San Francisco, CA
 94107. (415) 281-9777.
Motion Picture Association of America (MPAA). 15503 Ventura Boulevard, Encino, CA
 91436. (818) 995-6600.
International TV Association (ITVA). P.O. Box 2226, Redondo Beach, CA 91278. (310) 542-
 5324.
Motion Picture Editors Guild. 7715 Sunset Boulevard, Hollywood, CA 90046. (323) 876-4770.
Producers Guild of America. 400 S. Beverly Drive, Beverly Hills, CA 90212. (310) 557-0807.
Screen Actors Guild. 5757 Wilshire Boulevard, Los Angeles, CA 90036. (323) 954-1600.
Screen Composers of America. 2451 Nichols Canyon Road, Los Angeles, CA 90046. (323)
 876- 6040.
The Society of Composers and Lyricists. 400 S. Beverly Drive, Suite 214, Beverly Hills, CA
 90212. (310) 281-2812.

Women in Film (WIF). P.O. Box 2535, North Hollywood, CA 91602. (310) 271-3415.
Writers Guild of America, East. 555 West 57th Street, New York, NY 10019. (212) 767-7800.
Writers Guild of America, West. 7000 West Third Street, Los Angeles, CA 90048-4329. (323)
 951-4000.
World Intellectual Property Organization (WIPO). P.O. Box 18, CH-1211, Geneva, 20,
 Switzerland. 41-22-338-9111; United States office: 2 United Nations Plaza, Room 560,
 New York, NY 10017. (212) 963-6813.

WEB SITES

Allworth Press (*www.allworth.com*)
American Film Institute (*www.afionline.org*)
Association of Film Commissioners International (*www.afci.org*)
Association of Independent Video and Filmmakers (*www.aivf.org*)
Avid Technology (*www.avid.com*)
Baseline on the Web (*www.pkbaseline.com*)
Breakdown Service. Ltd. (*www.breakdownservices.com*)
Eastman Kodak (*www.kodak.com*)
Film Festivals Server (*www.filmfestivals.com*)
Film Maker (*www.FilmMaker.com*)
Filmmaker Magazine (*www.filmmag.com*)
Film Stew (*www.filmstew.com*)
Fuji (*www.fujifilm.com*)
Hollywood Creative Directory (*www.hcdonline.com*)
Independent Feature Project (*www.ifp.org*)
Independent Film Channel (*www.ifctv.com*)
IndieWIRE (*www.indiewire.com*)
Industry Labor Guide (*www.laborguide.com*)
International Entertainment, Multimedia and Intellectual Property Law and Business
 Network (*www.medialawyer.com*)
International Film Financing Conference (*www.iffcon.com*)
Internet Movie Database (*www.imdb.com*)
Landmark Theatres (*www.LandmarkTheatres.com*)
Mandy (*www.mandy.com*)
Money for Film and Video Artists (*www.artsusa.org*)
Screen International (*www.screendaily.com*)
Sundance (*www.sundance.org*)
The Hollywood Reporter (*www.hollywoodreporter.com*)
Variety (*www.variety.com*)
WebMovie: The Producer's Guide to the Web (*www.webmovie.com*)
World Intellectual Property Organization (*www.wipo.int*)
U.S. Copyright Office (*http://lcweb.loc.gov/copyright*)
U.S. State Department (*www.state.gov*)

Glossary

16:9. The aspect ratio of high-definition and digital television.
above-the-line. In a film budget, the costs for story and other rights, pay to writers, direc-
 tor, producer, and acting talent, plus related fringe benefits.
AC. Assistant Cameraman. The First AC is also referred to as a "focus puller."
AD. Assistant Director.
AFM. American Film Market.

all-in deal. An arrangement made for goods and/or services in which everything is to be provided at one set price.

ancillary markets. The film distribution markets that are secondary or subordinate to the theatrical and television markets.

aspect ratio. The relationship between the width and the height of a picture.

attachments. People who are connected to a film project prior to, and as a condition of, its being made.

baht. A unit of currency in Thailand.

below-the-line. In a film budget, all expenses and personnel that are not included above-the-line.

bicycling. Refers to the process of self-distributing a film from theater to theater.

bondable. A term used of individuals involved in the making of a film. It refers to their acceptability by a completion bond company in order for the company to extend a completion guarantee.

breakout. A film that performs above expectations.

completion bond. A production guarantee that assures investors that a film will be completed.

contingency. An amount of money required by a bonding company, usually a percentage of a production's budget, set aside for emergency purposes.

CRT. A type of video-to-film transfer machinery.

dailies. The printed takes during a film shoot are often developed overnight so that they can be viewed the following day, hence the term.

DAT. Digital Audio Tape.

deferral. The postponement of payment for services rendered until there are profits.

DGA. Directors Guild of America.

distribution deal. The agreement reached between a producer and a distributor governing release of the film to the public.

dolly. A wheeled platform upon which a film camera is mounted to afford smooth moving shots.

DP. Director of Photography.

draw. A person or element involved in a film that can "draw" an audience.

EBR. Electron Beam Recorder. Utilizes microscopic electron beams to record video onto film.

equity investor. A person who owns an interest in a film due to an investment of capital.

exchange rate. The value of U.S. currency against the currency of other countries.

exhibitors. Those who show films to the consumers: theater owners, cable networks, etc.

extras. Background performers who fill out the look of a scene but do not have dialogue. Also, something additional that was not previously anticipated.

field. One-half of a video frame.

film commission. An office financed by a government to promote its region as a filming location, thus bringing revenue to the region.

first-dollar. A kind of deal that pays a percentage of the gross moneys received at the box-office.

flicker. A shaking of the film or video when played at too slow a speed.

fps. Frames per second.

frame. In filmmaking, a single entire picture of video or film.

gaffer. The chief electrician on a film crew.

genre. The kind or type of film story.

grant. An amount of money given by a granting organization for the support of a project.

grip. One who handles props and scenery on a film set.

GST. Goods and Services Tax.

guerrilla filmmaking. The kind of ultra-low-budget filmmaking that frequently ignores all the rules and regulations in order to complete the project.

high-concept. A story that can be defined in one line and inspire interest. A high-concept is usually event-driven as opposed to character-driven.

high-definition video. A wide-screen video format that utilizes up to 1,080 lines of high-resolution video.

honey wagon. A transportation vehicle that contains multiple dressing rooms for actors on a film shoot and restrooms for cast and crew.

infrastructure. Basic facilities and installations, such as roads, power plants, communications, food services, accommodations, and transportation. Pertaining to filmmaking, this might also refer to studio facilities and equipment.

interlaced. Combined fields of video that create a single frame.

joint venture. When two or more separate entities join together to produce a film, sharing the risks and benefits.

kinescope. A system for transferring video to film using a synchronized camera and high-quality video monitors.

LA. Los Angeles.

lamp. Any light used to illuminate a film set.

letter of intent. Not quite a contract, yet it can be used as proof of an attachment to a film.

letter of interest. Less than a letter of intent, it merely expresses interest in a film project.

line producer. The person who oversees the actual production of a film on location.

location scout. The person hired to visit potential locations for filming and fill out location surveys so that the producer and director can make decisions on where to film.

low-angle. A camera setup in which the camera is placed low and is angled upward.

master scene. A form of screenwriting that depicts a full scene or sequence without consideration of the camera moves or distinction of individual shots.

negative pickup. The kind of deal where a distributor contracts to pay the producer all the expenses of producing a film, once it is acceptably delivered.

niche. A suitable position or place into which a particular film fits within the marketplace. It could be a genre or a demographic or some other narrowly specific position.

NTSC. National Television Standards Committee. The video standard used in the United States.

option. The right to buy, sell, or lease at a set price within a designated period of time. Most often utilized by a producer to obtain control of a screenplay or book from its writer in order to find backers to produce it.

P&A. Prints and Advertising.

PAL. Phase Alternation by Line. The video standard employed throughout most of the world, but not common to the United States.

pay-or-play. A kind of deal (usually with an actor) that guarantees payment, whether or not the film actually gets made as scheduled.

per diem. A daily stipend given to non-local crew and cast members to cover such expenses as meals, personal laundry, personal transportation, etcetera.

points. The percentage of interest that an investor (or participant) owns in a film.

premiere extras. Also referred to as "silent bits." Background performers who are specifically written into the script. They may have some action to perform, but they do not have dialogue.

presale. The sale or licensing of a film before it is made.

prints. The developed copies from film negatives.

progressive mode. A camera setting that captures an entire frame at once, as opposed to interlaced fields.

prospectus. A statement of the features of a new enterprise in order to attract backers.

prosumer. A kind of camera that is a compromise between professional and consumer quality.

raw stock. Film that has not yet been exposed.

residuals. Supplementary payments due to actors and certain above-the-line crew when the producer profits from future releases, secondary markets, or reruns.

resolution. The clarity of detail in a picture.

SAG. Screen Actors Guild.

screeners. People who act as a sieve to keep unwanted people or materials from getting to their employers. May also refer to film exhibitors.

SECAM. System Electronique pour Colour avec Memorie. A television standard developed in France.

set. In filmmaking, where the crew and cast are currently filming.

shot-by-shot. A form of screenwriting that depicts each move of the camera as an individual unit.

slate. A list of proposed projects for a studio or production company. Also refers to the slate board or "clapboard" that is used to record the important information pertaining to a filmed take.

slicks. One-page advertising tools, like miniature film posters, that are handed out to market a film.

standard. A set of requirements to which video equipment manufacturers adhere so that everything meshes.

strobing. Video playback or lighting that flickers at a steady rate.

spot rail. A metal pile or rail upon which production lights are hung.

storyboard. A pictorial representation of the film script, much like a comic strip, which visually demonstrates the director's vision, including camera angles and movements.

strip board. A board with detachable strips that is used for the scheduling of a film.

subsidy. A grant of money or services provided by a foreign government to encourage filming in that country.

take. Each attempt (between "action" and "cut") at capturing a shot on film.

telecine. A kind of machinery and the process for transferring film to videotape for editing purposes.

THX sound. The optimized sound quality system developed by Lucasfilm and installed in many cinemas.

trackers. The people employed in the film industry who keep track of scripts or film projects in development or in progress.

trades. The magazines and papers that are specifically related to the entertainment industry.

turnaround. When a production entity (often a studio) reverses its opinion on a film project during pre-production and ceases to move it forward. Also, the cast and crew are expected to receive minimum and specified hours of time between the wrap of one day's shooting and the start of the next day's shooting.

U.K. United Kingdom.

UPM. Unit Production Manager. The person who oversees daily operations of a production.

VAT. Value Added Tax.

VOD. Video On Demand.

work-for-hire. The producer should pay at least one dollar to the writer so that the producer retains full legal rights to the screenplay. Lee Wilson's copyright guide defines it as follows: "A work created by an independent contractor (a freelancer) if the work falls into one of nine categories of specially commissioned works named in the U.S. copyright statute and both the independent contractor and the person who commissions the creation of the work agree in writing that it is to be considered a work-for-hire . . ."

work print. A print version of a completed film that can be improved through editing and other post-production enhancements.

wrap. From the phrase "wrap it up," meaning the end of a day's shooting or the end of the last day of shooting.

Bibliography

Bayer, William. *Breaking Through, Selling Out, Dropping Dead and Other Notes on Filmmaking.* New York: Limelight Editions, 1971, 1989.

Blake, Larry. *Film Sound Today: An Anthology of Articles from Recording Engineers and Producers.* Reveille Press, 1984.

Chamness, Danford. *The Hollywood Guide to Film Budgeting and Script Breakdown for Low Budget Features.* Los Angeles: The Stanley J. Brooks Company, 1988.

Corman, Roger, with Jim Jerome. *How I Made a Hundred Movies in Hollywood and Never Lost a Dime.* New York: Random House, 1990.

Durie, John, Annika Pham, and Neil Watson. *Marketing and Selling Your Film Around the World: A Guide for Independent Filmmakers.* Los Angeles: Silman-James Press, 2000.

Gaspard, John, and Dale Newton. *Digital Filmmaking 101.* Los Angeles: Michael Wiese Productions, 2001.

Goldman, William. *Adventures in the Screen Trade.* New York: Warner Books, 1983.

Hamilton, Peter, and David Rosen. *Off-Hollywood: The Making and Marketing of Independent Films.* New York: Grove Weidenfeld, 1990.

Harmon, Renee. *Film Producing: Low Budget Films that Sell.* Hollywood: Samuel French Trade, 1988.

Hurst, Walter E., and William Storm Hale. *Motion Picture Distribution: Business or Racket?* Hollywood: Seven Arts Press, 1975, 1977.

Litwak, Mark. *Contracts in the Film and Television Industry.* Los Angeles: Silman-James Press, 1995.

———. *Deal Making in the Film and Television Industry.* Los Angeles: Silman-James Press, 1994.

Lumet, Sidney. *Making Movies.* Alfred A. Knopf, 1995.

Lyons, Donald. *Independent Visions.* New York: Ballantine Books, 1994.

Maier, Robert G. *Location Scouting and Management Handbook.* Boston: Focal Press, 1994.

Martell, William C. *The Secrets of Action Screenwriting, 2nd ed.* Los Angeles: Hammer Productions, 1998.

Mason, Paul, and Don Gold. *Producing for Hollywood: A Guide for Independent Producers.* New York: Allworth Press, 2000.

Schmidt, Rick. *Feature Filmmaking at Used Car Prices, 3rd ed.* New York: Penguin Books, 2000.

Seger, Linda. *Making A Good Script Great.* New York: Dodd, Mead and Company, 1987.

Stubbs, Liz, and Richard Rodriguez. *Making Independent Films: Advice from the Filmmakers.* New York: Allworth Press, 2000.

Index

Books from Allworth Press

Producing for Hollywood: A Guide for Independent Producers
by Paul Mason and Don Gold (paperback, 6 × 9, 272 pages, $19.95)

Directing for Film and Television, Revised Edition
by Christopher Lukas (paperback, 6 × 9, 256 pages, $19.95)

The Directors: Take One

The Directors: Take Two

Making Independent Films: Advice from the Film Makers
by Liz Stubbs and Richard Rodriguez (paperback, 6 × 9, 224 pages, $16.95)

The Filmmaker's Guide to Production Design

An Actor's Guide—Your First Year in Hollywood, Revised Edition
by Michael Saint Nicholas (paperback, 6 × 9, 272 pages, $18.95)

The Health & Safety Guide for Film, TV & Theater
by Monona Rossol (paperback, 6 × 9, 256 pages, $19.95)

Get the Picture? The Movie Lover's Guide to Watching Films
by Jim Piper (paperback, 6 × 9, 240 pages, $18.95)

Career Solutions for Creative People
by Dr. Rhonda Ormont (paperback, 6 × 9, 320 pages, $19.95)

The Screenwriter's Legal Guide
by Stephen F. Breimer (paperback, 6 × 9, 320 pages, $19.95)

The Screenwriter's Guide to Agents and Managers
by John Scott Lewinski (paperback, 6 × 9, 256 pages, $18.95)

Please write to request our free catalog. To order by credit card, call 1-800-491-2808 or send a check or money order to Allworth Press, 10 East 23rd Street, Suite 210, New York, NY 10010. Include $5 for shipping and handling for the first book ordered and $1 for each additional book. Ten dollars plus $1 for each additional book if ordering from Canada. New York State residents must add sales tax.

To see our complete catalog on the World Wide Web, or to order online, you can find us at *www.allworth.com*.